BALANCING THE SCALES

An Examination of the Manipulation and Transformation of Symbolic Concepts of Women

Edited by

Marie A. Conn
Therese McGuire

University Press of America,® Inc.
Lanham · New York · Oxford

Copyright © 2003 by
University Press of America,® Inc.
4501 Forbes Boulevard, Suite 200
Lanham, Maryland 20706

PO Box 317
Oxford
OX2 9RU, UK

This book is dedicated, with love and gratitude, to

Josephine Procopio Albarelli
Bob, Kelsey and Anders
Regis Duffy, OFM
Our families
Our students at Chestnut Hill
The Sisters of St. Joseph of Chestnut Hill

and to the memory of

Judith Ann Cleary, SSJ
Alice and Ira Conn
Bill and Pauline Lonnquist
John and Anna McGuire
Mark Porter, Sr.

Contents

List of Illustrations

Foreword

It is an honor to be asked by one's academic colleagues to write the foreword to a collaborative work that represents the good thinking and creative insights characteristic of the five women who contributed to this book. Each brings to the collaboration her own personal historical perspective as well as the wisdom and learning gleaned from her specific discipline. Such diversity allows the reader the opportunity to view the subject of woman from various vantage points. Since complex questions are seldom answered fully from any one viewpoint, an examination of the topic from a multiplicity of angles promises a rich, thoughtful, stimulating reading experience.

This book examines the attitudes, factors, beliefs, myths, and symbols in religion, art, psychology, and literature that reinforce patriarchy, minimalize the feminine, and underestimate or even denigrate the role and contributions of women. Using the analytical tools of their specific academic disciplines, the contributors carefully and critically dissect the subliminal and conspicuous messages about women that predominantly male artists, writers, theologians, and scripture scholars have perpetuated through the practice of their crafts. In so doing, they explore conscientiously those values that have been lost or repressed because, through the centuries, a dominant male culture has been in a position to present its point of view almost to the exclusion of women's. These values, which have been either excluded or minimized, include the feminine dimension of the Divine, equality between the sexes, the intellectual contributions of women, the sacredness of the earth, and the interdependent nature of the web of life. The reader has only to ponder the raw reality of the world to discover the truth in the conclusions drawn or pointed to by these writers.

That said, it is important to note at the beginning of a work such as this, that all of the authors respect and value men and their undeniably important contributions. This collection of essays is not about male-bashing or about celebrating women at the expense of men. Rather, it is a careful and thoughtful appraisal of a patriarchal system (into which men are born and initiated) that has consistently over the millennia insidiously

and blatantly worked against the individuation and recognition of women. To pit women against men is not the aim of this exploration. The goal is to examine from an academic perspective those elements and constructs of thought that negate the contributions and value of women in order to balance the scales in a way that respects and promotes the contributions of both.

The myths, plays, poems, and paintings chosen for analysis present a view of woman that can accurately be described as bi-polar. The writers rightly deduce that quite often woman is depicted as representative of two archetypal opposites—the whore, the bearer of woes, the seductress, the temptress, the allurer **or** the virgin, the princess, the holy mother. Woman is portrayed as the one befriended and beguiled by the serpent or the one who crushes its head and nullifies its power; the first is touchable, the second untouchable. The first symbolizes matter and possible damnation, the other the spirit and possible salvation. One leads men to hell, the other to heaven, an idea brought out clearly in Dr. Therese McGuire's exploration of the contrast between artistic renderings of the Whore of Bablylon and the Woman Clothed With the Sun. The clash of opposites, even when used for dramatic effect, is troublesome and creates an imbalance that is irrational and illogical.

Woman—who she is, what she thinks, how she acts, why she attracts—is a subject that has provoked the reflection of men throughout the millennia. A complicated biological being, woman is also a complex weave of intellect, will, emotions, and spirit. Thus it seems that a logical question to be asked by man is indeed, "Who is woman in and of herself?" Unfortunately, this is not the query that marks the quest for definition of the feminine. Rather man asks consistently throughout time, in literature and in life, "Who is woman to man?" More often than not, it is not woman in and of herself who is the subject of inquiry and puzzlement, but woman as she relates to man, woman as the one who can satisfy man's desire, woman as sexual being. Equally a subject for investigation is the woman who is strong, intellectual, defiant, self-reliant; aspiring to be"like a man," this woman is more repugnant and disquieting to man than the seducer. In either context, woman is not a subject in and of herself, but an object to be subdued, controlled, and conquered, indeed used. While this may seem a bit extreme, it is perhaps in the extreme that this passion of men to define woman is best dissected and analyzed. Men seem to aspire to make

women in the image they want, rather than working to accept them in the image in which God created them. One might say that since woman shared with man the fruit of the tree of knowledge, man has sought to push her back into a state of ignorance. It is a conflict of archetypal proportions.

Both Dr. Marie Conn and Dr. Nancy Porter include in their presentations a definition of archetypes and the role they play in the psyche. Archetypes as defined and used by psychiatrist Carl G. Jung, are clusters of energy within the unconscious that are common to all women and men simply because they are human beings. Archetypes are transcendent but become evident in images and ideas; indeed that is how their existence manifests itself. Acting like a magnet, the archetype gathers around it ideas, characteristics, and values that form a complex which then has the potential to manifest itself in conscious behavior. Myths, which include stories about the wise old man, the devil, the spiritual guide, the handsome prince, the fairy princess, give well-formulated expression to archetypes. Woman, the feminine, the Great Mother, whatever one wishes to call her, is one of the most powerful archetypes in the unconscious.

Man's view of woman is a mix of inherited archetypal material and material formed first from his own understanding of his mother, female siblings and relatives, and then augmented by his interactions with other women during his psycho-sexual development. These specific experiences contribute to the formation of a complex that becomes part of the larger, universal image of woman that resides in the individual psyche. When archetypes are manifested in the real world, they have the potential to assume inordinate power over the person who encounters them. The projection of an archetype obscures the reality of the person onto whom it is projected. For example, love at first sight results when a woman or man experiences the ideal archetype of man or woman in the other. The projections possess a numinous or other-worldly quality which has the capacity to captivate and capture the imagination. It may appear that the ideal mate has been "found," but in truth the real person in the encounter may be eclipsed. Until the projection ceases, the person cannot be accepted in and for herself.

As one reads through the pages of this book, the concept of the archetypal feminine emerges time and again as in age after age

unconscious projections from the male psyche obfuscate real women by externalizing negative ideas, preconceived notions, and inherited patterns of beliefs that demean women. The particular woman suffers immeasurably at the hands of the irrational Archetype. Men's collective unconscious contains material that takes form in images associated with the Whore of Babylon as well as with the Woman Clothed With the Sun; an image of Cleopatra as well as of the damsel in distress; an image of the wicked witch as well as of the fairy princess. It is the use of two conflicting archetypal images in diametrical opposition to each other that repeatedly blurs and obscures the reality of woman in her subjectivity and individuality. In the projection of an archetype, the subject receiving the projection becomes an object endowed with distorted characteristics, traits, and habits, rather than a subject formed by her own past experiences and choices. Throughout history, it seems that these conflicting archetypes effectively create misperceptions about real women who fall somewhere in between the Whore of Babylon and the Woman Clothed With the Sun. To see woman only as evil or only as pure is more than distortion, it is sheer absurdity. Woman is neither goddess nor devil; she is, like man, a human person formed in the same image and likeness of God as man.

Confident in the superiority of their intellect and will power, many men fear that which has the capacity to subvert the mind and subject it to matter. Instead of owning the complexity of their own emotional life, their drives, and passions, men blame women for seducing them. The story of Adam and Eve is replayed constantly throughout history. As Conn points out, many early interpreters of the Genesis myth portray woman as weaker, more easily misled, more readily compromised than men using their persuasive power to tempt men and cause them to submit to their lower nature. Indeed, there is a subtle inference latent in the Eden myth that msn succumbs to moral concupiscence **only** if he is provoked by woman. Woman, therefore, is viewed as having the power to cause a man to lose control, to act in a way that he would not choose if he were not first tempted. Man must then control woman lest he be controlled by her.

Dr. Barbara Lonnquist explores the evolution of the heroine in British literature from Elizabethan to Victorian times. From an historical perspective, she notes the stark contrast between the strong-willed, sexually potent, politically powerfully Cleopatra and a similarly

compelling and forceful Elizabeth I with their seeming opposite, the long-lived Queen Victoria, who reigned supreme in the domestic sphere while the New Woman, more reminiscent of Cleopatra and Elizabeth, emerged in the public sphere. The literature of the times in part reflects the monarchs who reigned. It is not then surprising that the strong Elizabethan heroine is as stark a contrast to the Victorian heroine as Victoria is to Elizabeth. During the reign of the legendary Virgin Queen, William Shakespeare created heroines whose strength, wit, and bold determination compared favorably with the traits that marked the woman who ruled all of England. Lonnquist would say that Shakespeare gave women a human face. During the Victorian Age writers debunked the image of the New Woman and celebrated those women who understood their place as wives and mothers. Lonnquist laments nineteenth-century literature and art that rendered women formless as well as faceless.

As the traits common to Shakespeare's Cleopatra and Elizabeth I find expression in the New Woman of nineteenth-century British society, men's deep seated fears are unearthed. Lonnquist points out that the New Woman threatens British manhood on two fronts: through her knowledge of things sexual she unsettles the home; through her knowledge of things intellectual she unsettles the patriarchy. Is it any wonder that she is identified in literature with the vampire or the demon or the witch, archetypal images each and all? More is operative here than is immediately evident.

According to Carl G. Jung, the anima is the unconscious feminine element in the male psyche and the animus is the unconscious masculine element in the female psyche, concepts explored by Porter. Both archetypes possess tremendous energy and power. Depth, maturity, wisdom, and balance result when the positive aspects of these archetypes are successfully integrated into the personality. Like all archetypes, they can be spontaneously projected onto the opposite sex and cause the subject of the projection to be imbued with "numinosity" or "larger than life" qualities. Jung explains that men can be caught in the grip of the anima and women of the animus. When this occurs, the results are quite interesting. A woman dominated by her animus becomes argumentative and expresses strong, unsubstantiated opinions, believing herself to be in possession of "absolute truth." Men, when victimized by their anima, become petulant, petty, emotional, and irrational. Basically, the worst is

brought out in each.[1]

It appears that nineteenth-century men experienced just such a phenomenon when confronted with the New Woman. Jung's description of the anima and animus provides a basis to explain men's reaction to women such as Cleopatra, Elizabeth I, and the New Woman. In asserting themselves politically, in transcending the merely domestic sphere, in being conversant with things sexual, these women exhibited those "manly qualities" that resulted in the spontaneous eruption of the patriarchy's collective anima. The threat to hearth and political security was intolerable. Because men were gripped by an irrational power, their reaction was irrational and these women were demonized. Lonnquist laments that in nineteenth-century art, Cleopatra, surely a symbol of the New Woman, was reduced to a lifeless form that did not even resemble the great Queen of the Nile. Interestingly, she also points to the fact that the unmarried Queen Elizabeth I, who sought to portray herself as unisex (male and female, King and Queen) is nonetheless urged by her subjects to marry—a woman not subject to a man is dangerously suspect.

Lonnquist notes even today strong women present a challenge to societies that continue to be threatened by them. Those qualities, choices, and public stances that mark women as independent, self-confident, assertive, and intelligent cause discomfort and anxiety in those who believe in the more private, unobtrusive, self-deprecating role of women. This was certainly true in Victorian England. Lonnquist raises interesting issues, questions, and contrasts in her literary explications that seek to shed light on the attitudes, fears, and preordained ideas that persist in marginalizing competent, self-assured women.

According to Conn, modern scholars, especially women theologians, have reinterpreted the Genesis myth and offered alternative understandings designed to refute and re-balance the scales in terms of Man and Woman, Adam and Eve. Conn notes that the concept of original sin as it has come to us from Saint Augustine casts women in a less than favorable light. She is seen as weak, easily mislead, naive; a temptress whose wiles have the potential to derail the more cerebral man from higher pursuits. So many similar wrong-headed notions and misdirected perceptions derive from an interpretation of scripture that may be more rooted in one man's guilt over his own philandering than in the intent of the Divine Author. Teilhard de Chardin, priest, prophet, poet, mystic, theologian, and scientist, offers a

theory of original sin that is of particular interest in light of Conn's presentation and the work of present-day theologians to reinterpret the Genesis myth with the tools and insight provided by modern methods of exegesis.

Teilhard de Chardin's explanation of original sin derives from an incisive, insightful logic that fits well with modern theories of evolution. "As far as the mind can reach, looking backwards, we find the world dominated by physical evil, impregnated with moral evil (sin is manifestly 'in potency' close to actuality as soon as the least spontaneity appears)— we find it *in a state of original sin*."[2] Teilhard maintains that "everything in the universe holds together physically, chemically, zoologically, too integrally for the *permanent* absence of death, suffering and evil (even for a small fraction of things) to be conceivable outside a *general state* of the world different from our own."[3] Teilhard points out that never was there a time in the history of the evolving world that death, in some form, did not exist, e.g., even the atom disintegrates.[4] The Fall was not some unique event that occurred at an identifiable point in history, but an event of such magnitude and cosmic significance that it is co-extensive with the entire sweep of history. It cannot be otherwise in a universe in evolution.

If one accepts the theory of evolution, then original sin can be defined as transcending an isolated act of a first couple created in a static world, instead, it becomes an omnipresent condition existing from the beginning of time. As a result, Teilhard insists that there is no longer a need to point the finger of blame at a first couple because in an organic, evolving universe the origin and problem of evil assume dramatically different proportions and can be defined in an inclusive way. "Physical and moral disorder, of one sort or another, must necessarily be produced simultaneously in a system which is developing its organic character, *so long as* the system is incompletely organized."[5] While Teilhard postulates that original sin is co-extensive with creation, he recognizes that with the advent of the human person sin and moral evil appear.[6] Interestingly, when outlining the role of humans in evolution, his theory of original sin points not only to past choices but to the future, when a mature and fully evolved humankind will be offered an ultimate choice for or against God.[7]

This explanation of original sin opens the biblical story to embrace the expanse of time in a way that attributes greater significance to individual

acts of obedience or disobedience during the entire sweep of human history. It takes the blame from a first couple and places the responsibility upon the shoulders of each and all who walk the path to final unification with God. Choices for or against unity, for or against integration, for or against interdependence, for or against the good, graduate to the level of a choice for or against the continuous evolution of the cosmos toward ultimate unity with the Divine. They also open the way for a very different understanding of the Creation myth and the role of woman.

Teilhard de Chardin would challenge man's limiting vision of woman, which relegates her to her role in reproduction; which subjugates her as an object of desire; which chains her to her domestic duties. In direct contradiction to the ill-conceived notions associated with poor interpretations of the Genesis myth, Teilhard recognizes Woman as the bearer of great spiritual good apart from her maternal role.

> However fundamental woman's maternity may be, it is almost nothing in comparison with her spiritual fertility. Woman brings fullness of being, sensibility, and self-revelation to the man who has loved her. . .
> Within the human mass there floats a certain power of development, represented by the forces of love, which infinitely surpass the power absorbed in the necessary concern for the reproduction of the human species.[8]

In misunderstanding the broader role of woman, man has neglected to include her perspective, her thoughts, her intellectual and emotional energies in the building-up of the world. In equating her usefulness solely with her reproductive function, in fearing her as a seductress, man relegates her to the role of an object rather than a person, reduces her to a function rather than helpmate and equal, and denies that very complementary aspect of creation that is necessary for him to reach fulfillment in the Absolute. Teilhard insists that the force of the feminine is designed to lead man to God and to a proper understanding of man's role in creation.

> In the present state of the world, man has not yet, in reality, been completely revealed to himself by woman, nor is the reciprocal revelation complete. In view, therefore, of the evolutive structure of the universe, it is impossible for one to be separated from the other while their development is still continuing. It is not in isolation (whether married or

unmarried), but in paired units, that the two portions, masculine and feminine, of nature are to rise up towards God.[9]

Indeed, Teilhard himself enjoyed deep, lasting, mutually enriching friendships with women throughout his life. From childhood, his relationships were built upon respectful and maturing interactions first with his mother, then with two of his sisters, Françoise and Marguerite-Marie, for whom he bore a special affection. His cousin, Marguerite Teillard-Chambon, with whom he fell in love, provided him with an intimacy that was both spiritual and intellectual. She was the one against whom he tested his ideas and emerging cosmic theology. The many letters he wrote to her testify to the importance he placed upon her critical assessment of his thought. Marguerite herself was an educated woman who was an accomplished administrator and writer.

Another close friend was philosopher and French feminist, Léontine Zanta. American communist Ida Treat and Jeanne Mortier, the literary executor to whom he entrusted the publication of his works, were likewise included his circle of feminine acquaintances. Also, there was the former wife of a scientific colleague, Professor Hellmut de Terra, Rhoda de Terra, with whom he enjoyed a deep, warm, and lasting friendship. It was while visiting her apartment in Easter of 1955 that he suddenly died.

Finally, there was the woman whose friendship with Teilhard raised many questions. Lucile Swan, an American sculptress whom he met in China, was the great love of his mature years. While she was helpful in assisting him with the on-going clarification of his thought and the translation of some of his essays, they disagreed over the nature of their relationship—she asking for more than he, as a celibate priest, was willing to give.[10] In the end, though she accepted his decision to remain fully faithful to his priestly commitment, there was an unresolved strain between them, complicated in part because of his friendship with Rhoda de Terra.

For the purposes of this study, it is important to emphasize that Teilhard accepted these women as individuals each with her own subjective nature, each with her own abilities, each with her own goals. He encouraged them to follow and to seek success in their intellectual and spiritual pursuits. He had high respect for them as equals and never tired of challenging them to fulfill their potential. That they were essential to his growth and maturation as well is not even questionable. "... from the critical moment when I rejected many of the old moulds in which my

family life and my religion had formed me and began to wake up and express myself in terms that were really my own, I have experienced no form of self-development without some feminine eye turned on me, some feminine influence at work."[11] Not only in words, but in actions, Teilhard demonstrated an all too rare appreciation for the presence of the feminine in his life—he was able to balance the scales. It is not surprising then that The Feminine plays a central role and is a key element in Teilhard's evolutionary cosmology. Indeed, he places The Feminine at the heart of humanity's journey to God.

This paleontologist/theologian defines creation as a continuous process of the unification of the elements of the world. The Feminine, not to be equated with an individual woman, is that power of attraction within evolution that from time's beginning causes the fragments of the world to unite in a very specific way, for this union of the elements does not absorb but differentiates the particles it unites. In establishing new relationships, the energies of creation distinguish and emphasize the components of which they are composed. Relationships are key in Teilhardian thought. As the building blocks of the universe, they are all that exists. Not to be in relationship is to be dis-integrated and tending toward isolation, a state commensurate with a fall back into nothingness.

Teilhard observes that from the moment of their birth, the created elements of the universe reached out to one another in order to establish a new entity—whether these were protons, electrons, and neutrons forming an atom, or hydrogen and oxygen atoms forming a water molecule, or molecules fashioning macromolecules and then the cell—evolution is one long story of relationships that build upon differentiation in order to achieve a cohesive and workable unity. "Everything in the universe is made by union and generation—by the coming together of elements that seek out one another, melt together two by two, and are born again in a third."[12] However, more elucidation is needed.

The great Teilhardian dictum is that union differentiates. Following upon that is the equally important dictum that love personalizes. Teilhard believes that love, in some rudimentary form, has existed from the conception of the universe—it is seen in the attraction of the elements to one another, an attraction that leads to the birth of new and more highly differentiated entities.

Strictly speaking, love does not as yet exist in the zones of the pre-living

and the non-reflective, since the centres are either not linked together or are only imperfectly centred. Nevertheless there can be no doubt that it is something in the way of love that is adumbrated and grows as a result of the mutual affinity which causes the particles to adhere to one another and maintains their unity during their convergent advance . . . The least one can say is that . . . the transformation undergone by this vague inter-sympathy between first atoms or the first living beings, as it becomes hominized, is a transformation into love. [13]

At the level of the human, when woman and man unite, it is neither to lose themselves in one another nor to extinguish their personal identity; on the contrary, the purpose of the union is to motivate each to become more authentically who she/he is, to be differentiated so that through the love that bonds them they will be more genuinely the singular person each was created to be. The purpose of union is to discover oneself at deeper levels of being.

What makes a center "individual'"is that it is distinct from the other centres that surround it. What makes it "personal" is being profoundly itself. . . The laws of union show us that true and legitimate "egoism" consists . . . in being united to others . . .; for it is only in that case that we succeed in realizing ourselves fully, without losing anything . . . of what makes us incommunicable. [14]

To relegate women to objects, to deny the feminine its power is to avoid contact with that very force and power that makes a man most himself and puts him in touch in a meaningful way with all else that exists.

"Woman is, for man, the symbol and personification of all the fulfillments we look for in the universe. . . . At the term of the spiritual power of matter, lies the spiritual power of the flesh and the feminine." [15]

Teilhard envisions a gradual growth toward the end time, the Parousia, in which the power of the feminine will pass beyond physical expression into a spiritual fecundity characteristic of a "universe made virgin." "He is dreaming of a collective sublimation of human love He has in mind a total dissociation between the essence of the Feminine', which remains, and 'the sexual', which passes away" [16] In the ideal, the ultimate form of The Feminine leads to the transcendence of matter. This happens over time and is fully realized only in the Beatific Vision.

The Feminine cannot be reduced to an ideal or a principle or an

ethereal notion. The consummate personalist, Teilhard gives The Feminine a human face, but it is a face that is hidden until its unveiling in paradise, as commentator Henri de Lubac points out.[17] Once the veil is removed the visage of Mary, Virgin and Mother, becomes manifest. This seems both logical and appropriate. As The Feminine has fueled the union of the elements of the universe, so Mary, the Pure One, unites heaven and earth through the power of the *fiat* that surrenders her very body to the God who wills to be incarnate.

> Lying between God and the earth, as a zone of mutual attraction, I draw them both together in a passionate union.
> – until the meeting takes place in me, in which the generation and plenitude of Christ are consummated throughout the centuries. . .
> I am Mary the Virgin, mother of human kind.[18]

The power of this passage and its dramatic impact on the imagination are undeniable. Henri de Lubac in his masterful interpretative work on the essay, "The Eternal Feminine," interprets clearly the message Teilhard seeks to convey. De Lubac insists that it is not the universal that becomes personal so that we might grasp and understand it; rather the personal, endowed with the power of its own innate character, assumes the dimension of the universal. The universal does not become personal, the personal becomes universal. God is universal precisely because God is the quintessential person and, therefore, the one in whom all things exist.

De Lubac demonstrates that Teilhard extrapolates from this principle in order to define the relationship of Mary to the universe. Mary is not presented as the prototypical symbol of the Feminine nor as the vessel in whom the ideal Feminine rests; just the opposite. Mary's intense personhood provides the openness necessary for the ideal Feminine to be universalized in her. For Teilhard, Mary does not carry the mystery of the Feminine; she **is** the mystery of the Feminine—the ultimate expression of the unification of God and the fullness of Creation.[19]

In naming the Eternal Feminine, Teilhard de Chardin, in a real sense, celebrates the Sacred Feminine without creating a new goddess to be worshiped. He further ingeniously fashions a new language and context within which to understand the unparalleled role of the Virgin Mary in the cosmos and in the universal extension of the salvific work of Christ. He introduces Mary from a fresh perspective, in a way that startles one into

a deeper and innovative understanding of her significance and her role in evolution. In her one sees the reality of the unification of opposites.

In turning now to the life of the historical Mary, it is important to emphasize that she is not a woman who fits the centuries-old, traditional role of wife and mother, though at first blush it may appear so. One has only to ponder the Magnificat in which the mighty are cast down and the lowly raised, where the just are celebrated and the unjust chastised, where the hungry are filled with good things and the rich banished unfed from the table, to know that this is no ordinary first-century woman. Her view of society is that of a revolutionary, not a sentimentalist; it is the view of a woman of strength, conviction, and courage; it is a view of woman who is a champion of the poor and oppressed.

The Black Madonna as described by Dr. Cecelia Cavanaugh finds a congruence with Mary of the Magnificat. Mary of the Magnificat and the Black Madonna stand in direct opposition to patriarchy, to a mentality that feeds the rich, exalts the influential, and pays lip service to the downtrodden. Indeed, the Black Madonna insists that her seat be far from the halls of power in the heart of the towns in which the poor dwell. Cavanaugh points out that these are sites often associated with ancient goddess worship and are filled with an enduring spiritual energy present and ever-new in age after age. Teilhard's poetic depiction of the energy of the Eternal Feminine resonates with the archetypal power simple people sense in earth's holy spaces, a sensitivity often unsettling to those in authority. Cavanaugh's description of the Black Madonna and her message resonates deeply with the Virgin who is unifier, reconciler of opposites and the mother who seeks out those far from the halls of power. The Black Madonna, as Cavanaugh presents her, holds in creative tension both the mystery and magic of ancient goddess worship and the holy, transcendent Son of whom she is mother. Never confusing her own humanity with the Divinity, she points beyond herself to God and others. The ongoing struggle between the powerful and the disenfranchised to define the holy in terms commensurate with each one's reality is ably demonstrated by Cavanaugh.

To celebrate the Virgin Mary is to acknowledge and embrace the totality of her *fiat* which bespeaks a love that extends to all those touched by the pervasive transformation of the Incarnation. To truly understand the Virgin Mary is to come to the realization that the power underlying

convergent evolution is love. According to Teilhard, "love is the supreme form and the totalizing principle of human energy."[20] While Teilhard's evolutionary cosmology focuses on the gradual growth and complexification of consciousness, he insists that the intellect takes second place to love. Mature human consciousness is animated and motivated by love in all of its endeavors.

In the ideal, Teilhard maintains that through their union with one another, woman and man experience a differentiation that personalizes and fulfills, and thereby generates a greater sense of responsibility and love for the cosmos, for others, and for God. While physical love occupies a definite place in evolution and is necessary for the propagation of the race, it is not in itself an end or goal. There must be a higher, spiritual expression of this love through which woman and man move together to convergence in God. "He would have to make it clear that beneath the diversity of its successive forms, The Feminine—the magnetic and unitive force—must lead to God...."[21] Woman and Man play a noble role in the unfolding of evolution, a role that invites them to evolve in their understanding of gender, sexuality, and immortality as evolution moves toward the endtime.

> . . . love is tending, in its fully hominized form, to fulfill a much larger function than the mere call to reproduction. Between Man and Woman, a specific and reciprocal power of sensitization and spiritual fertilization seems in truth to be still slumbering, demanding to be released in an irresistible upsurge toward everything which is truth and beauty.[22]

The powerful truth about the dignity of human beings, woman as well as man, and their relationship to God can be extrapolated from the thought of twentieth-century theologian, Karl Rahner. Rahner carefully and brilliantly developed a Christology and a complementary theological anthropology that gives voice to the incredible mystery that is human nature.

Rahner teaches that for Jesus Christ to be true God and true human, human nature had to be created with "an obediential potency for the hypostatic union." Simply put, human nature was made with the potential to reach ultimate fulfillment through union with God. If the second person of the Blessed Trinity is to become both God and human, human nature must possess an inherent, innate openness to receive the Divine Person

with a Divine Nature. If this potential were not present in human nature, the Incarnation of the Logos as authentically human and authentically Divine would have been impossible. Because human nature *in se* is created with this potential, the Logos, the Eternal Word, could have been born either male or female. What is of utmost importance is not the gender of the Second Person of the Trinity, but human nature itself which is fashioned in such a way that this union is possible.

Rahner insists that although human nature is created with this capacity, it is not frustrated if it is not fulfilled. The beautiful complement to being Incarnate God is being divinized by grace. As mystics have testified throughout the centuries, the human person is invited to become by grace what Jesus was by nature. At the heights of intimacy with the Divine, the human person "becomes God by participation." The invitation to such sublime union is extended not only to men, but to women, who, likewise, are made in the same image of God. Not only Saint John of the Cross but Saint Teresa of Avila, not only Saint Francis of Assisi but Saint Clare of Assisi, not only Saint Ignatius of Loyola but Saint Catherine of Siena, were filled with God and experienced the illuminative and unitive life of grace in the most profound and transformative of encounters.

This truly ennobling theological anthropology coupled with sound and tested spiritual theology offers quite a different vision of woman and man than what is found in the Genesis myth and its various negative interpretations. If one considers a different theory of original sin and, therefore, a different interpretation of the creation myth the scales are balanced and one recognizes that while both woman and man willfully fall into sin, they are nevertheless both created in the image and likeness of God and called to become by grace what Jesus the Christ is by nature.

This book clearly delineates the dichotomy between women who symbolize Eve and those who symbolize Mary, between women called whores and women honored as virgins; between women who are sinners and those who are saints, between women who "act like men" and women who act damsels in distress. The choice to examine historical and fictional women whom selected artists, writers, theologians, and psychologists present as diametrical opposites demonstrates clearly the exaggerated idea of woman that has been caricatured through the ages. By neglecting The Feminine, man has failed to cultivate, both in himself and in the world he has fashioned in own image, those qualities and values that the feminine

perspective emphasizes. Thus, one clearly sees in society the continuing struggle between interdependence and independence, between compassion and justice, between affect and intellect, between global community and national interests, between care for the earth and rape of the earth. While it may be that women, given the chance, might have as quickly resorted to matriarchy as men to patriarchy, it is certain that at this time in the world's history the age of both has passed. Society needs to learn from the wisdom of both women and men in order to bring about a global balance in which the best of The Feminine and the best of The Masculine find expression in the fullness of human persons committed to the co-creation of a world in which the mighty share their thrones with the powerless, the satisfied share their wealth with the lowly, and all are welcome at the feast—female and male they come, female and male in the image and the likeness of God. This book by its very existence challenges the reader to embrace such a vision—to do so is to take the first step toward balancing the scales.

Carol Jean Vale, SSJ, Ph.D
President
Chestnut Hill College

Notes

[1] See Herbert Read, Michael Fordham, and Gerhad Adler, eds., *The Collected Works of C. G. Jung*, R. F. C. Hull, trans. Bollingen Series XX, , vol. 9: Aion (Princeton: Princeton University Press, 1959), para. 24-42.

[2] Pierre Teilhard de Chardin, "Note on Some Possible Historical Interpretations of Original Sin, in *Christianity and Evolution*, Rene Hague, trans. (New York: Harcourt, Brace, Jovanovich, 1969), p. 47.

[3] Teilhard de Chardin, "Note on Some Possible Historical Interpretations of Original Sin, in *Christianity and Evolution*, p. 46.

[4] Teilhard de Chardin, "Reflections on Original Sin," in *Christianity and Evolution*, p. 189.

[5] Teilhard de Chardin, "Note on Some Possible Historical Interpretations of Original Sin," in *Christianity and Evolution*, p. 49.

[6] Teilhard de Chardin, "Crhist the Evolver, or a Logical Development of the Idea of Redemption," in *Christianity and Evolution*, p. 149n.

[7] Teilhard de Chardin, "Note on Some Possible Historical Interpretations of Original Sin," in *Christianity and Evolution*, p. 53.

[8] Pierre Teilhard de Chardin, "The Evolution of Chastity," in *Toward the Future*, Rene Hague, trans. (New York: Harcourt, Brace, Jovanovich, 1973), pp. 70; 71.

[9] Teilhard de Chardin, "The Evolution of Chastity," in *Toward the Future*, p. 71.

[10] Thomas M. King and Mary Wood Gilbert, eds., *The Letters of Teilhard de Chardin and Lucile Swan* (Washington, D.C., Georgetown Univesity Press, 1993), pp. 296-297.

[11] Pierre Teilhard de Chardin, "The Heart of Matter," in *The Heart of Matter*, Rene Hague, trans. (New York: Harcourt Brace Jovanovich, Publishers, 1978), p. 59.

[12] Pierre Teilhard De Chardin, "The Eternal Feminine," in *Writings in Time of War*, Rene Hague, trans. (New York: Harper and Row, 1968), p. 193.

[13] Pierre Teilhard De Chardin, "Centrology," In *Activation of Entergy*, Rene Hague, trans. (New York: Harcourt, Brace, Jovanovich, 1963), p. 119

[14] Teilhard de Chardin, "Centrology," in *Activation of Energy*, p. 117n.

[15] Teilhard de Chardin, "The Evolution of Chastity," in *Toward the Future*, p. 70.

[16] Henri de Lubac, *The Eternal Feminine, A Study on the Text of Teilhard de Chardin*, Rene Hague, trans. (New York: Harper & Row, 1971), p. 101.

[17] de Lubac, The Eternal Feminine, p. 104.

[18] Teilhard de Chardin, "The Eternal Feminine", in *Writings in Time of War*, pp. 200-201.

[19] de Lubac, *The Eternal Feminine*, pp. 118-119.

[20] Pierre Teilhard de Chardin, *Building the Earth*, trans. Noel Lindsay, trans. (Wilkes-Barre: Dimension Books, 1965), p. 82.

[21] Henri de Lubac, *The Eternal Feminine*, p. 22.

[22] Teilhard de Chardin, *Building the Earth*, p. 75.

Works Cited

de Chardin, Pierre Teilhard. *Activation of Energy*. Rene Hague, trans. New York: Harcourt, Brace, Jovanovich, 1963.

_____. *Christianity and Evolution*. Rene Hague, trans. New York: Harcourt, Brace, Jovanovich, 1969.

_____. *The Heart of Matter*. Rene Hague, trans. New York: Harcourt Brace Jovanovich, Publishers, 1978.

_____. *Toward the Future*. Rene Hague, trans. New York: Harcourt, Brace, Jovanovich, 1973.

_____. *Writings in Time of War*. Rene Hague, trans. New York: Harper and Row, 1968.

de Lubac, Henri. *The Eternal Frminine: A Study on the Text of Teilhard de Chardin*. Rene Hague, trans. New York: Harper & Row, 1971.

King, Thomas M. and Mary Wood Gilbert, eds. *The Letters of Teilhard de Chardin and Lucile Swan*. Washington, DC: Georgetown University Press, 1993.

Read, Herbert, Michael Fordham, and Gerhad Adler, eds. *The Collected Works of C. G. Jung*. R. F. C. Hull, trans. Bollingen Series XX. Vol. 9: Aion. Princeton: Princeton University Press, 1959.

Preface

The essays contained in this book grew out of collaboration among faculty members of Chestnut Hill College, Philadelphia, and represent several years of research, dialogue, and enjoyable repartee over tea sandwiches and sherry. Thanks are due to our colleagues for their enthusiasm, to our students for providing sounding boards for some of our ideas, and to our President, Carol Jean Vale, SSJ, PhD, for her unflagging support of our project.

We owe a particular debt of gratitude to Lisa Oliveri, SSJ, MA, Instructor in Computer Science, another of our faculty colleagues, who willingly accepted the onerous task of preparing the camera ready version of our manuscript in the midst of her own classes and work on her dissertation. Ruth O'Neill, SSJ, MA, Director of the Foreign Language Resource Center, generously agreed to assist with the work of copyreading the final draft. We are grateful also to University Press of America for accepting our proposal and bringing our project to fruition.

<div align="right">

Marie A. Conn
Therese McGuire, SSJ

</div>

About the Contributors

Cecelia J. Cavanaugh, SSJ, Associate Professor of Spanish, holds a PhD from the University of North Carolina at Chapel Hill.

Marie A. Conn, Professor of Religious Studies, holds a PhD from the University of Notre Dame.

Barbara Lonnquist, Associate Professor of English, holds a PhD from the University of Pennsylvania.

Therese McGuire, SSJ, Professor of Art, holds a PhD from New York University.

Nancy Porter, Assistant Professor of Psychology, holds a PhD from the University of Pennsylvania.

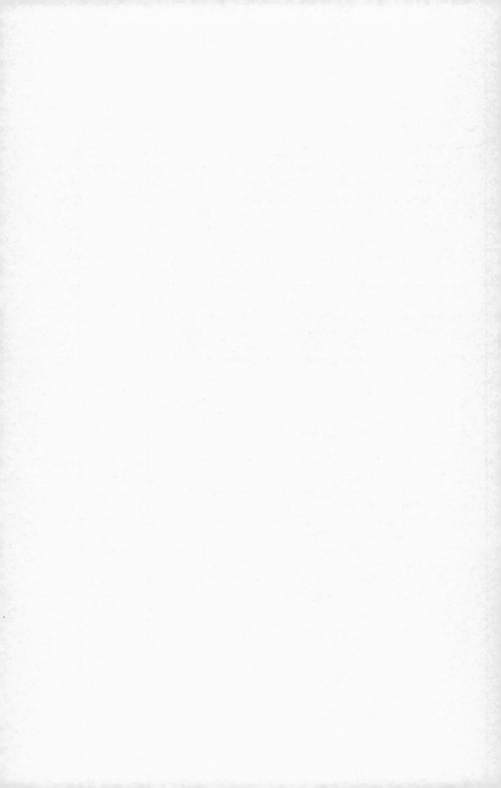

Introduction

One of the challenges for faculty of a small liberal arts college is finding creative ways to work together in order to be mutually enriched. Several years ago, five women on the faculty of Chestnut Hill College in Philadelphia began discussing the impact of the so-called patriarchal revolution on images of women and the implications for scholarship and pedagogy in virtually all disciplines. This book grew out of that discussion.

In the opening essay, Marie Conn attempts to recapture the ancient figure of Pandora, the great Earth Mother denigrated and transformed by the Greek poet Hesiod in the eighth century BCE. Pandora, the giver of all gifts, becomes Pandora, the bringer of all evil, and it is this Pandora who is presented as the archetype of woman. So after some 25,000 years of human history during which the goddess was revered and woman was honored, Hesiod helps set the stage for what has come to be called the patriarchal revolution. This change in Greek religious mythology has tremendous influence on the biblical writers and later biblical exegetes. Like Pandora, Eve is pressed into service by Christian writers to fill a role not originally hers. Eve the female archetype becomes Eve the seductress who brings Adam to ruin and unleashes sin and death on all humanity.

In her essay, Therese McGuire, SSJ, explores symbolic images employed by scholars and artists for two mythical women, the Whore of Babylon and the Woman Clothed with the Sun, whose origins stem from the pen of the seer of the Apocalypse. These two women stand as the antithesis of each other, evoking the message handed down from the time of Hesiod that women fit into one of two categories: that of Eve who was believed tempts Adam or that of Mary who embodies all that is good. Using the lens of tenth-century Ende and twelfth-century Herrad, two medieval women artists who portrayed these mythical women, McGuire does an iconographical study of their portrayal.

For her part, Cecelia J. Cavanaugh, SSJ, looks at examples of the Black Madonna, seen by many as an echo of the ancient earth goddess. She places her study in the context of the dichotomy between institutional religion and politics and popular belief and culture. Cavanaugh bases her study on the Black Madonna at Montserrat in Spain and Our Lady of Guadalupe at Tepeyac in Mexico. These black virgins, so well-loved but often so misunderstood, present archetypal images that still have much to teach us.

Barbara Lonnquist uses nineteenth-century literature to examine the role of Cleopatra, who became the spectacle that could not be staged, but only transfigured. Lonnquist's essay looks at Cleopatra as a prototype of the sexually and socially powerful New Woman and at the same time a figure whose human integrity was effaced or disembodied by the process of mythmaking. Cleopatra's legacy survived, dismembered into the images of her myth; the hybrid serpent woman (lamia), the mermaid, and ultimately the pale vampire are her shadows, and reminders of a more glorious, or at least more human, feminine past.

Finally, Nancy Porter examines the psychological importance of mythical archetypes in human culture. Porter traces the image of the goddess in a variety of cultures which revered Mother Earth under a variety of names and honored the women who mirrored her. After the patriarchal revolution, female deities were demoted and the ensuing imbalance affects us to this day. In the face of our contemporary rampage toward "progress" and ultimately self-destruction, Porter sees a need for a new myth of the planet that reaffirms the notions of interdependence, preservation of divine nature, and the balance of the opposites that are the Yin and the Yang, the female and the male.

Taken together, these essays serve to raise awareness of the changing historical perception of women and of the manipulation of concepts of the feminine, a manipulation that began nearly 3000 years ago and continues to affect us to this day.

Chapter 1

Pandora and Eve: The Manipulation and Transformation of Female Archetypes

Marie A. Conn

> The Babylonian Tiamat was the monster God Chaos; the Greek Pandora's curiosity unleashed every woe upon humankind; and the Hebrew Eve was cut down to mere woman, dominated by man, a villainess of a story of the origin of human misfortunes, especially death.[1]

Introduction

Myth has been described as "a symbolic narrative that is flung out like a life preserver from the collective psyche toward a phenomenon it does not understand and yet cannot avoid addressing."[2] Creation myths provide insights into a society's ethos, its root beliefs, and provide the basis for many of its customs and even its legal system. "In the myths of creation of the cosmos, religious traditions express their understanding of the ultimate meaning of the world and of human

existence."[3] Myths that show humans coming from trees or plants, or being transmuted from other animals, seem to emphasize humanity's intimate link to nature. More sophisticated myths, like the Prometheus cycle, which includes Pandora, or the biblical account of Eden, where we encounter Eve, attempt to answer questions about humanity's moral and spiritual place in the universe.[4]

One of the results of the increasingly sophisticated study of ancient languages and texts has been a deepening appreciation of how symbols both reflect and help shape a people's self-image. Nowhere is this more apparent than in the rediscovery of the layers of earlier tradition now recognized as forming the underpinning of the well-known Hellenic, so-called "Classic" myths of ancient Greece. Further, since Hesiod's Prometheus cycle provides the kernel of subsequent biblical mythology, ignorance of the earlier stories has affected virtually the whole course of Western civilization.

Prior to the so-called "patriarchal revolution," goddess-centered religion was firmly rooted in the ancient world. The goddess represented order and wisdom, giving and protecting life. Unlike the remote, judgmental Olympian gods, pre-Hellenic goddesses represented the very energy of people's everyday lives, combining power and compassion.[5]

Ancient goddesses had real functions in their religious systems. They helped conceptualize culture and interacted with gods in the working of the cosmos. Goddesses were an integral part of ancient religion and thought, making female stereotypes sacred. Goddesses were in charge of activities considered basic to human life: weaving, agriculture, healing, as well as the cultural arts and learning.[6]

The mother goddess, the mother of all life, was seen as creator, nurturer, and provider, the giver of love and inspiration. The mother goddess acted as humanity's protector and guardian. Tied to the cycles of nature, however, she was also connected to death as the prelude to rebirth. "Perhaps the greatest gift of the goddess is teaching us that good and evil, life and death, are inextricably intertwined."[7]

First humans in creation myths function as archetypes, not prototypes. Their actions did not happen in time, did not affect people's lives, and do not continue to be formative through successive generations. There is no implication that the world might be different if first humans had acted differently. Humans in ancient creation myths are real and relevant not because they are first (prototypes), but because they represent what is essentially human (archetypes).[8]

As the role of the male as warrior developed and the male part in procreation was better understood, myths increasingly showed goddess-power being threatened by male deities. Religion began to reflect the new reality, becoming dominated by a warrior Father God of thunder and lightning. The cosmic warlord battled the goddess, either usurping her throne as son, assimilating her into his religion, or simply destroying her. "The patriarchal conspiracy has turned the Goddess into a shrew, who spends much of her time fuming with rage and jealousy."[9]

By overthrowing the goddess, men also took from women their divine connection. Childbirth continued to be important, indeed critical, for society, but the goddess of female reproduction was suppressed and women were denied her comfort. Nor was this true only in non-biblical religions. "What is striking about the cult of Yahweh is the lack of imaginative space it offered women."[10]

Since the patriarchal revolution, history is really "the history written by the winners, the dominant societies; the record of the male-dominant, authoritarian, and war-centered societies."[11] And, since there is little or no direct evidence about women, what we get from the myths and from the bible are, in the words of one scholar, "male blueprints for female behavior....Our cultural and literary heritage is so heavily textured with these patterns that we think they are natural. From the time of Homer and the Bible we have been taught this is the way it should be, the way society is supposed to function."[12]

Pandora offers a prime example of how the manipulation of a symbol affects subsequent interpretation. Pandora was originally equivalent to Mother Earth, "the Giver of All Gifts," creator of nature, intelligence, creativity. Later, she became, like Eve after her, the original cause of evil on earth.[13]

Pandora, once the incarnation of the earth goddess, was transformed in the seventh century BCE by the Greek poet Hesiod in order to reflect male fears or needs. "...the box that once was surely her life-producing womb—the womb-bundle of the old Earth Mother—now becomes the sources of all evil."[14] "Pandora, once known as the generous one, could but sit in infamy as the giver of all evil and stare blankly at the folds of the robe in her lap, aggrieved."[15]

Perhaps no story has had a more profound negative impact on women throughout Western history than the biblical story of Eve. Depicted as created after, and therefore secondary to, Adam, Eve is regularly described as weak, seductive, and evil. And it is this Eve who becomes the prototype of all women.[16] Thus, what is said of Eve is

applied to all her daughters. Woman, and so women, are characterized by traits like vanity, moral weakness, and sexual frailty.[17]

As early as the second century of the Christian era, Tertullian was describing Eve as "the devil's gateway," she who corrupted Adam and caused Jesus' death.[18] Despite Eve's relatively minor role in the Hebrew Scriptures, the early church fathers translated her into a sort of Everywoman, as the prototypical evil.[19]

So, as many feminist biblical scholars have pointed out, and as open-minded people have long recognized, the Garden of Eden has meant a disturbing legacy for women throughout more than two millennia. Biblical attitudes have insinuated themselves into the very roots of Western civilization, permeating all areas of social life, from law courts to workplaces to contemporary advertising. "The corporate logo of Apple Computers recalls Eve's bite of the forbidden fruit (from the tree, after all, of knowledge)."[20]

Like Pandora, Eve is pressed into service by Christian writers to fill a role not originally hers. Pandora, the giver of all gifts, becomes Pandora, the deceiver of men and bringer of evil. Eve, the female archetype, becomes Eve, the seductress who brings Adam to ruin and unleashes sin and death on all humanity. Through the manipulation of their stories and symbols, the male writers of classical Greek mythology and the male editors of Genesis perverted the relationship between men and women, and legitimized the status of women as second-class citizens in human, and even heavenly, societies.

It seems important to go back, to dig into the roots of these stories, to recapture the power of the original symbols, to allow Pandora the mother goddess and Eve the mother of all the living to emerge from centuries of vilification and misinterpretation. It is a formidable task, but one that is worth the effort.

Pandora

The (Pre-Hellenic) Myth of Pandora

Earth-Mother had given the mortals life. This puzzled them greatly. They would stare curiously at one another, then turn away to forage for food. Slowly they found that hunger has many forms. One morning the humans followed an unusually plump bear cub to a hillside covered with bushes that hung heavy with red berries. They began to feast at once, hardly aware of the tremors beginning beneath their feet. As the quaking increased, a chasm gaped at the crest of the hill. From it arose Pandora with Her earthen *pithos*. The mortals were paralyzed with fear but the Goddess drew them into her aura.

I am Pandora. Giver of All Gifts. She lifted the lid from the large jar. From it she took a pomegranate, which became an apple, which became a lemon, which became a pear. *I bring you flowering trees that bear fruit, gnarled trees hung with olives and this, the grapevine that will sustain you.* She reached into the jar for a handful of seeds and sprinkled them over the hillside. *I bring you plants for hunger and illness, for weaving and dyeing. Hidden beneath My surface you will find minerals, ore, and clay of endless form.* She took from the jar two flat stones. *Attend with care My plainest gift: I bring you flint.* Then Pandora turned the jar on its side, inundating the hillside with her flowing grace. The mortals were bathed in the changing colors of Her aura. *I bring you wonder, curiosity, memory. I bring you wisdom. I bring you justice with mercy. I bring you caring and communal bonds. I bring you courage, strength, endurance. I bring you loving kindness for all beings. I bring you the seeds of peace.*[21]

How different is this vision of Pandora from traditional images of the silly, even dangerous girl created by the gods as a punishment for human arrogance. Pandora originally is "Gaia emerging in human form from the earth,"[22] rich in gifts and generous in giving. She is "first woman," albeit with a dark side, like all early goddesses. The goddess was herself a metaphor for the whole mystery of human life and thus embodied both light and dark, life and death.[23] Often portrayed in the form of a trinity, or "triple goddess," Mother Earth did indeed give life, but it was she, too, who called mortals to herself when that life had run its course. In Greek mythology, Luna, goddess of the moon, Artemis, goddess of the hunt, and Hecate, queen of the underworld, are three facets of one primal deity. The goddess is thus "part of the fabric of our being to which all humanity must inwardly relate if we are to have an inner balance in our souls."[24] The goddess was the source of life, of death, and of rebirth in the days when humanity felt deeply its connection to the cycles of nature.

By the time of the rise of the great civilizations of Mesopotamia and Egypt in the third millennium BCE, the goddess had been preeminent for at least 25,000 years. But as agriculture and animal husbandry developed, so did the role of the male as warrior protector. At the same time, the male role in procreation was coming to be recognized, and goddess territory was being invaded by warlike Indo-Europeans who lived in infertile regions and apparently turned to violence as a means of increasing their wealth. The goddess was increasingly threatened by remote sky gods. The cosmic warrior god-king battled the goddess, sometimes dethroning her, sometimes assimilating her, sometimes

simply destroying her.[25] The goddess persisted, but usually only in relationship to the gods.

Pandora is a powerful example of this patriarchal subversion of a people's core myths. Usually pictured on ancient pottery rising from the earth, arms outstretched and filled with gifts, Pandora no longer brings the abundance of earth to humanity but is instead the cause of misery, disease, and death. Even her very nature is changed: no longer born of the earth, she is now the handiwork of the gods.

In Pandora's case, the exact moment of her transformation and denigration seems obvious. The Greek poet Hesiod,[26] who has been described as "a resentful, pessimistic, rural misogynist,"[27] made Pandora part of his version of the Prometheus cycle, a series of myths that clarify the respective situations of mortals and immortals and thus define the human condition. Men existed before the Prometheus myths,[28] and apparently had everything they needed from the gods, whom they in turn worshiped. The Prometheus cycle changed that relationship and introduced Pandora as the first woman, created by the gods to inflict punishment on humanity.[29]

Hesiod told Pandora's story twice, in the *Theogeny* and in *Works and Days*.[30] Prometheus, son of the Titan Iapetos, begs Zeus to share fire with the men Prometheus has fashioned.[31] When his pleas fall on deaf ears, Prometheus dares to challenge Zeus' authority by stealing an ember from the Olympian hearth. Furthermore, Prometheus tricks Zeus into accepting an offering of scraps and entrails from the men by instructing them to hide the mess under a tempting layer of fat that gives off a delightful odor when burnt as a sacrifice. Furious, Zeus resolves to punish both Prometheus and mortal men. Prometheus is chained to a rock in the Caucasus Mountains where every day an eagle eats his liver which grows again each night. But Zeus has something more subtle in mind for the men. "In requital for fire I will give to men an evil thing, wherein the hearts of them all shall rejoice, and they shall lovingly entreat their own plague."[32] The gods fashion an artificial creature from which the *genos* of women derives. She is called Pandora and, in one version of the story, she foolishly opens a jar of afflictions, which are thus let loose upon the world.[33]

So Pandora results from a game of wits between Zeus and Prometheus, a game filled with deceptions. "Zeus wins, of course, and in return for the theft of fire, he has Hephaistos, the artisan god, fabricate the first woman as a molded creature, who astounds men by her god-given beauty and ruins them by her thievish nature."[34]

The fire denied to men by Zeus symbolizes all the resources that allowed them to live without having to cultivate the land. Once Prometheus gives fire to men, they have to be responsible for their own existence. The work will be hard, but they can survive without the gods.

Pandora is not a substitute for the fire, which is never again withdrawn. Rather, she is compensation, an evil to balance the good.

According to the *Theogeny* (561-591), Hephaistos makes Pandora like a young virgin. Athena robes her like a bride in silvery garments with a veil, garlands of flowers, and a golden crown. Pandora is wonderful to behold (*thauma idesthai*), a dangerous trap (*dolos*), an unwelcome supplement to those with whom she dwells. In *Works and Days* (46-104), Hesiod provides much more detail. Hephaistos fashions Pandora out of water and earth, giving her the face of a goddess but the voice and strength of a human. Athena teaches her how to weave; Aphrodite pours grace (*charis*) over her head; Hermes gives her a shameless mind and a thievish nature. Athena dresses her like a virginal bride while the Graces give her golden necklaces and the Hours crown her with spring flowers. Hermes names her Pandora, because "all *pantes*) the gods gave her a gift (*doron*), a sorrow to men who live on bread."[35] In the *Theogeny*, Pandora as the prototype of woman is lazy, greedy, and wasteful. Alone, men could provide well for themselves; with wives, they have to double their work and they still will not have enough.[36] Although warned by his brother Prometheus not to accept any gifts from the gods, Epimetheus takes Pandora as his bride.

"Taken together, these [two versions] now define the new and permanent quality of human life—its ambiguity and deceitfulness—a mixture of evils concealed under beautiful exteriors and virtues under ugly ones."[37] Woman is fundamentally different from man, concealing truth in order to deceive.

The "jar" appears in *Works and Days*, although there is some difficulty in interpreting the meaning of evils escaping and hope remaining inaccessible. The evils may represent humanity's powers escaping its control. Hope remains because it is internal, but even hope can be "evil," because it can represent illusions and because it has no power to stop other problems.

The Renaissance humanist Erasmus turned *pithos* (jar/urn) into *pyxis* (box), slang for female genitals, "thus imposing an indelible sexual innuendo on the original vessel, once the sacred body of the mother goddess containing and conferring all the gifts of life and death."[38] This may have been a collapsing of Pandora with Psyche,

whose story is told in Apuleius' *The Golden Ass*. Venus has Psyche carry a *pyxis* to Hades and fill it with a little of Persephone's makeup. Psyche opens the box and is overcome by the vapors, faints, and has to be rescued by Eros. The point is that women succumb easily to temptation, placing subjective desire before objective command. The urn of life becomes the box of death. A woman's sex is both the sign and the cause of her moral inferiority.[39] And so, the box of Pandora "is proverbial, and that is all the more remarkable as she never had a box at all."[40]

Works and Days puts more responsibility on Pandora, since evil enters the world as a result of her direct action. The jar was there before Pandora, but it was closed, symbolizing human control over evil. Now, although no longer fully dependent on the gods, humans once again have need of them.[41]

Pandora, however, cannot literally have been the first woman, so in what sense does Hesiod refer to her in that way? Prometheus "created" humanity in the sense that he made human knowledge, cooperation, and society necessary. So, Pandora is the first woman *in society*. She represents the separation into masculine and feminine roles. She is the *first truly human* woman, and as such she prefigures a certain distribution of male and female roles, different from that observable among the gods.[42] Prometheus is the creator of humans as political beings; Pandora is the first woman to live in a society.[43]

There are common elements to both versions of the Pandora story. Women are a superfluous element, an unnecessary addition to a previously harmonious society. Women form a *genos*, a distinct group, as if they reproduced themselves. Women do not introduce sexual difference or reproduction *per se*, but they do initiate misbehavior and human distress. The feminine equals privation.[44]

In the Hesiodic tradition it was marriage, along with sacrifice and agriculture, that defined the human condition as falling between that of god and beast. Whatever man may think of Pandora, that "lovely curse" the gods contrive for him, he cannot escape the will of the gods or the necessity embodied in "the accursed race of women."[45] "The ambivalent figure of Pandora, born at the dawn of the seventh century in an historic and economic context that goes some way toward toward accounting for the bitterness of the myth, is an essential element of the Greek tradition."[46]

"The story of Pandora can be classified as a variant of a wide-spread myth that both creates woman as a secondary category following the creation or prior existence of men and also associates her

creation with the origin of what is conveniently called 'the human condition'—that is, with bringing death and evil into the world along with the laborious toil of human existence."[47] For the Greeks, woman was a separate, even alien being, bringing no solace for man's loneliness, but divine punishment.

The influence on later biblical myth and Christian interpretation is unmistakable. Pandora, mother of the race of women, is reflected in Eve, mother of all the living. Just as Zeus took over the creation of the mother-goddess, so Yahweh creates Eve as secondary, not primary, creation. "He for God only, she for God in him," as Milton observes in *Paradise Lost*. John Chrysostom in the fourth century CE, taken with Hesiod's *kalon kakon* (beautiful evil), described woman as "an inescapable punishment, a necessary evil,…a domestic danger, a delectable detriment, an evil nature, painted with fair colors."[48]

Eve

"In his recasting of the myth of Pandora, [Hesiod] achieves what Hebrew myth achieved in the story of the Fall—he places the blame of woman and her sexual nature for bringing evil into the world."[49] Like Pandora, Eve represents a flaw in creation. Early Christian writers were brutal in their judgment of Eve and their subsequent conviction that all women were instruments of the devil, and that sexuality itself was evil. The attitude became so pervasive that we are still dealing with victims of rape and abuse who are blamed for their attackers' actions. Eve's "sin" became the inherent sinfulness of the flesh. Women were the gateway to the devil and only virginity was the gateway to immortality. The spiritual life had to be separate from natural life. How did all this happen?

Scholars who take an historical-critical approach to biblical material have discerned two different sources behind the two accounts of creation in Genesis 1 and Genesis 2-3. Genesis 1 is attributed to the Priestly or P source, while Genesis 2-3 is attributed to the Yahwist or J source. The two accounts differ significantly, reflecting the time, the language, the theology, and the politics of the two sources. P is generally dated to the Exile, around 500 BCE, and, as the label implies, seems to represent the concerns of the priests. J is more primitive, dating to around 1000 BCE. J's language is earthy, where P's is august and poetic; J's Yahweh stoops down and shapes the creatures, then walks and talks with them in the cool of the evening; P's Elohim is transcendent, creating with a word. Adam and Eve are part of the J material.[50]

Perhaps no one part of biblical literature has suffered more from mistranslation and misinterpretation than Genesis 2-4, and no single figure has been more misunderstood and maligned than the woman we have come to know as Eve. Described biblically as "the mother of all the living," she has, instead, come to be regarded as the mother of all human troubles, inferior, weak, and even evil.

According to Genesis, Eve was created so Adam could have a suitable partner, someone to complement him (2:18). The description of Eve's creation is just as long as that of Adam's, and the process is just as involved. God is just as intimately a part of Eve's fashioning as Adam's. Adam's excitement celebrates her as his other half, not his servant (2:23). In fact, the creation of woman serves as the summit and climax of this part of the creation story.

In the traditional understanding of the text, Eve was created to be the man's "helper," and even this was sometimes limited to help only for the purpose of procreation. fourth-century writers like Ambrose and Augustine labeled women inferior, secondary, evil, seductive. Aquinas in the thirteenth century said women were defective by nature.[51] In the *Malleus Maleficarum*, a particularly insidious handbook that spurred the so-called witch hunts in fifteenth to seventeenth-century Europe , two Dominican priests used Aristotle, Augustine, and Aquinas to give theological justification to the mass slaughter of innocent women.[52] This attitude continued in Luther and other reformers and can still be found echoed in some twentieth-century church documents.[53]

In 1895, in her edition of *The Woman's Bible*, Elizabeth Cady Stanton pioneered scholarly efforts to depatriarchalize biblical interpretation. Stanton saw Eve as lofty, with courage and dignity, a woman whose behavior was perhaps even superior to that of Adam. One of today's leading scripture scholars, the literary critic Phyllis Trible, insists that the problem with Genesis is not with the text itself, but with the centuries of sexist interpretation.[54]

Trible deals with several issues in an attempt to begin a reconstruction of the Garden.[55] One such issue is the order of creation. Tradition sees Eve as inferior because she was created last, but in the Priestly version, humans are all created last and are considered the crown of creation. To be consistent, Eve must be considered the crown of creation in J. Another approach to this same issue is seeing the creation of the woman in J as the completion of a literary "circle of creation." It is not Adam who is created first but the basically sexless "earth creature." In fact, Trible notes, it is a mistake to think of that first human creature as being male at all. The Hebrew *ha-'adam* denotes a

being created from the earth. The creation of the companion or helper results in the differentiation of male and female (Gn. 2:21-23). So the act of creating woman also creates man and thus completes the creative process begun in Genesis 2:7.

Much has also been made of the fact that the serpent speaks to the woman and, apparently, not to the man. Tradition sees this as proof that Eve is morally weaker and so the easier target, but it could just as easily be interpreted to mean that Eve was more intelligent and independent and so a preferred dialogue partner. There is also evidence that the Hebrew verb forms indicate the serpent is addressing the couple, not just the woman. In fact, when she answers, she uses "we." It can further be said that the woman ate the fruit, not because of the serpent's words but because it looked delightful and tasty (Gn. 3:5-6). Nor does the woman "tempt" Adam into joining her in some great act of rebellion. She simply shares the fruit with him and he eats it. It should be remembered, too, that the woman had not yet been created when Yahweh gave the prohibition about eating the fruit of that particular tree. One other consideration in this scene is the ancient and deeply-rooted connected between the serpent, the tree, and ancient mother earth goddesses. Perhaps the editors of J are taking the opportunity to stamp out goddess worship, a practice that continued long after the sky gods took over.

As for Adam "naming" Eve, something traditionally cited as evidence for man's authority over woman, the usual word for "calling the name" in the naming formula is not used in Genesis 2:23. The calling of the woman does not signify man's power over her but his joy at their mutuality. The man does name the woman Eve in Genesis 3:20, but by then the mutuality and equality between the man and woman have been corrupted. So man's naming, and thus dominating, of the woman is not part of the goodness of creation, but a symbol of our first sinfulness. Male does not dominate female by divine intent; this is a condition which must be overcome.

Unlike the simpleminded, evil, seductive, weak Eve of tradition, Trible's Eve emerges as intelligent, informed, and perceptive. But when women reach out for knowledge, they are often exiled. When they try to form communities, they are punished. Liberating Eve can be exhausting, forcing us to face the "always steep climb up the rocky face of patriarchy."[56]

One of the most devastating misreadings of Genesis 3 has led to the long-held belief that Yahweh "cursed" Eve, but the Hebrew text may not support such a reading. The woman is, in fact, not cursed; the

serpent is. Yahweh also curses the ground when speaking to Adam, but the word is not used when Yahweh speaks to Eve. Furthermore, pain in childbirth must be put both in the context of the story and in the cultural context of the time. Goddesses bear children easily in Mesopotamian mythology. Perhaps Eve is being punished for desiring to be goddess-like. Punishment is a consistent theme in J.

Nor does the text say that Yahweh gave men control over women. When Yahweh tells Eve that her desire will be for her man, the word translated as "desire" can also mean "desirable," giving the idea that women will be attractive to men. In biblical terms, to be desirable is potentially to be in danger. J does not envision woman flinging herself in abject desire at a man but rather is concerned with man's arrogant abuse of power with regard to another person sexually. This is another common motif in Mesopotamian mythology.[57] Danger and sin are possible, but can be avoided. Woman may have strong sex appeal but man has the capacity to act responsibly. While this may be a warning and a reflection of the social, physical, and political strength of men, it is surely not a curse on Eve.[58]

The whole tree-serpent-woman event may be concerned with contrasts: sexuality and birth pangs; blame and guilt; nakedness and clothing. The story reflects a shift in male-female relationships, links morality with mortality, and explores a change in the divine-human interaction. It seems to focus on links and barriers between human and divine.[59]

The meaning of the tree of the knowledge of good and evil remains obscure. Even the nakedness may refer simply to the difference between humans and other animals. All other animals have covering of some kind; only humanity is not "weather-resistant."[60] Even sexual activity had to be possible before the serpent event, or humanity could not fulfill the divine directive to increase and multiply. The difference may lie in the human exercise of free will. "...by eating the fruit of the knowledge of good and evil and inviting Adam to follow her example, Eve set in train a new phase of history, where humanity exchanged the simplicity and ease of unthinking obedience for the complexity and challenge of the freedom to choose.."[61] Much of the J material emphasizes humanity's freedom to make moral choices.

Nor should we lost sight of the etiological value of Genesis 2-3, where the early Hebrews expressed their beliefs about the realities of life, the relationship between them and God, and gave form to their "Golden Age." On one level, the story of Adam and Eve "speaks to something fundamental in human nature, tells of something universal to

human experience. Perhaps, most simply, it looks back nostalgically to the irrecoverable world of childhood while justifying the need to change." The Garden of Eden is the archetypal embodiment of the Golden Age. "If Eve had not eaten the fruit of knowledge, human history could not have begun." Eve bolted humanity "out of the stasis of Eden into the harsh realities of the human condition."[62]

Finally, there is a parallel to Genesis 2-3 in "The Hypostases of the Archons," a fragment in the Nag Hammadi library.[63] In this version of the story, the editors value the woman's actions and prefer the desire for knowledge over obedience.

An Aside: "Original Sin"

It is impossible to discuss Eve without reflecting on the huge theological shift in early Christian thinking that seems to have started in the fourth century. That shift is still with us in the form of the Catholic doctrine of original sin. After Constantine's so-called conversion, the interpretation of Genesis 2-3 changed radically, from a story of our moral freedom—freedom of all kinds was precious during persecution—to a story of human bondage and corruption brought on by sexuality. Much of this reinterpretation can be laid at the door of the fifth-century bishop, Augustine. Even though Augustine's view of original sin broke radically from the tradition, it triumphed and became part of Western cultural thought. It cannot escape notice that, whatever Augustine's teaching on "original sin" meant theologically, it was politically expedient—"damaged" human beings need external government by both church and state. Moral choices are, after all, often political ones. What we believe and act on has a lot to do with our social, political, cultural, religious, and philosophical situation.[64]

During the fourth and fifth centuries, following the lead of John Chrysostom, bishops like Pelagius, a devout Christian ascetic from Britain, had argued that human will could not affect natural events, i.e., humans could neither bring on nor avoid their own death; death was simply a natural part of human existence. Humans were, however, free to make moral choices. This view was considered orthodox until Augustine managed to have Pelagius and his followers excommunicated and exiled.

Where Pelagius held that all creation is basically good, Augustine taught that Adam's human choice brought morality, sexual depravity, and the ability to choose sin into the world. He went on to describe humanity as universally tainted with sin from the mother's womb—"original sin."

Pelagius countered Augustine's declarations by pointing out that such a teaching clearly repudiates the twin foundations of Christian faith, namely, the goodness of creation and the freedom of the human will. Although mortality might be viewed as a punishment for Adam's sin, a just God would punish only Adam; God would not condemn the whole human race for one person's sin. Mortality is part of the nature of humanity, just as it is natural for all created species. Both sides in the debate claimed to find biblical support in Genesis.

One of Pelagius' supporters, Julian of Eclanum, taught that Adam's death was spiritual and moral, not physical. We all share Adam's power to choose our own moral destiny. But Augustine insisted that by their act of will Adam and Eve changed the very structure of the universe, permanently corrupting human nature. Woman's fertility and all sexual desire bring involuntary suffering. Eve did not pass fertility, but sin, to women.

In Augustine's view, Eve was responsible for women's suffering and Adam for men's. "Adam's single arbitrary act of will rendered all subsequent acts of human will inoperative." Mortality, desire, all suffering in humans, animals, and crops is due to the "moral and spiritual deterioration that Eve and Adam introduced." Augustine's view of the heredity transmission of original sin has been official Catholic doctrine ever since.[65]

Julian's stance demythologizes the power of Adam and Eve: the world is basically good and we do have the power to make moral choices. His view is more scientific and rests on the ancient affirmations that the world was created good and that we are responsible for our moral choices. Sadly, Augustine's more pessimistic view has had the dominant influence on Western Christianity and has helped pervert the ancestral story of Genesis 2-3.[66]

Paul is often blamed (or praised) for introducing the doctrine of original sin which was then expanded by Augustine. This would seem unfounded especially since Paul, like Jesus and most of Jesus' early followers, was Jewish; the doctrine of original sin has never been part of traditional Judaism. So what does Paul make of Adam and the serpent event?[67] Paul does look to Genesis and Adam, setting up a parallel in Romans 5:12 between the one man bringing sin and death into the world and the one Man bringing power over death and sin, but Paul does not posit inherited guilt. He says we all follow the path of Adam.

Death and sin are, for Paul, the major enemies of humanity, and those are the two things the Resurrection conquered. But in a pivotal

phrase in Romans 5:12, Paul uses the Greek *eph ho*—inasmuch as all
sinned—which Jerome incorrectly translated into Latin as *in quo*—in
whom all sinned. This is the translation Augustine would have used and
it is this translation which lends credence to a belief in inherited guilt.

Furthermore, all of this is based on Genesis 3, which was taken as
literal history by the Western church until the nineteenth century. We
now recognize that Genesis 1-11 is not about history or science. It is
about the Israelites' root beliefs in the one God Yahweh. The creation
story in Genesis parallels all the creation stories from all the cultures in
the Ancient Near East.

Genesis does not tell us about the first men and women, nor does it
justify the traditional teaching on original sin. Certainly no one person
did in the whole human race. And, if we take Genesis seriously, then
the negative anthropology of the doctrine of original sin—all humans
are born damaged—ignores the repeated declaration that all creation is
good, indeed very good. We do not die because of sin; plants and
animals die, too. Death is part of creation, even if the why remains a
mystery. Jesus' death and resurrection give us the power to cope with
death.

Our experience has outstripped the old formulation. We are
influenced by hereditary and environment, but not by inherited guilt.
Sin is a social reality: when a sin is committed, it has a ripple effect.
But the old doctrine ignores the ripple effect of virtue. Sin and virtue
both have a social dimension.

Finally, the traditional teaching on original sin risks reducing
Christian baptism (at least for Catholics) to a water-bath necessary to
wash the stain of sin from the soul and open the gates of heaven. But
Christian initiation is so much more than that. It is the welcome into the
Christian community and the sign of the bond that exists between the
newly baptized and Christ, and of the bond among the members of the
whole community. It would seem that the effort to reinterpret Eve
could have the added benefit of revitalizing the whole of the Christian
life.

Conclusion

"From Homer to Attic tragedy, it is in terms of the myths that poets
work out their deepest thoughts; both history and philosophy emerge
from mythical thought, and both poetry and the visual arts remained
always attached to mythical subjects."[68] Hesiod has been labeled the
father of Greek misogyny. In truth, his *Works and Days* rivals Genesis
3 in scapegoating the female. In doing so, Hesiod was reflecting the

position of the Athenian women of his day: excluded from public life, they were nevertheless needed to replenish the state with citizens, something which made them the cause of both fascination and unease.

"Women—always the sex that most obviously possessed the awesome and very messy physical ability to bring forth life—were the losers in this shifting of cultural ideology toward transcendence."[69] Hesiod's Pandora is beautiful to look at, but a deadly trap.

> From her comes all the race of womankind,
> The deadly female race and tribe of wives
> Who live with mortal men and bring them harm,
> No help to them in dreadful poverty....
> Women are bad for men, and they conspire
> In wrong, and Zeus the Thunderer made it so. (*Works and Days*)

"The male hero of Greek legends moved through a landscape thronged with female monsters, whom he must defeat or outwit in order to survive."[70] The ancient Greeks considered sexuality as an encroachment on male autonomy. Even procreation is ambivalent in Hesiod. Woman, who had once been considered the human image of the goddess, is no longer linked to earth's fertility. "On the contrary, Hesiod separates woman from the bountiful earth by inverting the usual etymology of her name from an active to a passive construction, from the one who gives to the one who is given. Not 'the giver of all gifts,' as a related epithet of Gaia (Earth) indicates, 'Pandora' is here glossed as 'the one to whom the gods have given all gifts.'"[71]

Eve also suffers for the sake of the establishment of a new sky God, the Hebrew Yahweh. Although there is evidence that the Hebrews continued to honor the goddess under her Canaanite names Asherah, Astarte, and Anath, the introduction of monotheism demanded that she officially lose her status. As with the triumph of Zeus in Greek mythology, so the focus on Yahweh may have reflected a "new social order and a new psychology in mythic terms. The attempt to establish a monolithic cult paralleled the attempt to establish a society in which father-right predominated...."[72]

Pandora, who rose from the earth with gifts for all, has become, like Eve, the source of human toil, pain, and death. The serpent, once the life-giving symbol of the goddess, becomes destructive in Genesis, associated later with the devil. By the fifteenth century, the "forbidden fruit" had become an apple and a symbol of sexual intercourse. Eve was the seducer of Adam. Sexuality belonged not to God but to the devil.

So, the symbols have been perverted. The strong, independent female figures with whom women through the centuries might have identified—Athena, Pandora, the Magdalene, even poor Eve—have been supplanted in Christian thought by Mary, the necessarily virgin mother of Jesus.[73] After all, if sexuality equals the primary sin, then freedom from sin can only be found in virginity. So the interpretation of ancient creation myths has sacrificed the image to the word: narratives have been generalized out of context and "wrenched into shapes that support the prevailing social order."[74]

"When modeling is done by the divine, the modeling does not simply illustrate; it authorizes and approves what it models."[75] Greek mythology affirmed women's status as non-citizens; biblical mythology made women second-class in the eyes of the very Creator. Divine stereotypes lend powerful support to societal attitudes and inhibit change. The challenge for each new generation, then, is to build on the ever-increasing store of human knowledge, to continually reinterpret the ideas of the past. Symbols must be continually cracked open, made to speak in new ways. There is no worthier place to start than with the ancient goddess Pandora, and with her biblical counterpart, Mother Eve.

Notes

[1] Leonard J. Biallas, *Myths: Gods, Heroes, and Saviors* (Mystic, CT: Twenty-Third Publications, 1989), p. 56.

[2] Judith Yarnell, *Transformation of Circe: The History of An Enchantress* (Chicago: University of Illinois Press, 1994), p. 3.

[3] Biallas, *Myths*, p. 39.

[4] Richard Y. Hathorn, *Greek Mythology* (Beirut: American University of Beirut, 1977), p. 39.

[5] Charlene Spretnak, *Lost Goddesses of Early Greece: A Collection of Pre-Hellenic Myths* (Boston: Beacon Press, 1978), pp. 17-18.

[6] Tikva Frymer-Hensky, *In the Wake of the Goddess: Women, Culture, and the Biblical Transformation of Pagan Myth* (New York: The Free Press, 1992), pp. viii, 14, 32-41.

[7] Biallas, *Myths*, pp. 56-57

[8] Biallas, *Myths*, pp. 63-64.

[9] David Leeming and Jake Page, *Goddess: Myths of the Female Divine* (New York: Oxford University Press, 1994), pp. 51, 88.

[10] Pamela Norris, *Eve: A Biography* (New York: New York University Press, 1999), p. 23.

[11] Alice Bach, "Introduction Man's World, Woman's Place: Sexual Politics in the Hebrew Bible," in Alice Bach, ed., *Women in the Hebrew Bible* (New York: Routledge, 1999), p. xiii.

[12] Bach, "Introduction," pp. xiii-xiv.

[13] Martha Ann and Dorothy Myers Imel, *Goddess in World Mythology* (New York: Oxford University Press, 1993), p. 203.

[14] Leeming and Page, *Goddess*, p. 116.

[15] Leeming and Page, *Goddess*, p. 118.

[16] Pamela J. Milne, "Eve & Adam—Is a Feminist Reading Possible," *Bible Review* (June 1988,) pp. 14, 16.

[17] Norris, *Eve*, p. 5.

[18] Tertullian, "On Female Dress" (1:1), S. Therwall, trans., in Alexander Roberts and James Donaldson, eds., *The Writings of Tertullian* Vol. 1, *Ante-Nicene Christian Library* Vol. XI (Edinburgh, 1869), p. 304.

[19] Norris, *Eve*, p. 41.

[20] Cullen Murphy, "The Bible According to Eve," *U. S. News & World Report* (August 10, 1998), p. 49.

[21] Spretnak, *Lost Goddesses*, p. 51.

[22] Christine Downing, *The Goddess: Mythological Images of the Feminine* (New York: The Continuum Publishing Company, 1999), pp. 153-154.

[23] Leeming and Page, *Goddess*, p. 3.

[24] Adam McLean, *The Triple Goddess: An Exploration of the Archetypal Feminine* (Grand Rapids, MI: Phanes Press, 1989), p. 7.

[25] Leeming and Page, *Goddess*, pp. 47, 51, 88-89.

[26] Hesiod, c.700 BCE, was the first author of a systematic mythology. His father was from Cyme, on the coast of Asia Minor, but poverty forced him to move. Hesiod "met the Muses" under Mount Helicon and became a singer and speaker who was "argumentative, suspicious, ironically humorous, frugal, fond of proverbs, wary of women." John Boardman, Jasper Griffin, and Oswyn Murray, *The Oxford History of the Classical World* (New York: Oxford University Press, 1986), p. 88.

[27] Julia O'Faolain and Lauro Martines, eds., *Not in God's Image: Women in History from the Greeks to the Victorians* (New York: Harper & Row, Publishers, 1973), p. 4.

[28] There is no single uniform Greek version of the creation of men. While this apparent lack of concern over the "details" of human creation may seem odd to readers of the bible, which opens with the creation stories of Genesis, we should keep in mind that, after Genesis, neither Adam nor Eve is ever mentioned again in the Hebrew Scriptures. "Early man is not as constantly aware of his ultimate origins as those who are brought up on the theory of evolution." Boardman et al, *Oxford History*, p. 80.

[29] Jean Rudhardt, "*Pandora: Hésiode et les femmes,*" *Museum Helveticum* 43 (1986), pp. 231-232.

[30] The *Theogeny* is a cosmogonic poem; *Works and Days* is a didactic work of wisdom literature. Hesiod did not invent the Prometheus/Pandora cycle, but

he "must have found it ready to his hand, and have enjoyed it so much that he told it twice,..." C. Kerengi, *The God of the Greeks* (London: Thanes and Hudson, 1951), p. 216.

[31] Prometheus (forethought) and his brother Epimetheus (hindsight) had been given the task of repopulating the earth after the first race of men and creatures was destroyed.

[32] Hesiod, *Works and Days* 42 in F. M. Comford, *Greek Religious Thought from Homer to the Age of Alexander* (New York: AMS Press, 1969), p. 23.

[33] Guilia Sissa, "The Sexual Philosophies of Plato and Aristotle," in Pauline S. Pantel, ed., *A History of Women in the West I: From Ancient Goddesses to Christian Saints*, Arthus Goldhammer, trans. (Cambridge, MA: The Belknop Press of Harvard University Press, 1991), pp. 60-61. Sissa points to Plato who, in his *Timaeus*, described the *genos* of women as a later degenerative mutation of the human race. According to Plato, the souls of men who had behaved in a cowardly manner were reincarnated in the bodies of women.

[34] Froma I. Zeitlin, "The Economics of Hesiod's Pandora," in Ellen D. Reeder, ed., *Pandora: Women in Classical Greece* (Baltimore: The Walters Art Gallery, 1995), p. 49.

[35] Zeitlin, "Economics," p. 49.

[36] Rudhardt, "*Pandora*," pp. 231-234.

[37] Zeitlin, "Economics," p. 50.

[38] Erasmus, *Adagiorum Chiliades Tres* (Basel, 1508). Cited in D. and E. Panofsky, *Pandora's Box: The Changing Aspects of a Mythical Symbol* (New York, 1956), p. 233.

[39] Anne Baring and Jules Cashford, *The Myth of the Goddess: Evolution of An Image* (London: Arkana, 1991), pp. 216, 517-519.

[40] François Lissarrogue, "Women, Boxes, Containers: Some Signs and Metaphors," in Reeder, *Pandora*, p. 91.

[41] Rudhardt, "*Pandora*," pp. 235-236.

[42] Nicole Loraux, "What Is a Goddess," in Pantel, *History*, p. 21. In another article, Loraux notes that Pandora is the mother of humanity, but not the mother of women. Cf. Nicole Loraux, "*Sur la race des femmes et quelques-unes de ses tribus,*" *Arethusa* 11 (1978), p. 45.

[43] Rudhart, "*Pandora*," pp. 238-239.

[44] Sissa, "Sexual Philosophies," pp. 61-62.

[45] Louise Bruit Zaidman, "Pandora's Daughters and Rituals in Grecian Cities," in Pantel, *History*, p. 362.

[46] Zaidman, "Pandora's Daughters," p. 376.

[47] Zeitlin, "Economics," p. 50.

[48] John Chrysostom, *In Mattheum Homili* xxxii, *Ex Capite* xix (a) Migne, PG, Vol. 56, p. 803.

[49] Gerda Lerner, *The Creation of Patriarchy* (New York: Oxford University Press, 1986), p. 204.

[50] For more on Pentateuchal sources see, for example, Bernhard W. Anderson, *Understanding the Old Testament* 4th Edition (Upper Saddle River,

NJ: Prentice Hall, 1998), pp. 18-22, 59-61, 406-416; Lawrence Boadt, *Reading the Old Testament* (New York: Paulist Press, 1984), pp. 69-108.

[51] Thomas Aquinas, *Summa Theologica*, Part I, Question 92, Article 1.

[52] For a fuller description of the witch hunts and the *Malleus Maleficarum*, see Chapter 3, "Victims of the Witch Craze: Scapegoats in a Time of Turmoil," in Marie Conn, *Noble Daughters: Unheralded Women in Western Christianity, 13th to 18th Centuries* (Westport, CT: Greenwood Press, 2000), pp. 57-74, esp. pp. 66-69.

[53] Milne, "Eve & Adam," p. 14. An important source for the history of images of Eve is J. A. Phillips, *Eve: The History of An Idea* (San Francisco: Harper and Row, 1984).

[54] Milne, "Eve & Adam," pp. 17-19.

[55] See, for example, Phyllis Trible, "Depatriarchalizing in Biblical Interpretation," *Journal of the American Academy of Religion* 12 (1973), pp. 39-42; and "Eve and Adam: Genesis 2-3 Reread," *Andover Newton Quarterly* 13 (1973), pp. 251-258, reprinted in Carol Christ and Judith Plaskow, eds., *Womanspirit Rising* (New York: Harper and Row, 1979), pp. 74-83.

[56] Bach, "Introduction," p. xx.

[57] Adrien Janis Bledstein, "Was Eve Cursed?" *Bible Review* (February 1993), pp. 42-43.

[58] Bledstein, "Was Eve," p. 4.

[59] Reuven Kimelman, "The Seduction of Eve and the Exegetical Politics of Gender," in Bach, *Women*, pp. 241-242.

[60] Norris, *Eve*, p. 26.

[61] Norris, *Eve*, p. 28.

[62] Norris, *Eve*, pp. 36-37.

[63] Nag Hammadi is a village in Upper Egypt. In 1945, the remains of thirteen codices, including "The Nature of the Archons," were accidentally discovered there in jars. Upon examination, the codices were found to be Coptic, possibly Gnostic, writings from the fourth century CE. The Nag Hammadi material suggests that there was a great deal of diversity in materials and traditions in early Christianity. See Pheme Perkins, "Nag Hammadi," in Everett Ferguson, ed., *Encyclopedia of Early Christianity* (New York: Garland Publishing, Inc., 1990), pp. 636-637. Perkins has also provided a good introduction to Gnosticism on pages 371-376 of the same volume.

[64] Elaine Pagels, *Adam, Eve, and the Serpent* (New York: Random House, 1988), p. xxvi.

[65] Pagels, *Adam, Eve*, p. 134. This information is widely available. Here I am using Pagels' sixth chapter, "The Nature of Nature," pp. 127-150.

[66] Pagels, *Adam, Eve*, pp. 147-148, 150.

[67] Much of my thinking about Paul has been influenced by Addison Wright, SS, and his lectures at Marywood University.

[68] Boardman et al, *Oxford History*, p. 79.

[69] Yarnell, *Transformation*, pp. 69, 78.

[70] Bonnie S. Anderson and Judith P. Zinsser, *A History of Their Own: Women in Europe from Prehistory to the Present* Volume 1 (New York: Harper & Row, 1988), pp. 49-50.

[71] Zeitlin, "Economics," p. 51.

[72] Downing, *Goddess*, p. 14.

[73] Although it is beyond the scope of this chapter, an examination of the two Marys—Mary the mother of Jesus and Mary Magdalene—would yield much to think about. Mary the mother of Jesus becomes the "new Eve," while the Magdalene becomes the "second Eve." Both suffer as a result. Mary the mother of Jesus is desexed and used as a red herring in discussions about the role of women in the church. Mary of Magdala undergoes a disastrous and unfair transformation, from the "Apostle to the Apostles" to a reformed prostitute. Both deserve reclamation and many scholars are working toward this goal.

[74] Baring and Cashford, *Myth*, pp. 302, 525, 539, 541. For a more general study of the impact of literacy on the goddess cultures, see Leonard Schlain, *The Alphabet Versus the Goddess: The Conflict between Word and Image* (New York: Penguin/Arkana, 1998).

[75] Frymer-Kensky, *In the Wake*, p. 25.

Works Cited

Anderson, Bernhard W. *Understanding the Old Testament*. 4th Edition. Upper Saddle River, NJ: Prentice Hall, 1998.

Anderson, Bonnie S. and Judith P. Zinsser. *A History of Their Own: Women in Europe from Prehistory to the Present*. Volume 1. New York: Harper & Row, 1988.

Bach, Alice, ed. *Women in the Hebrew Bible*. New York: Routledge, 1999.

Baring, Anne and Jules Cashford. *The Myth of the Goddess: Evolution of An Image*. London: Arkana, 1991.

Biallas, Leonard J. *Myths: Gods, Heroes, and Saviors*. Mystic, CT: Twenty-Third Publications, 1989.

Bledstein, Adrien Janis, "Was Eve Cursed?" *Bible Review* (February 1993): 42-45.

Boadt, Lawrence. *Reading the Old Testament*. New York: Paulist Press, 1984.

Boardman, John, Jasper Griffin, and Oswyn Murray. *The Oxford History of the Classical World*. New York: Oxford University Press, 1986.

Christ, Carol and Judith Plaskow. *Womanspirit Rising*. New York: Harper and Row, 1979.

Comford, F. M. *Greek Religious Thought from Homer to the Age of Alexander the Great*. New York: AMS Press, 1969.

Conn, Marie. *Noble Daughters: Unheralded Women in Western Christianity, 13th to 18th Centuries*. Westport, CT: Greenwood Press, 2000.

Downing, Christine. *The Goddess: Mythological Images of the Feminine*. New York: The Continuum Publishing Company, 1999.

Ferguson, Everett, ed. *Encyclopedia of Early Christianity*. New York: Garland Publishing, Inc., 1990.

Frymer-Hensky, Tikva. *In the Wake of the Goddess: Women, Culture, and the Biblical Transformation of Pagan Myths*. New York: The Free Press, 1992.

Hathorn, Richard Y. *Greek Mythology*. Beirut: American University of Beirut, 1977.

Kerengi, C. *The God of the Greeks*. London: Thanes and Hudson, 1951.

Leeming, David and Jake Page. *Goddess: Myths of the Feminine Divine*. New York: Oxford University Press, 1994.

Lerner, Gerda. *The Creation of Patriarchy*. New York: Oxford University Press, 1986.

Loraux, Nicole, "*Sur la race des femmes et quelques-unes de ses tribus,*" *Arethusa* 11 (1978): 43-89.

McLean, Adam. *The Triple Goddess: An Exploration of the Archetypal Feminine.* Grand Rapids, MI: Phanes Press, 1989.

Milne, Pamela J., "Eve & Adam—Is a Feminist Reading Possible," *Bible Review* (June 1988): 12-21, 39.

Murphy, Cullen, "The Bible According to Eve," *U. S. News & World Report.* (August 10, 1998): 304.

Myers Imel, Martha and and Dorothy Myers Imel. *Goddess in World Mythology.* New York: Oxford University Press, 1993.

Norris, Pamela. *Eve: A Biography.* New York: New York University Press, 1999.

O'Faolain, Julia and Lauro Martines, eds. *Not in God's Image: Women in History from the Greeks to the Victorians.* New York: Harper & Row, Publishers, 1973.

Pagels, Elaine. *Adam, Eve, and the Serpent* (New York: Random House, 1988.

Panofsky, D. and Panofsky, E. *Pandora's Box: The Changing Aspects of a Mythical Symbol.* New York, 1956.

Pantel, Pauline S., ed. *A History of Women in the West I: From Ancient Goddesses to Christian Saints.* Arthus Goldhammer, trans. Cambridge, MA: The Belknop Press of Harvard University Press, 1991.

Phillips, J. A. *Eve: The History of An Idea.* San Francisco: Harper and Row, 1984.

Reeder, Ellen D., ed. *Pandora: Women in Classical Greece.* Baltimore: The Walters Art Gallery, 1995.

Roberts, Alexander and James Donaldson, eds. S. Therwall, trans. *The Writings of Tertullian*. Volume I. *Ante-Nicene Christian Library*. Volume XI. Edinburge, 1869.

Rudhardt, Jean, *"Pandora: Hésiode et les femmes,"* *Museum Helveticum* 43 (1986): 231-246.

Schlain, Leonard. *The Alphabet Versus the Goddess: The Conflict between Word and Image*. New York: Penguin/Arkana, 1998.

Spretnak, Charlene. *Lost Goddesses of Early Greece: A Collection of Pre-Hellenic Myths*. Boston: Beacon Press, 1978.

Trible, Phyllis, "Depatriarchalizing in Biblical Interpretation." *Journal of the American Academy of Religion* 12 (1973): 39-42.

_____, "Eve and Adam: Genesis 2-3 Reread." *Andover Newton Quarterly* 13 (1973): 251-258.

Yarnell, Judith. *Transformation of Circe: The History of an Enchantress*. Chicago: University of Chicago Press, 1994.

Chapter 2

Symbolic Images of Women:
The Whore of Babylon
and the Woman Clothed with the Sun

Thérèse McGuire, SSJ

> Medieval Art is eminently symbolical. Form was almost always
> conceived as the embodiment of the spirit. For the artists were as
> skilled as the theologians at spiritualizing matter.[1]

In the Middle Ages, artists and writers conveyed eternal truth and
beauty to the observer by means of symbols. The medieval mind found
itself at home in the world of symbolic representations; consequently
one of the most striking features of medieval art stems from its ability
to unite theology with the popular tendency for symbolism so evident
in almost all of its painting, sculpture, and architecture.

As voiceless teachers, symbols both reflect and help shape a
culture's self-image. It is important to observe just how truly critical is
an historical awareness of symbols and their evolution through the
course of centuries. From late antiquity until the dawn of the eighteenth

century, much of the visual art of Europe was ultimately based upon written texts. According to Meyer Schapiro, "The painter and sculptor had the task of translating the word—religious, historical, or poetic—into visual image."[2] In this so-called translation of the words, or in its interpretation, medieval artists found expression in the use of symbols.

> Every work of art is a mirror, reflecting the time and place in which it was made, and the feelings of the human beings who created it. The artist is either drawn to the material, to actions and appearances, or to the spiritual, to dreams and emotions.[3]

Symbolism should not be confused with a picture language; scholars intended symbolic images to inspire deep thought, and to reveal a beauty that is more than earthly. For Augustine, the purpose of art is rightly to be seen as "the manifestation of beauty," understood as a reflection of the eternal essence.[4]

As Gilbert and Kuhn stated, "Beauty, then, that strictly taken belongs only to God as a Divine Name, was let down from heaven to earth by means of a cosmic chord of symbolism."[5] Ladner believes that "the messages of the *Book of Revelations* have become an enigma for modern scholars. Few have dared to interpret these words with absolute certainty for they admit of varied messages."[6] This chapter will be devoted to exploring symbolic images employed by scholars and artists for two mythical women whose concepts evolved in theology and art after the so-call "patriarchal revolution" and into the medieval period. These two mystical women, whose origins stem from the pen of the apocalyptic seer, stand as the antithesis of each other; they are known as the *Whore of Babylon* and the *Woman Clothed with the Sun*.

The Whore of Babylon
The author of Revelations gives a graphic description of the mythical woman known to us as the Whore of Babylon.

> One of the seven angels who held the seven blows came and spoke with me saying, "Come, I will reveal to you the verdict upon the great harlot who is established upon many waters, with whom the kings of the earth have committed adultery, and the earth-dwellers have been intoxicated with the passion of her impurity." And in spirit he carried me away into the wilderness and I saw a woman enthroned on a scarlet monster, which was full of blasphemous names; it had seven heads and ten horns.[7]

Very often, in the writing of the prophets, cities were personified as women. Obviously the author of the Apocalypse is not referring to the

real Babylon, the ancient city in Chaldea; he refers to a mystical Babylon that has all the characteristics of that notorious city. Even the word harlot or whore in prophetic language is equated with idolatry,[8] and in the eyes and minds of the writers of the Old Testament the harlot had to be embodied by a woman who might entice men to idolatry.

The symbolic images of the Whore of Babylon, taken from Ende's interpretation found in the tenth century *Beatus MS.* housed in the Cathedral Treasury in Gerona, Spain,[9] and the 12th-century interpretation of the harlot found in Herrad of Landsberg's manuscript, *Hortus Deliciarum (The Garden of Delights)*[10] present prime examples of how women artists interpreted abstract spiritual concepts in a concrete manner.

In the second half of the eighth century, around the year 776, an Asturian priest, Beatus of the monastery of Santo Toribio, Liebana wrote a commentary on the Apocalypse to refute the heresy of Adoptionism (the belief that Jesus was a "mere man"). The commentary had a profound influence on scholars throughout European monastic communities, but especially in Spanish monasteries from the ninth to the twelfth centuries.[11] Monks and nuns copied the commentary in almost every monastery in Spain and challenged the imaginations of their illuminators. These illuminations "constitute the richest tradition of illumination in the Iberian peninsula, equal to the place held by Gospel and Psalter illustration elsewhere in Europe."[12] Georges Betaille surmises that, "Its popularity was no doubt due to the anxiety caused by the Adventist movement[13] of the time, especially in a region where Christianity was directly threatened."[14] At the beginning of the tenth century Christians living in the Muslim section of the south of Spain were urged to move to the northern areas; these Christians were called Mozarabs. A group of Benedictine monks moved to Escalda and established a monastery near Leon. These monks brought with them the style of painting, which they had imbibed from their Moorish neighbors; this style became known as the Mozarabic Style.

The Monastery of St. Miguel de Escalda near Leon once had a great library; it was the home of Magius [Maius], the teacher of Emeterius. Book production assumed great importance in this Mozarabic monastery. One of the manuscripts produced there (*The Maius Beatus*, c. 940-945), illuminated by the monk Maius with his pupil and helper, Emeterius, later became known as the *Morgan Beatus*. The double monastery of San Salvador de Tabara produced the *Gerona Beatus* illuminated by both the monk Emeterius and the nun Ende. Mozarabic monastics not only signed their works, but they also included the names of patrons and painters, the date of completion, and even brief notes,

prayers, and appeals for appreciation. Both the *Morgan* and the *Gerona* manuscripts contain signatures and the date 975. A comparison of Ende's interpretation of the *Whore of Babylon* with those rendered by Maius and Emeterius engenders interesting speculation. One can easily determine those executed by Ende since they are far superior in simplicity and delicacy of design and style.

In the Apocalypse the writer describes his vision of the Whore of Babylon:

> Come here and I will show you the punishment given to the famous prostitute who rules enthroned beside abundant waters, the one with whom all the kings of the earth have committed fornication, and who has made all the population of the world drunk with the wine of her adultery.[15]

Beatus, in his *Commentary on the Apocalypse*, identified the Whore of Babylon with all the evils of the world and with iniquity in general; the kings of the earth represent those who are enmeshed not only in the delights of the flesh, but also those who have prostituted themselves by reverting back to, or by continuing in the adoration of pagan gods, goddesses, and customs. In most interpretations of the *Beatus MS.*, Babylon is normally equated with ancient Rome, while the beast is likened to the Roman emperors, especially to those who persecuted the early Christians. Some scholars identify the city as Jerusalem in its last days of domination by the Romans as the Babylon of Revelations. Ford presents a striking argument that the city is indeed Jerusalem whose leaders succumbed to the seductions of Roman idolatry as symbolized by the Temple built by the Gentile, King Herod. Illuminators in the Iberian Peninsula had a different interpretation; they envisioned the Whore as a symbol for the Moorish conquerors who inhabited the southern area of Spain. The Apocalyptic writer continues: "He took me in spirit to a desert, and there I saw a woman riding a scarlet beast, which had seven heads and ten horns and had blasphemous titles written all over it."[16]

Some paintings representative of the earlier stages of iconographic interpretations of the *Beatus Manuscripts* depict the Whore of Babylon as a woman seated on a throne immersed in water. However, Magius (*Morgan Beatus*, folio 194v)[17] identifies her in more specific terms (Figure 1). The upper border of her crown suggests crenellations of an Islamic type, and the crescent in the center of the crown is a sign associated in Islamic art with regality or divinity. The water has also given way to a cushioned divan of Islamic association. As a result of

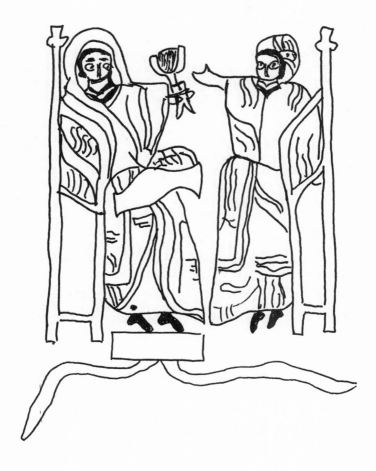

Figure 1. "The Great Whore and the Kings of the Earth." *Morgan Beatus MS.* MS 644 Folio 194v. Pierpont Morgan Library, New York.

these changes, Maius encouraged the reader, in turning to the illustration, to associate the seducer specifically with the Muslim culture of the peninsula. The influence of Maius can be seen in the illustration of the Whore of Babylon in the *Gerona MS* (Figure 2) as executed by his pupil Emeterius. In the double monastery of San Salvatore,[18] the nun Ende, the collaborator of Emeterius, also equated the harlot with the Islamic domination of much of Spain at that time. However, Ende portrays the Whore in a different way.

Ende's "Whore of Babylon" (Figure 3), riding astride the fabulous scarlet-colored beast, wears pantaloons, the typical costume of Moorish women. Here Ende represents the Harlot as one of the non-Christian Moors, and therefore, the symbol of Babylon for the Christians of the northern Iberian Peninsula in the tenth century. Ende continues the association by omitting the seven heads of the beast since the seven heads represented the Seven Hills of Rome. The Harlot turns toward the rulers of the world trying to prove to her viewers that she wishes to entice them. As part of an historic action, she becomes a transcendent figure with a distinct axis of her own. By employing typical Mozarabic colors, Ende reinforces her message. The illuminator of the *Morgan Beatus MS 429*, folio 125 (Figure 4), also depicts the Whore riding astride, but, although the beast sports the seven heads, the Harlot wears an Islamic crown.

The Harlot holds a golden cup in her upraised hand. This golden cup, beautiful to behold on the outside, nevertheless contains all the abominations, filth, and evils of an idolatrous world. Ende portrays a fabulous beast with the beak of a bird and the tail of a snake; it carries the Harlot into a wasteland symbolized by a single very beautiful stylized tree. She omits the waters as an unnecessary symbol in an arid land.

Two centuries later, a woman of the Frankish Kingdom undertook the mammoth task of putting together an encyclopedia of all the knowledge of the twelfth century. Herrad of Landsberg, one of the brightest lights in the assemblage of 12th-century women, ruled as abbess of the Alsatian monastery comprised of Augustinian canonesses. She came from the region of Alsace Lorraine near Strasbourg, which at that time belonged to the Frankish Kingdom. Herrad spent her life in monastic seclusion, absorbed the knowledge of the great writers who preceded her, studied the literary and artistic works of her contemporaries, immersed herself in mystical experiences and religious teachings, and devised a plan whereby she might share this knowledge with her sisters. Her plan resulted in a masterpiece of twelfth-century art. In her monastery of Mont Sainte-Odile, Herrad authored and

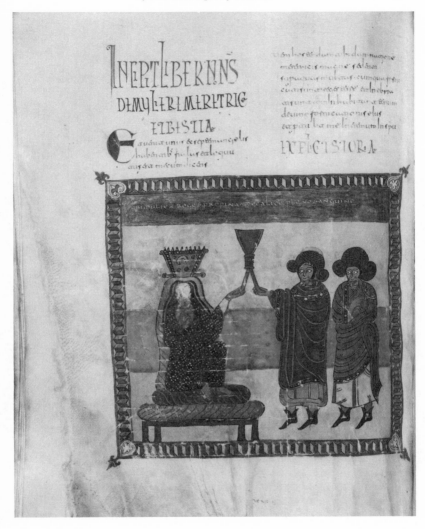

Figure 2. "The Great Whore." *Gerona MS.* Gerona Cathedral Treasury, Spain

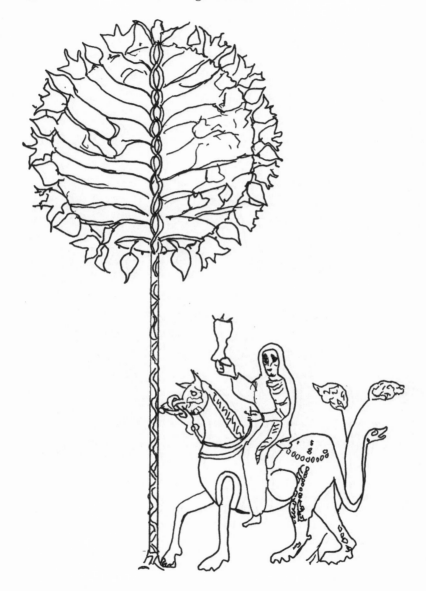

Figure 3. "The Whore of Babylon." Ende. *The Gerona MS. Gerona Cathedral Treasury, Spain.*

cornua decem. bettia quam uidifti. funt. et non é. tutura é ascendere de abisso. et in pditionem ire. Et mirabantur. qui habi tant in tra. quoz non é fcripta nomta in libro uite. a constitutione mundi. uiden tes betham. qm furt. et non é. et uentura

difti. decem reges funt. qui regnum no dum acceperunt. S. poteftatem quasi regs una hora accipiunt poft beftia. hi unam fententiam habét. et uirturem et potefta tem suam beftie dant. f int ftoria.

mulier feder super bethia.

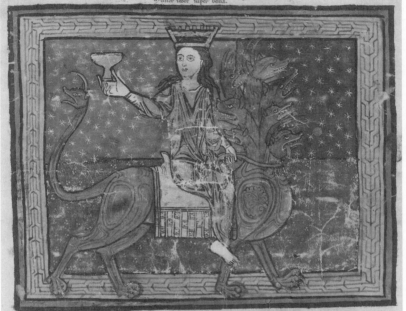

EXPLANATIO. SUPRA. SCRIPTE. ISTORIE. Et uidr mulierem fedentem fu per betham. hic hoftenditur beftia ipfis effe. Promific eni hoftendere. fedentem fup aqs multas. Beftia et aqua unum funt. ideft ipfis. Corruptelam dicit federe fup ipfios in heremo. Et ertur. beftia. et heremus unu

funt. Beftia aut dictum é. corpus é ad ufarius agno. ideft corpus diabli. qui s homines mali. In quo corpore nunc diabo lus nunc caput udur occifum. ideft facer dotes mali in quos diabolus fe transfigu rat in angelum lucis et nuncupatur alio nomine diabolus. Sunt ipfis accipiendus é. quod hoc totum una ciuitas babilon

Figure 4. "The Whore of Babylon." *Morgan Beatus MS. 429. Pierpont Morgan Library, New York.*

illuminated the encyclopedic work, *Hortus Deliciarum* (*The Garden of Delights*) which she compiled to educate the nuns in her monastery. *The Book of Revelation*, also known as the *Apocalypse*, supplied Herrad with a theme for one of her most monumental paintings, "The Whore of Babylon" (Figure 5).

John continues with his narrative:

> The woman was dressed in purple and scarlet, and glittered with gold and jewels and pearls, and she was holding a gold wine cup filled with the disgusting filth of her fornication; on her forehead was written a name, a cryptic name: "Babylon the Great," the mother of all the prostitutes and of all the filthy practices on the earth. I saw that she was drunk, drunk with the blood of the saints, and the blood of the martyrs of Jesus.[19]

Herrad's Whore, dressed as a member of the royal court of the Frankish Kingdom, wears the typical royal crown worn by the emperor, Frederick Barbarossa. The circle of the crown bears the inscription, *Babylon Magna* (Babylon the Great), the mother of abomination. Dressed in scarlet and purple, the colors employed by Roman emperors and Frankish kings alike, the Whore radiates the aura of sovereign power.[20] The Harlot represents the embodiment of the evils that inflict themselves insidiously into most governments of the word at any given time. Dressed in the royal robes worn by ruling members of the Frankish Kingdom and wearing the Frankish crown upon her head, the Harlot assumes the identity of corrupt officials of the twelfth century.

Seated on a bright red beast, the Whore leads her mount through the waters, which surround her. The waters are not the cleansing refreshing waters of the Spirit of God, but the polluted waters of evil made so by contact with the seven-headed beast. This fabulous monster has the feet of an ox while the seven heads resemble those of leopards. Herrad arranged the seven heads springing from the neck of the beast rather than from the breast of the monster as many other medieval artists had depicted them. The large head and the first two small ones have two horns, the following four have one each which together create the ten horns mentioned by the seer. The Whore, who has forsaken Yahweh for pagan gods, raises her golden cup filled with the intoxicating wine of idolatry and forbidden pleasures. Her purple robe with white ornaments and her green cape with darker decorations reveal that she is a queen.

According to the account of John, the beast with its seven heads (symbolic of the seven hills of Rome) walks through the waters of

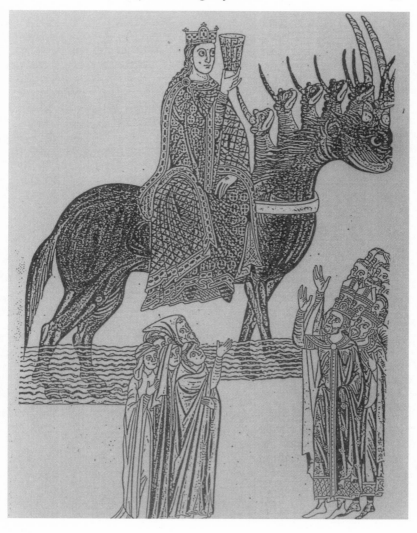

Figure 5. "The Great Whore of Babylon." Herrad of Landsberg.
Hortus Deliciarum. Folio 258 r.

perdition while the Whore of Babylon (the goddess of Rome) attempts to entice kings, prelates, monks, nuns, and laity who stand on the shore, to follow her in her pleasures, seductions and idolatry of the pagan world. They stretch their hands towards the great harlot as if they are about to surrender to her seductions. Herrad enlarges the symbolic sense of the great Babylon; she does not, like the Prophet of Patmos, see only pagan Rome which no longer existed in the twelfth century, but the personification of Temptation or of the triple concupiscence which will continue to exist up to the end of the world, constantly making numerous victims.[21]

The apocalyptic seer continues the narrative of his vision by telling us the fate of the Great Whore:

> Come here and I will show you the punishment given to the famous prostitute who rules enthroned beside abundant waters, the one with whom all the kings of the eart have committed fornication, and who has made all the population of the world drunk with the wine of her adultery. Fallen, fallen is Babylon the great, who gave every nation to drink of the wine of the lust of her harlotry.[22]
> (Figure 6)

In the preceding miniature the triumphant harlot glories in her ability to lure humans into perdition; in this miniature, the harlot is precipitated into the abyss and flames of hell. In the Old Testament, burning with fire appears as a punishment for incest, for harlotry, for keeping forbidden articles, and generally for not obeying the word of God. In the twelfth century, "death by fire" was inflicted on heretics and infidels. Herrad depicts the great harlot overturned with her head down, her knees bent and with a silly grin on her face. Artists of the twelfth century often associated the grin with the folly of sinfulness. The crown remains on her head since she retains her title as Queen of Evil, but the cup of perdition escapes her hand. Two angels push her into the flames with their tridents. The scarlet beast keeps an upright position; only the mouths of the seven heads, which were closed in the preceding illumination, are here wide open as they roar in anguish and frustration at the downfall. The kings of the earth and other followers of the beast who will suffer continuous unending punishment by fire stand at the edge of the abyss; some hold their noses against the unbearable stench that rises from the pit. Two figures hold a handful of dirt over their heads to cover themselves with dust as a symbol of grief for their folly, but their feet are already slipping over the edge of the abyss. Next

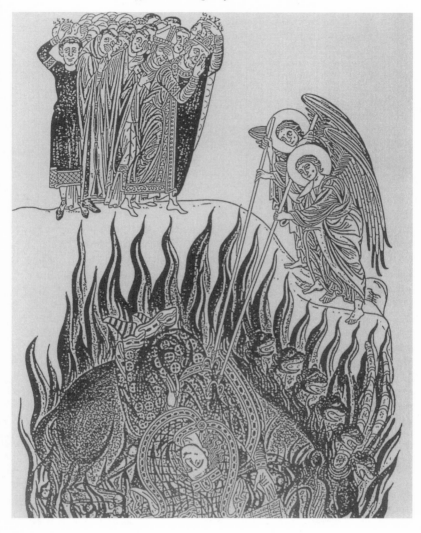

Figure 6. "The Great Babylon Overturned." Herrad of Landsberg. *Hortus Deliciarum.* Folio 258 v.

to these outcasts Herrad wrote the following text composed of fragments from Chapter 18 of the Apocalypse:

> All their wealth and power has been lost and Babylon is no more. The kings of the earth, the damned, who committed fornication and lived in delights, will cry over her and strike their breasts seeing the smoke of her burning; they will stand far off from her in fear of torment, covering their heads with dust saying;
>
> Alas! Alas! Thou great city, thou mighty city Babylon! In one hour has thy judgment come! All her wealth has been laid waste, and all is lost in her! Babylon is no more.[23]

The individual history of every being is intrinsically bound to the history of her own era. The formation of minds, the acceptance of beliefs, the promulgation of ideologies, and even the creative process, all depend upon, and revolve around, a person's distinctive niche in the annals of time. But paintings (that is exceptional paintings) live and breathe and speak to each generation that takes the time to look. Ende and Herrad had their own meanings, colored by their own ethos, but their paintings can be appreciated today for their color, their design, and their tangible mystery of creation.

Evil vs. good, reward vs. punishment, heaven vs. hell, love vs. hatred—these continue to confuse and confound humanity. Each generation receives the challenge to depict it in as meaningful a way as did the medieval artists. Art expresses the spiritual in the tangible, but, as Burkhardt reminds us, "the renewal of Christian art is not conceivable without an awakening of the contemplative spirit at the heart of Christianity; in the absence of this foundation every attempt to restore Christian art must fail; it can never be anything but a barren reconstruction."[24]

The Woman Clothed with the Sun

Now a great sign appeared in the heavens: a woman adorned with the sun, standing on the moon, and with the twelve stars on her head for a crown.

Many medieval artists copied existing illustrations from model books or from other manuscripts, then applied them to given texts, without considering too carefully the appropriateness of the illustrations.[25] Herrad adhered strictly to the text when she envisioned and portrayed the *Mulier Amicta Sole* (the Woman Clothed with the Sun). (Figure 7)

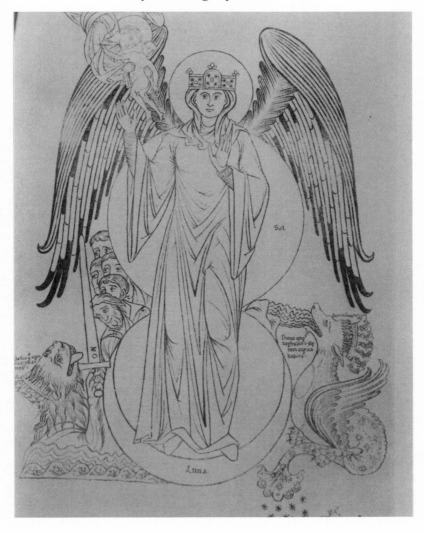

Figure 7. "*Mulier Amicta Sole*" (The Woman Clothed with the Sun) Harrad of Landsberg. *Hortus Deliciarum.* Folio 261 v.

The figure, a celestial woman adorned in splendor, standing over a foot high, dominates the entire folio and surpasses the height of some of the early panel paintings.[26] This woman is no ordinary woman; she symbolizes the church.[27] The monumental frontal position of this woman sets her apart as a cultic image of great importance,[28] while the color of her garment, a rich crimson, proclaims her majesty. Herrad states in the commentary accompanying the painting, "The Woman seen in heaven is the church whom Christ introduced into the celestial kingdom."[29] But, as is so often the case in medieval art, a second interpretation of the woman's identity can also be discerned. In the twelfth century, there was an increasing interest in the Virgin Mary in literature as well as in art; the belief that the Woman Clothed with the Sun symbolized Mary, the Mother of God, prevailed. Many early Fathers of the Church maintained that the woman symbolized both the church and Mary. This belief flourished in the twelfth century as a consequence of the lyrical sermons and writings of Bernard of Clairvaux (1091-1153). If the woman is the image of the church, then according to customary exegesis, she is the bride of Christ. Moreover, some scholars interpreted many passages of the Song of Songs as the love song between Yahweh and his bride in the covenant relationship. Interpretation of the bride as the church soon evolved into the acceptance of the bride as Mary. It became commonplace to find images of Mary in the passages of the Song, especially those passages dealing with light. "Who is she arising like the dawn, fair as the moon, bright as the sun, terrible as an army with banners?"[30] In her company Herrad explains that the Lady "is clothed with the sun because Jesus Christ the sun of Justice, surrounds her with his brilliance."[31] To compensate for her inability to portray a garment of sun, Herrad places a huge sun disk behind the woman, the church, "who poses standing on the luminous crescent of the moon which is a lesser light [lying] subordinate under the woman's feet."[32] A third disk behind the head of the majestic queen, a symbol of sanctity and divine inspiration, completes the trinity of light that concurrently enlightens and protects her noble personage. Illuminated and enveloped in the light of God's love, the woman becomes the antithesis of the evil one who dwells in darkness. The three disks combine into a type of madorla of light; they are not in the most common form of mandorla reserved for the image of God, at this point in history, but the implication of *Theotokos* (Mother of God) validated the use of this symbol of theophany.[33]

A diadem of twelve stars crowns the noble brow of the woman. The symolbic number twelve appears in the Apocalypse as the number of gates of the Heavenly City on which are inscribed the names of the

Twelve Tribes of Israel, and to the twelve foundation stones which bear the names of the twelve apostles of the Lamb. The crown of stars seems to span in symbolism both the Old and New Testaments, combining the kingdom of Israel with the fulfillment of the prophecies found in the new kingdom of the church. Herrad explains that the twelve stars symbolize the doctrine transmitted by the twelve apostles.[34]

In the Old Testament, the image of light signified the Divine Presence. With ease, therefore, medieval theologians concluded that the Woman Clothed with the Sun was Mary who was "Resplendent as the Sun," for within her dwelt the Incarnate Son of God. Yahweh wrapped the woman in a garment of light, the sun, to thwart the dragon and to dispel the aura of evil directed against her. Combined with the light under her feet, the stars of her crown emitted an additional source of light. Thus symbolically clothed with the three lights of heaven, the woman is prepared to face and to overcome the Prince of Darkness.

In medieval art, presenting a figure in a frontal view expressed the identity of a cult figure with a distinct axis of its own, or as a vehicle for the sacred or transcendent.[35] The monumental frontal appearance of this woman sets her apart as a cultic image of great importance.[36] A study of medieval iconography discloses that symbolic images were assigned to such things as parts of the human body. In this painting the "wide open eyes" of the woman signify knowledge; the elegance of the movement of her hands symbolizes power; the ears slightly bent forward portray her willingness to listen to God's word; and the woman's legs so straight and firm beneath the dampfold drapery exhibit her stability; her aristocratic bearing emphasizes her queenship. Another clue to the majesty of this person is implied in the color of her robe, a rich crimson, the color assigned to royalty, luxury and magnificence.[37] Herrad's ability to use these attributes so effectively indicates the depth of her knowledge of medieval iconography as well as the degree of sensitivity with which she approaches her subject.

The Woman, image of Israel who mothers the Messianic Savior, "bears the name woman, because she is always giving birth to a new race."[38] Groaning, the woman cried aloud in the pangs of childbirth. The apocalyptic seer envisioned this groaning, not as demoniac shouting, nor as an incantation to rouse evil spirits,[39] but rather as a solemn proclamation that Yahweh remembered his promise to his people, and that the messianic birth pangs had begun. Theologically, groaning was considered to be an expression of the longing of the soul for Yahweh, as well as a petition in time of need: "the Spirit himself makes intercession for us with the Father with groanings that cannot be expressed in speech."[40] The woman's pain in giving birth fulfills

Yahweh's prediction that Eve would bring forth her children in suffering;[41] it also echoes the joyful anticipation that one of her offspring would overcome the deadly serpent.[42] Herrad portrays the moments after the birth of the child; the queenly bearing of the woman whose child has been snatched from the jaws of the dragon shines forth now that her child has been rescued. The dragon is the second great sign that appears in the heavens.

Then a second sign appeared in the sky, a huge red dragon which had seven heads and ten horns, and each of the seven heads was crowned with a coronet. Its tail dragged a third of the stars from the sky and dropped them to the earth, and the dragon stopped in front of the woman as she was to have her child, so that he could eat it as soon as it was born from its mother.43

In direct contrast to the beautifully poised woman who represents the harmony and beauty of the universe, the dragon, king and high priest of all evil and chaos appears. Herrad describes the dragon: "The red dragon is the devil: he is called the dragon because he is filled with the venom of evil, and red, because he was a murderer from the beginning."[44]

From ancient times dragons were generally considered symbols of evil and chaos. The dragon, therefore, is the direct antithesis of Yahweh who is the source of all order and peace in the world. A primordial struggle between the dragon, the prince of lies, and Yahweh, the King of Justice and ruler of the earth has always existed. To the warlike bloody color of the dragon, the apocalyptic seer adds another fabulous feature: the dragon has seven heads and ten horns. Jerome states that the devil has as many heads as there are sins;[45] while Hall identifies them further as symbolizing the seven deadly sins.[46] Herrad's contemporaries would have had little difficulty with this image of the deadly sins for she personified them in her *Psychomachia* (Battle of the Virtues and Vices). Many medieval artists attempted to depict the fabulous dragon of the Apocalypse, a task made more difficult since the seer made no mention of how these seven heads were attached to the dragon. Herrad solves the problem by creating a crown for the main head which rests on ten horns springing from the head. The decoration of the crown is cleverly fashioned of six small heads of beasts, each crowned with a coronet. The diadem is an appropriate symbol for the Prince of Darkness, ruler of the underworld.

With his tail, the dragon swept a third of the stars from the sky and dropped them to earth. Twelfth-century scholars held that Satan, in his revolt and in his fall, took a third of the angels with him. Furthermore,

they believed that throughout the ages the devil continues to capture some souls of the people of God, chosen beings who were destined to "shine as stars" for all eternity.

In addition to the symbolism of stars already cited, Herrad may have assigned to the stars in the woman's crown the symbol of angels. This interpretation would be appropriate if we consider the additional interpretation of the woman as *Theotokos*, the Mother of God. By the eleventh century Mary was known by the title of *Domina Angelorum* (Queen of Angels).[47] One of the favorite hymns of that time was "*Ave Domina Angelorum*" ("Hail, Queen of Angels"). Therefore the stars/angels may be considered as a protective force guarding the woman against the assaults of the dragon whose tail lacks the power to sweep the stars from her crown.

> The dragon waited for the birth of the woman's man child so that he might devour it, but was thwarted by the swiftness of an angel who snatched the child and bore it away to safety.
>
> The woman brought a man child into the world, the son who was to rule all the nations with an iron scepter, and the child was taken straight up to God and his throne, while the woman escaped into the desert, where God had made a place of safety ready for her.[48]

Herrad portrays the moment of the child's rescue. Only the top half of the angel is seen, giving a sense of swiftness and urgency. The woman's eyes follow the action of the angel; she has not yet turned to flee from the dragon. "As soon as the devil found himself thrown down to the earth, he sprang in pursuit of the woman—but she was given a huge pair of eagle's wings to fly away from the serpent into the desert."[49]

Revelation specifically states that the woman was given eagle's wings to aid her escape. The image of eagle's wings can be traced back to Old Testament symbolism which used this image as a sign of Yahweh's love and protection, of divine power and strength. "You have seen for yourselves how I bore you up on eagle's wings and brought you here to myself."[50] *Theotokos* was borne on eagle's wings because "she possesses the two precepts of charity on which, as on two wings, she escapes from the demon."[51] When he saw that the woman would escape, the dragon attempted to drown her: "So the serpent vomited water from his mouth, like a river, after the woman, to sweep her away in the current, but the earth came to her rescue; it opened its mouth and swallowed the river thrown up by the dragon's jaw."[52]

In order to create a semblance of the earth, Herrad places a mound of earth in the crevice resulting from the tangency of the two curved lines of the sun and the moon. Taking pity on the plight of the woman, the earth separated like a mouth to swallow the river. Herrad: "the great river symbolizes a new persecution with which the dragon endeavors to drown the woman since she has escaped his previous onslaught, but the earth soon swallowed this river when God brought this trial to an end."[53]

Enraged because the woman has eluded him, the dragon summons Leviathan from the depths of the sea to make war on the children of God.

Then I saw a beast emerge from the sea; it had seven heads and ten horns, with a coronet on each of its twelve horns, and its heads were marked with blasphemous titles. I saw the beast was like a leopard, with paws like a bear and a mouth like a lion.[54]

To Leviathan the dragon delegated his authority to entice human souls to follow the evil one. Herrad's inscription identifies the second beast as Antichrist, whom the demon will completely fill. In the Old Law the sea stood as a symbol for all chaos, therefore, the monster emerging from the sea was an ominous sign portending that evil would have its triumph.[55] Herrad explains, "The beast which then appeared and to whom the dragon had given his power, is the Antichrist whom the demon will completely fill. The beast, armed with a sword, strikes the saints who resist him."[56] On the sword is inscribed an O and an N. Since the copyist failed to indicate Herrad's explanation of these letters and since I have not been able to find a reference to the meaning of these letters, I presume to suggest they may stand form *Omnia Nationes* since Leviathan was called upon to persecute and to draw *All Nations* to the worship of the Antichrist. Or they may signify the words *Opus Neronis*, the work of Nero, who persecuted the Christians.

Herrad once again solves the problem of depicting the monster's ten horns and seven heads. She has the ten horns emerging from the monster's head; these horns in turn support a crown of six small heads which form a decorative motif along the edge of the crown. No blasphemous phrases decorate the heads, perhaps because Herrad would not wish to use blasphemous phrases even in a work of art. The whole appearance of Leviathan complements the picture of the dragon.

Thus Herrad depicts her version of the Apocalyptic Woman Clothed with the Sun. Her interpretation, as in almost all medieval art, is grounded firmly on scripture, on the writings of the Fathers of the

Church, and on the commentaries and glosses available to her. Although Herrad employed almost all the iconographical elements afforded to her by twelfth-century codes of symbolism, her painting of the Woman remained uniquely her own. Symbolism constituted one of the characteristic traits of apocalyptic writing; Herrad proved her ability to translate symbolic writing into paintings. She featured the painting rather than the text which she utilized to explain particular points. The language of her paintings was genuinely mystical, as were the texts she chose to accompany them.

The contrast between the Whore of Babylon and the Woman Clothed with the Sun evokes the message handed down from the time of Hesiod that women fit into one of two categories: that of Eve who was believed to have tempted Adam or that of Mary who embodies all that is good. The modern world has witnessed an ever-growing awareness of the rights and privileges that belong to half the world's population long held in bondage, that is, to women. Christ frequently addressed his mother using the beautiful word, "Woman."[57] He did not call her slave or concubine, servant or inferior being; he called her "woman." Christ tried to teach the dignity and worth of women. Christ allowed Mary, the sister of Lazarus and Martha, to sit at his feet while he taught (an unheard of thing for a woman at that time) to teach us that women too could be educated. He revealed his mission for the first time to the Samaritan woman at the well. And he sent a woman, Mary Magdalene, to his disciples to announce the resurrection. "The modern world should be clearly reminded that the rise and fall of nations, the growth or decline of true culture, largely depends on the position that woman occupies in the consciousness and attitudes of a people."[58]

Notes

[1] Emile Male, *Religious Art from the Twelfth to the Eighteenth Century* (New York: The Noonday Press, 1965), p. 82.

[2] Meyer Schapiro, *Words and Pictures: On the Literal and Symbolic in the Illustration of a Text* (New York: Mouton Publishers, 1973), p. 9.

[3] Theodore Rousseau, "Forward," in Kenneth Clark, *Masterpieces of Fifty Centuries: Metropolitan Museum of Art* (New York: E. P. Dutton, 1970), p. 47.

[4] Albert Hofstader and Richard Kuhns, eds., *Philosophies of Art and Beauty: Selected Readings in Aesthetics from Plato to Heidegger* (Chicago: University of Chicago Press, 1976), p. 172.

[5] Katherine Everett Gilbert and Helmut Kuhn, *A History of Esthetics* (New York: Macmillan, 1939), p. 151.

[6] Gerhart Ladner, "Medieval and Modern Understanding of Symbolism: A Comparison," *Speculum: A Journal of Medieval Studies* April 1979, LIV:2, p. 233.

[7] J. M. Ford, *The Anchor Bible: Revelation: Introduction, Translation and Commentary* (New York: Doubleday and Company, Inc., 1975), p. 277.

[8] John Williams, *The Illustrated Beatus: A Corpus of the Illustrations of the Commentary on the Apocalypse: the Ninth and Tenth Centuries* (London: Harvey Miller Publishers, 1994), p. 26.

[9] "The concluding notes by the scribe provide information on the person who copied it and the year of its completion. On fol. 284 there is an entry: *SENIOR PRESBITER SCRIPSIT.* On fol. 284v we read above the capital omega: *DNICVS ABBA LIBER FIERI PRECEPIT*, below: *ENDE PINTRIX ET DI AIUTRIX PRTREmeterius ET PRSTR....* Their joint work was completed in 975 A.D." William Neuss, "The Miniatures of the Gerona Codex in the Light of Other Illuminated MSS. of the *Beatus* Apocalypse," in Cesar E. Dubler, ed., *The Apocalypse of Gerona* (New York: Philip C. Duchnes, 1962), p. 48.

[10] A. Straub and G. Keller, *Harrad of Landsberg: Hortus Deliciarum* (New York: Caratzas Brothers, Publishers, 1977).

[11] "only about twenty four [copies of the manuscript] being known to be extant. The region whence they came is restricted; only one so far as it is known, having been written outside the Peninsula, and that by a Spaniard for a Spanish abbot [Saint-Sever MS]" Georgia Goddard King, *Divagations on the Beatus* [Cambridge, 1930), p. 1.

[12] David Seth Raizman, *The later Morgan Beatus (MS 429) and Late Romanesque Illumination in Spain* (Ann Arbor, MI), p. 1.

[13] Adventist—a member of any of certain Christian denominations which maintained that the expected second coming of Christ was near at hand.

[14] "*sa vogue doit sans doute etre rattachee aux croyances adventistes que eurent coura a cette époque, en particular dans une region ou le christianisme etait directment menace.*" Georges Betaille, *L'Apocalypse de Saint-Sever* (Paris, 1929), pp. 74-75.

[15] Rev. 17:1-2.

[16] Rev. 17:3.

[17] The *Morgan Beatus MS* is housed in the Pierpont Morgan Library in New York City.

[18]"double monasteries had existed at an earlier age in England...as examples, St. Hilda's at Whitby, and St. Etheldreda's at Ely." J. Arthur Floyd, "An Extinct Religious Order and Its Founder," *The Catholic World* June 1896, LXIII: 375, p. 351. Also: "after the arrival of St. Columban and his Irish disciples, double monasteries increased rapidly in Gaul....Germany developed them in the eighth century....in Spain development came in the second half of the ninth century." Sister Mary Pia Heinrich, "The Canonesses and Education in the Early Middle Ages," an unpublished dissertation for the PhD, The Catholic University of America, Washington, DC, 1924, p. 59.

[19] Rev.

[20] Straub and Keller, *Herrad*, p. 236.

[21] Straub and Keller, *Herrad*, p. 236.

[22] Rev.

[23] Rev.

[24] Titus Burkhardt, *Sacred Art in East and West: Its Principles and Methods* (London: Perennial Books, 1967), p. 150.

[25] Thomas A. Sebeok, ed., *Approaches to Semiotics* (University of Indiana Press), p. 9.

[26] Rosalie Green et al, *Harrad of Hohenburg: Hortus Deliciarum* (London: The Warburg Institute, 1979), p. 36.

[27] Charles Sears Baldwin, *Medieval Rhetoric and Poetic: Interpreted from Representative Works* (MA: Peter Smith Publisher, 1959), p. 242.

[28] Straub, *Herrad*, p. 248.

[29] Straub, *Herrad*, p. 240.

[30] Song of Songs 6:10.

[31] Straub, *Herrad*, p. 240.

[32] Charles Gerard, *Les Artistes de L'Alsace de Moyen Ages pendant Le Moyen-Age* (Nancy: Librairie des Arts et Metiers-Editions, 1977), pp. 81-82.

[33] Andre Grabar, "The Virgin in a Mandorla of Light," in Kurt Weitzman, ed., *Late Classical and Medieval Studies in Honor of Albert Mathias Friend, Jr.* (Princeton: Princeton University Press, 1955), p. 310.

[34] Straub, *Herrad*, p. 240.

[35] Schapiro, *Words*, p. 41.

[36] Straub, *Herrad*, p. 240.

[37] G. D. Coulton, *Medieval Faith and Symbolism, Part I of Art and Reformation* (New York: Harper, 1958), p. 164.

[38] Straub, *Herrad*, p. 240.

[39] *Jerusalem Bible*, Job 3:8-9, n. 731.

[40] Rom. 8:26.

[41] Gn. 3:16.

[42] Gn. 3:15.

[43] Rev. 12:3-4.

[44] Straub, *Herrad*, p. 240.

[45] Marie Ligouri Ewald, translator, *The Homilies of Jerome* (Washington, DC, 1964), p. 55.

[46] James Hall, *Dictionary of Subjects and Symbols in Art* (New York: Harper and Row, 1974), p. 25.

[47] Michael O'Carroll, *Theotokos: A Theological Encyclopedia of the Blessed Virgin Mary* (Delaware: Michael Glazier, Inc., 1982), p. 27.

[48] Rev. 13:1-3.

[49] Rev. 12:13-1-4

[50] Ex. 19:4.

[51] Straub, *Herrad*, p. 240.

[52] Rev. 12:15-17.

[53] Straub, *Herrad*, p. 240.

[54] Rev. 13:1-3.
[55] Edward Schillebeeckx, *Hermeneutics: The Handwritten Manuscripts* (Montana: Scholars Press, 1977), p. 451.
[56] Straub, *Herrad*, p. 240.
[57] Paul VI, "The Role of Women in Contemporary Society," Address to the Convention of the Union of Italian Catholic Jurists, December 1974, cited in Elizabeth McPherson, ed., *The Pope Speaks*, Spring 1974-Spring 1975, 18:4, p. 318.
[58] Augustine Frotz, "Address to the General Congregation," October 29, 1964, cited in Eva-Maria Jung, "Women at the Council: Spectators or Collaborators?" *The Catholic World*, February 1965, 200:1, p. 284.

Works Cited

Baldwin, Charles Sears. *Medieval Rhetoric and Poetic: Interpreted from Representative Works*. MA: Peter Smith Publisher, 1959.

Betaille, Georges. *The Apocalypse of Saint-Sever*. paris, 1929.

Burkhardt, Titus. *Sacred Art in East and West: Its Principles and Methods*. London: Perennial Books, 1967.

Coulton, G. D. *Medieval Faith and Symbolism: Part I of Art and Reformation*. New York: Harper, 1958.

Floyd, J. Arthur, "An Extinct Religious Order and Its Founder," *The Catholic World* LXIII (June 1896): 375.

Ford, J. M. *The Anchor Bible: Revelation: Introduction and Commentary*. New York: Doubleday and Company, Inc., 1975.

Frotz, Augustine, "Address to the General Congregation," October 29, 1964, cited in Eva-Maria Jung, "Women at the Council: Spectators or Collaborators?" *The Catholic World* 200 (February 1965): 1.

Gerard, Charles. *Les Artistes, de l'Alsace de Moyen-Age*. Nancy: Librairie des Arts et Métiers Editions, 1977.

Gilbert, Katherine Everett and Helmut Kuhn. *A History of Esthetics*. New York: The Macmillan Company, 1939.

Grabar, Andre, "The Virgin in a Mandorla of Light," in Kurt Weitzman, ed. *Late Classical and Medieval Studies in Honor of Albert Mathias, Jr.* Princeton: Princeton University Press, 1955.

Green, Rosalie et al. *Herald of Hohenburg: Hortus Deliciarum*. London: The Warburg Institute, 1979.

Hall, James. *Dictionary of Subjects and Symbols in Art*. New York: Harper and Row, 1974.

Heinrich, Sr. mary Pia, "The Canonesses and Education in the Early Middle Ages, an unpublished dissertation for the Ph.D., The Catholic University of America, Washington, D. C., 1924.

Hofstader, Albert and Richard Kuhns, eds. *Philosophies of Art and Beauty: Selected Readings in Aesthetics from Plato to Heidegger*. Chicago: University of Chicago Press, 1976.

King, Georgia Goddard. *Divagations on the Beatus*. Cambridge, MA: Cambridge University Press, 1930.

Ladner, Gerhart, "Medieval and Modern Understanding of Symbolism: A Comparison," *Speculum: A Journal of Medieval Studies* LIV (April 1979): 2.

Male, Emile. *Religious Art from the Twelfth to the Eighteenth Century*. New York: The Noonday Press, 1965.

Neuss, William, "The Miniatures of the Gerona Codex in the Light of Other Illuminated MSS. of the Beatus Apocalypse," in Desar E. Dubler, ed., *The Apocalypse of Gerona*. New York: Philip C. Duchnes, 1962.

O'Carroll, Michael. *Theotokos: A Theological Encyclopedia of the Blessed Virgin Mary*. Delaware: Michael Glazier, Inc., 1982.

Pope Paul VI, "The Role of Women in Contemporary Society," in Elizabeth McPherson, ed., *The Pope Speaks* 18 (Spring 1974-Spring 1975): 4.

Raizman, David Seth. *The Late Morgan Beatus (MA 429) and Late Romanesque Illumination in Spain*. Ann Arbor, MI, 1983.

Rousseau, Theodore, "Foreword," in Kenneth Clark, *Masterpieces of Fifty Centuries: Metropolitan Museum of Art*. New York: E. P. Dutton, 1970.

Sebeok, Thomas A., ed., *Approaches to Semiotics* The Hague: Mouton, 1972.

Schapiro, Meyer. *Words and Pictures: On the Literal and the Symbolic in the Illustration of a Text*. The Hague and Paris: Mouton, 1973.

Schillebeechkx, Edward. *Christ: the Experience of Jesus as Lord*. New York: The Crossroad Publishing Company, 1981.

Williams, John. *The Illustrated Beatus: A Corpus of Illustrations of the Commentary on the Apocalypse: the Ninth and Twelfth Centuries*. London: Harvey Miller Publications, 1994.

Chapter 3

"Am I Not Your Mother?"
Identity and Resistance
at Tepeyac and Montserrat

Cecelia J Cavanaugh, SSJ

Introduction
I begin this essay with two anecdotes.
November 1997 "*¡Qué no me toquen a la Virgen!*" Iliana's earnest brown eyes were brimming as she repreated the phrase, "*¡Qué no me toquen a la Virgen!*" "Don't touch my Virgin!" My former student and friend was settling into a new job in Madrid, and we had reunited during my stay in that city. Freshly arrived from her native Mexico, she was encountering culture shock and was happy to share with a familiar trusted person some of the opprobrium she had been receiving from persons she had approached as fellow Spanish speakers. The Castillians had been teasing her, criticizing her Mexican Spanish and manner, and she was *harta*, fed up. "They laugh at the way I do things, say things; they say I use Indian words, that I don't really speak Spanish." In an

effort to turn the conversation to more familiar, happier themes, I remarked on the upcoming feast of Our Lady of Guadalupe. "How will you celebrate *la fiesta de la Virgin?*" I had visited the shrine at Tepeyac, Mexico City, just that summer with Iliana's father and was still savoring happy memories of my experience. To my surprise, indignation replaced melancholy on my protegée's face. "Do you know what they said? That our Virgin is not the real Guadalupe...that she is just a copy of the Spanish one...that we imitated them...I told them, 'You can criticize anything you want about me, the words I use, how I speak, my customs and manners...but *don't touch my Virgin!*"

Little did I know that one year later I would begin collaborating on this collection of essays on manipulated symbols of the feminine. Little did I know that even as she broke my heart with her pain, Iliana was providing me with a window into, and moving affirmation of the deep association between devotion to a Madonna and identity. Subsequent study and a visit to a second Marian shrine, at Montserrat in Catalonia, Spain, would reveal fascinating connections and resonances from culture to culture.

June 14, 2001 Visiting another friend in Mexico City, we brave the throngs in the *zócalo* who have come for the Corpus Christi celebrations. Inside and out, parents bring their children, carrying straw mules and dressed as "little Indians" to receive a blessing from Christ in the Eucharist. Alongside this folkloric practice, which honors the simple faith of human and beast in the presence of Christ in the Eucharist, the institutional church is staging a public manifestation. The Corpus Christi procession, for many years carried out inside the cathedral building, is leaving the church and making it way around the plaza, stopping at four large altars set up for worship. Loudspeakers carry the voice of the Cardinal as he preaches his Corpus Christi sermon. The worshipers in the procession and the families of the make-believe *inditos* seem oblivious to one another. Observing the scene, Dolores, who has lived in Mexico City over the past 50 years, muses that a church which for many years was suppressed, even outlawed, has now come out into the public light. I wonder at the effect of such validation on the message of the gospel. To me, with my limited experience of Mexico City, the people playing out the drama of the Indians seem more in the spirit of the feast, and I recall the throngs of people at the Basilica of Guadalupe-Tontantzín, seemingly ignoring the celebration of the Eucharist, single-mindedly making their way through the Mass-goers to pay homage to her image enshrined over an altar.

This dichotomy of institutional religion and faith in the popular culture provides a context for the consideration of the Black Madonna

phenomenon. The Black Madonna, her origins, significance, the manipulation of devotion to her by ecclesiastical authority and the implications of all these factors for identity issues among oppressed persons are universal. In this chapter, I will explore these two Marian icons, Our Lady of Montserrat in Catalonia, Spain, and Our Lady of Guadalupe in Tepeyac, Mexico City. Of necessity, I will also study the image and cult of Our Lady of Guadalupe in Cáceres, Spain, as a point of comparison. Basing my reading on the images of Nuestra Señora de Montserrat in Catalonia, Spain and Guadalupe-Tonantzín[1] in Mexico, and of the Spanish Guadalupe to whom she is "related," I will draw out commonalities and differences with an eye to the intrinsic power contained in these dark Virgins, and the particular relationship, in the case of Montserrat and Guadalupe-Tonantzín between devotion to the Madonna, and/or to her shrine and regional and cultural identity.[2] The political resistance practiced at Montserrat which grounds itself in the shelter of the Marian shrine, and the cultural and religious resistance practiced at Tepeyac are distinct from each other. In each case, this essential connection between the Madonna and what she represents and a deep sense of personal, cultural, religious and national identity has further implications not only for a sense of identity and dignity, but also for the intrinsic human rights of oppressed minorities.

How is it that places which since time immemorial have been loci of encounter between human beings and the Feminine Divine empower the marginalized and the poor? We shall see that in spite of the efforts of the social, political and ecclesiastical authorities to undermine, reinterpret or appropriate these encounters—a dynamic which Moss calls "official versus living religion" (69), there endures a relationship between the local faithful and the worship site. James Freeman notes the Mother Goddess' "ties to social classes, castes or identifiable groups within a culture" (xvii). This relationship of the Goddess and subsequently the Madonna with particular groups establishes "religion as a vehicle used by the downtrodden to liberate themselves from human exploitation and want" (Birnbaum xix). Ean Begg articulates this role of the Black Virgin throughout history:

> She has always helped her supplicants to circumvent the rigidities of patriarchal legislation and is traditionally on the side of the physical processes—healing the sick, easing the pangs of childbirth, making the milk flow...Politically, she is in favour of freedom and integrity, the right of peoples, cities, and nations to be inviolate and independent from outside interference. Nowhere is this more evident

than in the history of the Queen of Poland, the Black Madonna of Czestochowa (28).

General History

It is commonly accepted that the sites of devotion to Black Madonnas in Europe are originally sites of goddess worship.[3] Ean Begg cites 450 such sites worldwide, not counting Africa (3). These sites feature black Madonnas "renowned as miracle workers" (Moss and Cappannari 56). The similarity in the legends that surround the founding of these Marian enclaves all involve the miraculous revelation of a hidden image of the Virgin by the Virgin herself, always to a person of the humble classes. Scholars agree that the images reverenced since the 12th century in these churches are not the original images. It is widely held that the original images were representations of a goddess, usually a domestic, kitchen or hearth goddess hidden by its (usually female) owner. This was not to protect it from the oncoming pagans, as the Christian myths would later tell it, but rather to protect it from the Christian priests' zealous destruction. Indeed, original "pilgrimages" may have been visits to the hiding place in an attempt to continue the cult of that goddess. So, the root devotion, the connection with the Divine in these places is with its Feminine manifestation and with a decided place, charged with spiritual energy. It is no coincidence, then, that many Black Madonna legends repeat stories of men's trying to move the image to a more appropriate place. In these legends, the image "refuses" to move, reiterating the essential relationship between cult and place (Moss 69; Begg 54). Even in the Guadalupe-Tonzntzín myth, the Virgin insists that her temple be build at Tepeyac, not in the city: "...make known to him (the bishop) how I very much desire that he build me a home *right here,* that he may erect my temple on the plain" (Elizondo, *Guadalupe* 70).[4]

Today, although both Montserrat and Guadalupe-Tonantzín are enshrined in newer basilicas, the "original" site of their discovery continues to be the object of veneration and pilgrimage. Does this indicate the fidelity of the goddess experienced by the people? Unbroken chains of worship and devotion occur in these places. The images have been manipulated, the legends rewritten, the actual statues or paintings retouched, but the relationship between the faithful and "their Virgin" is unbroken.[5]

The "blackness" of these Madonnas is discussed and analyzed in their founding myths, subsequent histories and in countless attempts at a critical analysis of their phenomena. The essential, "was this image always black?" and, "if yes, then why?" receives diverse answers.[6] It

has been suggested that some originally white Madonnas have been repainted black because of the perception that Black Madonnas are more powerful.[7] Birnbaum observes:

> Black is the color of the earth and the ancient color of regeneration, a matter of perception, imagination, and beliefs often not conscious, a phenomenon suggested in people's continuing to call a Madonna black even after the image has been whitened by the Church (3).

Begg states, "Five minutes in contemplation of her (any Black Madonna) suffice to convince that one is in the presence not of some antique doll, but of a great power, the *mana* of the age-old goddess of life, death and rebirth" (130-10).

Those Madonnas which were originally representations of an Earth mother goddess were most likely fashioned from stone or wood, and are naturally dark, (Begg 130). Others may be black as a result of having been fired in kilns or buried. Moss and Cappannari theorize that the blackness of the Madonna represents her telluric nature. They quote Augustine who determines that Mary is associated with the earth as that from which the Divine Son, Jesus, emerges (65). Many Black Madonnas, replacements for goddess images, are Byzantine in origin. This may reflect an attempt to depict Mary as the black woman in the *Song of Songs*,[8] to emphasize her Semitic heritage, or to imitate the Moorish women encountered by the Crusaders (Birnbaum 121). Begg suggests that Black Madonnas may refer to Mary Magdalene and the Gnostic tradition which celebrates her role in the spreading of the gospel (128-9). Montserrat is reported to be black, *morena* since 718 CE (Moss 58). The explanation that she is black as a result of years of candle soot is rejected by her own historians.[9] The Guadalupe of Extremadura is a Black Madonna.

Black Madonnas associated with Latin America and Africa are more easily interpreted as attempts to identify Mary with the local indigenous population whose conversion is a goal of the Catholic missionaries, or as representations of the Mother of God created by the indigenous population, in its own image (Moss 55). This could explain the image of Guadalupe-Tonantzín, depicted as an indigenous woman. Her darkness is in complete opposition not only to Spanish Virgins— *Nuestra Señora de los Remedios* is the most significant rival—but also to the Spanish themselves.

All of the myths provide an early association of the Madonna image with the apostles. Typically the legend states that the image was crafted (usually by Luke) with the Virgin herself as the model. One of the 12

apostles—Peter, Thomas, James, and so on—carried the image with him as he evangelized. Hence, Peter carried Montserrat to Barcelona where she was hidden in 718 CE during the conquest of the Iberian peninsula by the Moors and then discovered in 880 CE (Moss 58). Nuestra Señora de Guadalupe de Extremadura, carved by Luke, had belong to Gregory, a father of the church (LaFaye 221).

A fascinating application of this formula can be found in the Guadalupe-Tonantizín lore. Prior to Mexican Independence, Father Servando Teresa de Mier actually preached a homily declaring that the image revered in Tepeyac (probably not the image we see today) was first brought to the Mexicans by Thomas the apostle, whom they named Quetzacoatl (Wolf 38; Zires 296). This rewriting of history to the point of reinterpreting Indian cosmology demonstrates the extent to which these legends were manipulated to the institution's purpose.

The site of the discovery of the original image of *Nuestra Señora de Montserrat* was first a temple of Venus (Begg 257). The association of *Nuestra Señora de Montserrat* with fertility most likely originated with this former cult. The legend of Montserrat, which Laplana acknowledges as composed after the fact to explain the "metahistorical sense of history" (15), explains the discovery of an image of "Our Lady" who had been venerated in a church there at Montserrat from early times. The first written record of this cult is from 888 CE. Laplana is reluctant to place an image in the church that early (15). The legend records an apparition of the Virgin to shepherds which led to the image's hiding place. Attempts to move the image failed, as the image became too heavy to budge (16). By 1025, the shrine had become a monastery. There is still no written record of an image; by the 12th century, Laplana acknowledges, lamps were burning in homage before the altar. This may insinuate the presence of an image "as the visible presence of Our Lady must have been the cause behind this practice of offering lamps and candles, a custom that has never since ceased during the history of the site" (19). Miracle stories abound, from the 12th century on. It is interesting to note that these miracles do not occur necessarily at Montserrat. Rather, persons who have prayed to the Virgin are answered (often in a vision) by Mary, who tells them she is the Virgin reverenced at Montserrat. The subsequent pilgrimage is to give thanks for favors received.

The history of Montserrat and the monastic community based in the shrine is replete with exodus and return. Concerned for the safety of the image, the monks fled (taking the statue with them) in the wake of invasion by the French (1908-10), "the liberals" (1882), secularization (1834-44) and the Spanish Civil War (1936-9) (253-9).

Even during periods when the image was absent, history records consistent visits by the faithful to the site. To this day, the most casual of young Catholic couples visit Montserrat after their wedding, to ask the Virgin's blessing on their union, and, traditionally, to ask for children. The monastery has, literally, become the honeymoon capital of Catalonia and the monks have built a hotel to accommodate newlyweds and scores of other visitors.

The Guadalupe image of Extremadura holds much in common with Montserrat and the other European Black Madonnas. The statue was found in 1329 by a cowherd. This statue, "carved by St. Luke, had belonged to St. Gregory, a father of the Church" (LaFaye 221). Just as, later, Guadalupe-Tonantzín would appear to comfort the Indians after their conquest by the Spaniards, so in the Extremadura legend cited in the Codex of 1440, "after the sword of the Moor had passed through almost all of Spain, it pleased God, our Lord, to comfort the Christians so they might regain the courage they had lost. Thus [the apparition of the Virgin] gave them new courage" (LaFaye 219). Miraculous events occurred—the reviving of a dead cow and then of a dead child. Attempts to move the statue failed and by 1389, Alfonso XI had erected a monastery to house it (Callejo 16). Tormo y Monzó notes that prior to the building of the Escorial, the Monastery of Nuestra Señora de Guadalupe was the premiere monastery of Spain. The image venerated in the monastery is from the Romanic period; the Virgin is decidedly black.

The importance of this Black Madonna lies in its relationship to Castilian Catholic identity. Like many others discovered during the Reconquest, the discovery of the Madonna and the establishment of a shrine marks a gain of territory by the Catholics over the Moors and affirms the intrinsic tie between Catholicism and emerging Spanish nationalism. Callejo refers to the shrine as *"un santuario de la Hispanidad"* (156) and the triumphant, militaristic, imperialism it ratified is personified in one of Guadalupe's devotees, the conquistador, Hernán Cortés. The function of this Guadalupe as a symbol of "Hispanic Christianity against the Moors" (Zires 287) was transferred easily, literally carried over by the *Conquistadores* to the New World. Columbus' visiting this shrine is documented (Callejo 92). Perhaps in fulfillment of a promise made there, he named one of his discoveries the island *Guadalupe*. The brothers Pizarro and Hernán Cortés, the conquerors of Peru and Mexico, were known Guadalupe devotees (LaFaye 226). Significantly, Cortés would visit the shrine to Teteo Innan, also known as Toan or Tonantzín, located near Tenochtitlan (Motz 154-5). This shrine to the mother of the maize god and "our

mother" is the location of the Guadalupe apparitions in 1531. Could Cortés have carried not only the pro-Christian, anti-heathen ideology associated with Guadalupe but also an image of his Black Madonna? It seems possible. And there is evidence that the Spaniards, who named their homes and new settlements *Guadalupe*, in honor of the Virgin of Extremadura probably carried replicas of that image and may have imposed that image on the Indians at Tepeyac (LaFaye 233). The irony, of course, is that the New World Guadalupe, from her beginnings as Madonna identifies herself not with the *Conquistador*, but with the conquered.

Because the founding events of the Guadalupe-Tonantzín cult as it known today occurred four hundred years later than most other Black Madonna cults, and because these events are chronicled as part of the Post-Conquest narrative, they provide a modern window into the dynamics of the subjugation of native worship by Christianity. Perhaps a more accurate term is the *attempt* at subjugation, since, as we will see, the worship of the goddess most certainly continued after 1531 until the present day.

The *Nican mopohua*, an early narration of the Guadalupe-Tonantizín event written in Nahuatl, contains the crucial elements of the Marian phase of the cult. In 1531, an Indian on his way to the Catholic church for instruction was distracted by the fragrance of *flowers* and the sound of *music* coming from Tepeyac, a hill sacred to the goddess Tonantzín. *Flor y canto* signifies poetry, or sacred text in Nahuatl; the Indian, Juan Diego, followed these signs and met a Nahua lady who told him that she was the mother of God (Le∴n Portilla 54). The Lady insisted that a temple be built for her on this sacred spot so that the people would have a place to come and tell her their plight, so that she could listen to them. Juan Diego was unsuccessful in convincing the bishop. A second and third encounter between the Virgin and Juan Diego resulted in the miraculous cure of his uncle and the delivering of miraculous flowers to the bishop in Juan Diego's *tilma*, which, opened, revealed the image of Guadalupe-Tonantizín (Elizondo *OL Guadalupe as Cultural Symbol* 5-22).

The text of the *Nican Mopohua* has been analyzed extensively and the Nahuatl cosmology contained therein affirms the connection between Mary/Guadalupe and the Aztec goddess TonantzPn and probably goddesses which predate her. The written text follows 1531, and may be an attempt to codify a devotion very much in force. It is telling that the belief of the typical devotee of Guadalupe-Tonantzín is focused on her presence with the people, and not necessarily on the

event. My friend Dolores recalls that prior to the beatification of Juan Diego, and most recently, prior to his canonization in 2002, many questioned the historicity surrounding his life. The popular response to the polemic was, "It may well be that Juan Diego did not exist. What is certain is that the Virgin appeared to him!" We will discuss the attempts of the early Church in Mexico to suppress the cult. Thus, even within the ecclesiastical context, fidelity to Guadalupe-Tonantzín and to one's identity as her child entails resistance.

Montserrat has been a seat of nationalism for many years. Whether they were resisting the French as Spaniards, the "liberals" as Catholics, or the *Castellanos* as *Catalanes*, her followers were inspired in the defense of identity and her monastery has provided a refuge from the oppressor.

During the French occupation of Spain, the monastery supported the resistance movement:

> For the monks of Montserrat in the first half of the 19th century, it was difficult to remain on the margins of the popular movement, impregnated with patriotism and religious devotion, which opposed the revolutionary ideas coming from France. And when these ideas were realized in the form of the Napoleonic occupation of the national territory, the monastery, like all the other churches was obliged to lend its entire support to the resistance movement, donating to it all its treasures to help pay for the war effort (Laplana 30).

More than one hundred years later, as the Franco government (1939-75) sought to suppress regional autonomy, culture and language, Hank Johnston recorded verbatim an interview with a young Catalan anti-Franco activist in his study, *Tales of Nationalism*:

> ...And then all the things about Montserrat, the Virgin of Montserrat. All this was kept very much alive at home....Then I think that all this symbolism and religiosity involving Montserrat is, let's say, a Catalanist activity. Not on account of ideological conviction in the sense of having a formula of a, like, like, ideology, as a rational belief; but rather a vital attitude, let's say. I think it is through Montserrat, for example, that a Catalanist attitude was kept alive in these, uh, Catholic families (56).

The young man's observations lead Johnston to conclude that the monastery's efforts, grounded both in the privileges accorded the Catholic church by Franco's government and in the centuries-old

relationship between Montserrat and the people of Catalonia, "played a crucial function in maintaining the symbolic assocation of the Catalan church with the opposition" (57). Ironically, the protection provided the monastery by the government provided opportunities for the use of Catalan in liturgy, assembly and publication—all illegal outside of the Church at that time. The mass demonstrations in 1947 and in 1959 against language and culture proscriptions provided an otherwise impossible stage for Catalonia's major writers (57, 126). In 1953, the abbot of Montserrat founded a group of young Catholic leaders called "Christian Catalans" which would be recognized in the history of the anti-Franco movement for its "oppositional tenure" and its "considerable impact on nationalist agitation" (92). The *nova cançó* which "demonstrated the fusion of anti-Francoism and nationalism through the combination of medium and message" originated in 1959 in response to a call for "new songs" which would nourish the vitality of Catalonia. This call was published in a magazine of the Montserrat monastery (Johnston 179).

The "keeping alive" of language, faith and identity in a family-based religious devotion resonates with the observations of the Spanish missionaries in the early days of the Guadalupe-Tonantzín cult. It is difficult to imagine today that the Catholic clergy would object to devotion accorded to Mary. Yet, it is very clear in the early chronicles of the new Mexican Church that the missionaries detected subterfuge! Father Bernardino de Sahagún who would write the history of Mexico in Spanish and Nahuatl, protested the cult in 1556; his sermon is quoted by many historigraphers of the Guadalupe-Tonantzín cult:

> Now that the Church of our Lady of Guadalupe has been built there, they call her Tonantzín, too…The term refers…to that ancient Tonantzín and this state of affairs should be remedied, because the proper name of the Mother of God is not Tonantzín, but Dios and Nantzín. It seems to be a satanic device to mask idolatry…and they come from far away to visit that Tonantzín as much as before, a devotion which is also suspect because there are many churches of our Lady everywhere and they do not go to them; and they come from faraway lands to this Tonantzín as of old (in Wolf 35).

The timeless, deep connection with Guadalupe-Tonantzín experienced on every level by the Mexican people eventually produced an identification with her which easily adapted to an emerging national consciousness. Thus, at moments of division between the Church and State, or on the level of racial distinction, Guadalupe-Tonantzín

transcends all such distinction and belongs to everyone. Her cult is unaffected by policies which outlaw public religious functions or attempt to secularize Mexican public life. Her followers are unimpressed by Madonnas imported from European mainstream Catholicism.

Fray Servando Teresa de Mier's homily in which he attributes the Guadalupe-Tonantzín image to St. Thomas/Quetzacoatl is, Zires explains, an attempt to deprive the Spaniards of any credit for bringing Christianity and Marian devotion to Mexico. Thus, Guadalupe-Tonantzín becomes *"un emblema antihispanista"* (Zires 297). As he led the effort for Independence, Miguel Hidalgo y Castillo employed the Guadalupe-Tonantzín image and its accompanying devotion in 1810 as a banner, to inspire the Revolution armies (Wolf 34; Zires 298). She becomes not only the patroness but actually a "soldier" in the division led by José María Morelos y Pavón in the same war of Independence. Indeed, Mary-Guadalupe was pitted against the Spanish patroness, *Nuestra Señora de los Remedios* (Johnson 194). In the ensuing years, visits to the shrine of Guadalupe-Tonantzín were required political protocol for the arrival of new dignitaries and government figures, to inaugurate political events (Johnson 195). During the revolution, rebels used her image (Wolf 34). Even in the years following the Revolution when the Church was suppressed, religious education outlawed and priests and nuns deprived of citizens' rights, her feast was a national holiday (Johnson 195), and the yearly call of the President, *"¡Viva México! ¡Viva la Revolución"* still ended with *"¡Viva la Virgen de Guadalupe!"* Her untouchable presence united Mexico and the Church even as they were at odds with one another. The continuing practice of her cult reflects the real (lack of) effect of Institutional policy on the lives of the poor.[10] Somehow this image, this devotion is so powerful and so intrinsic to Mexican consciousness that it can be separated from and independent of the Religious Institution which supposedly houses it. This dynamic illustrates the power and the transformative potential contained in the devotion rendered to the Black Madonna, specifically to Guadalupe-Tonantzín.

Guadalupe-Tonantzín offers other interesting oppositions. Clearly her message, intended for the indigenous peoples and channeled through one of their own, could polarize Indians against Spaniards. Wolf states that "the apparition of the Guadalupe to an Indian commoner thus represents on one level the return of Tonantzín" (37). Elizondo notes that this empowering of Juan Diego as the Virgin's delegate creates a clergy/laity dichotomy which "explains the Spanish missionaries' rejection of the cult" (46) and represents "a divine protest

against elitist policies" (47). The most striking opposition is that of the Male/Female representation of Diving Being and Presence. For Moss the Black Madonna mediates the darkness (65). Is this the darkness rejected by the Enlightenment, and embraced now in emerging human consciousness? Is this the vindication of the feminine?

Whereas Montserrat creates identity questions or clarifies or catalyzes identity for her devotees, Guadalupe-Tonantzín polemicizes the identity of God: white or *morena*? Powerful or poor? Conquistador or conquered? Male or female? Even today (see Sandstrom 27) the cult of Tonantzín flourishes among the Nahua lower class. She continues to be the Mother of the poor. Wolf's observation that the revelation of Tepeyac is "a new order of right relationship and place in society for its illegitimate children" (37) can be applied to both Montserrat and Guadalupe-Tonantzín.

Because these Madonnas are revered on previously established worship sites, the gathering of the faithful is a natural occurrence. In some places, due to a cult's syncretic nature (Guadalupe-Tonantzín), at others, because of the language employed in worship (Montserrat), often because of the strong sentiments of local identity attached to the cult or, in general, because of the power present when people gather with a common focus, institutions have tried to suppress devotion to these Black Madonnas. The efforts of an Institution (Rome, France, Spain, Franco) to impose its own order and/or reinterpretation of these worship sites for its own political gain are undermined by the very nature of the Madonna (Birnbaum xix). Furthermore, the attempts of institutional religion, aligned with the predominant political power to undermine the belief system and practice of a minority or subordinate culture are, in Birnbaum's words, "doomed to failure without the economic and social liberation of the followers [of the cult]" (xix). When the Church or a government attempts to undermine a devotion without providing that which the devotion provides—connection, hope, sustenance—the people continue to be faithful to the one who has been faithful to them. As long as the people are deprived, the cult flourishes on its own terms. The power of the Church to sanction is meaningless to them. This empowers the poor or marginalized and threatens the Institution. Franco's attempts to subjugate the use of the Catalan language was canceled out by its use in Church, something his government had approbated.

In *The Cult of the Black Madonna*, Ean Begg articulates the provocative questions about the meaning of these phenomena all over the world:

...But it is strange too that the Black Virgins which have been with us so long and in such great numbers, so often hidden and rediscovered, should now for the first time become widely recognized as a separate category within the iconography of the Virgin in the west. 'We are living,' wrong Jung (*The Undiscovered Self*, pp110ff) 'in what the Greeks called the *Kairos*—the right time—for a "metamorphosis of the gods," i.e., of the fundamental principles of symbols.' If this is the right time, or high time for us to discover the Black Virgin, how can we know what she is trying to say to us? (127).

While the recognition of the Black Madonnas as a "separate category" in Marian devotion may be a recent development, the recognition of these Black Madonnas by their faithful is as ancient as the cults themselves. It seems that the fundamental life force they represent and have made present for centuries can no longer tolerate suppression or dismissal by the structures of power. It would also seem that those individuals who, by virtue of their class, education or personal circumstances have power or influence, and who also appreciate all that the Black Madonna represents are in a unique position to be of help to her less fortunate devotees.

Of course, today one can cite powerful implications of this black, female power-figure for a white male order. The fertility and life force associated first with the Mother Goddess and passed on to the Black Madonna hold a two-edged challenge for a society which increasingly devalues life and for a church which institutionalizes and idolizes celibacy and fixates on sexual issues as sinful.

Birnbaum observes/highlights "women's insistence on their difference suggested in the moral and political difference of black Madonnas from the subordinated and passive white Madonna of the church" (4). Both Montserrat's and Guadalupe-Tonantzín's shrines are considered holy places of intercession for those with no other recourse. This emphasizes the special power attributed to Black Madonnas already cited. Mary Elizabeth Perry notes that in addition to its protective, maternal attributes, the mantle worn by Nuestra Señora de Montserrat also holds a "chausable quality," implying Mary's function as priest (119). In *Guadalupe, Mother of the New Creation*, Elizondo explains,

Our Lady is of the highest nobility, for she is dressed in the blue-green of divinity...her dress is the color of earth and is adorned with various floral arrangements, indicating the flourishing of the new humanity that she will bring about....her face radiates concern and

compassion for all those in need. Her hands offer everything that she is to us (78).

A reading of the Virgin's words to Juan Diego which suspends attribution to Mary, the mother of the Christian's Jesus affirms her autonomy and authority. Juan Diego was on the road to the Catholic Church on the occasion of the first apparition and between the church and his uncle's house during a third encounter with the Virgin. Indeed, on this third occasion, the text reveals that he was trying to avoid the Virgin, hence, he bypassed the site of their encounter. Her questions, "Why do you go there (to the church);" "Am I not your mother? Are you not under my shadow and my protection? Am I not your source of life? Whom else do you need?" imply his rejection of the Tonantzín cult. They are haunting words, protests from a rejected deity, who longs to continue not to rule, but to serve her people. The initial intention for the temple that Guadalupe-Tonantzín requests is that it be a place where she can hear and attend the people's needs, indeed their cause, much like a magistrate. This mirrors the reality that the Church newly imposed on the indigenous was not only neglecting them, but in many cases abusing them. Placed in the mouth of a native, Guadalupe's words are a longing for the old order and/or a cry for justice in the new order. Virgil Elizondo eloquently opposes Guadalupe-Tonantzín's "priesthood" with the Spanish clergy:

> In Spanish temples they (the Indians) were put down by the priests, the living icons of God the Father; in the hermitage of Tepeyac they would be uplifted by the Mother of God. The fathers told the Indians about hell and damnation; the Mother offered protection and comfort. The fathers spoke about the hereafter; she spoke about the here and now. The fathers spoke and the Indians listened; she wanted to listen to all those who cry and suffer in silence. The fathers had many rules and doctrines; the Mother had simple love and compassion (71).

The alliance of Montserrat and those who lived her message at the monastery and of Guadalupe-Tonantzín and those who heard her message with the oppressed and the marginalized offer a dynamic pattern for the empowerment of persons who by virtue of their gender, race, class or lifestyle are relegated to a minority status with a consequent loss of rights. Elizondo's words apply to both cults and to any situation in which position serves the powerful:

> In the (Spanish) temples, the friars perpetuated the superior-inferior relationship that had been established by the conquest and even

argues that it could not be otherwise. In fact they would make this superior-inferior relationship appear to be of divine order and thus established for all eternity. This is definitely not the kind of temple and relationship the Lady is asking for. The type of relationship perpetuated in the Spanish temples and in the centers of power was the counter side of the kingdom of God as lived and proclaimed by Jesus. That is why the Lady wanted her temple built away from the new center of civil-religious power in Mexico City and among the people at Tepeyac (71-2).

This masculine-feminine dichotomy is noted by Johnson, who posits the Virgin as "representing what Plato termed the female éros (the emotional, passionate, metaphysical principle...)" and Jesus as representing: the male lógos (the rational, doctrinal principle)" (193).

For Begg, the Black Virgin represents both personal and Institutional potential. She is "underneath all our conditioning, hidden in the crypt of our being, near the waters of life;" "the dark latency of our own essential nature" (144). Hidden in the "earth" of human marginalized experience, the Black Virgin waits to be discovered once again. When her female energy is released, the poor will evangelize, women will know a new equality and the earth will be renewed.

The syncretic dynamic noted by Moss and Cappannari in virtually every instance of Black Madonna devotion they studied (67) has important implications for this chapter which explores how revisiting these Feminine manifestations of the Divine presence might lead to a transformation of society and of human relationships. The oppositions present in these Madonnas are not polarized, but rather united in their cult. Perry notes that

> as a folk figure, who has been nicknamed and adored through song and dance, the (black) Virgin of Montserrat can represent difference while remaining a part of shared human experience. The style of this statue, with its blending of Eastern Byzantine and Western Iberian influences can teach us the special strength of putting together differences (123).

Although any reference to Catalan nationalism is conspicuously absent from Perry's essay, her references to the union of other cultures in Spanish culture—Christian, Jewish and Muslim—can be applied to the same goal of diversity in community (123-4). Harvey L. Johnson makes a similar observation about Guadalupe-Tonantzín:

> Worship of the Dark Madonna resulted in reconciliation of two opposing worlds—in the fusion of two religions, two traditions, and two cultures. She offers an excellent example of accommodation of Christian practices to deep-rooted Indian beliefs and customs. In a sense, the Catholic Virgin and the Aztec Goddess joined hands at Tepeyac to satisfy the spiritual needs of two conflicting societies from which the Mexican people were to emerge (192-3).

James Freeman attributes this unifying power to the place of "the mother or mother goddess as a central cultural symbol that both contains multiple meanings in different contexts and serves as a unifying symbol for widely divergent elements of a culture" (xvi-xvii).

Far from home, criticized by a superior (her new employer) for being "Indian" in her speech and manner, Iliana grounded her dignity in her sense of herself as the daughter of "my Virgin." Her firmness as she narrated the story to me reminded me of an earlier time when she was describing her family to me and she told me, "I'm *morena* like my mother." The same sense of connectedness, of identity and dignity rooted in one's origins, one's lineage, withstands onslaught by the authoritative "other." Sadly, this anecdote reminds us, that even today, persons are judged by race and speech patterns and that racism, sexism and nationalism continue. We have seen one antidote—faith in a Divine presence which endures and overcomes oppressions small and large-scale.

The overwhelming presence of the loudspeakers in the *zócalo* on Corpus Christi Thursday were in sharp contrast to the desires expressed by Guadalupe-Tonantzín, who desired that a place be built where she might listen to the cares of the people. This loving presence, this Feminine manifestation of the Divine which listens, nurtures, affirms and answers is the model needed for human relationships if they are to be just, compassionate, and inclusive. Ean Begg expresses it well:

> Our ancient, battered, much-loved, little-understood Black Virgins are a still-living archetypal image that lies at the heart of our civilization and has a message for us. The feminine principle is not a theory but real and it has a will of its own which we ignore at our peril. It is an independent principle and cannot be forced against its will to go anywhere or do anything without bringing retribution on the perpetrator. She brings forth, nourishes, protects, heals, receives at death and immortalizes her children who follow the way of nature...As the spirit of light in darkness she comes to break the chains of those who live in the prison of unconsciousness and restore them to their true home. In the trackless forest, she is both the underground magnetism and the intuition that

senses it, pointing the traveler in the right direction. She is, traditionally, the compassionate one (Begg 134).

Notes

[1] For purposes of clarity, the Black Madonna of Extremadura, Spain, will be referred as Guadalupe, and the Virgin of Tepeyac, Mexico, will be referred to as Guadalupe-Tonantzín. This distinction underlines, in the case of the Mexican Madonna, the syncretic nature of the cult and one thesis of this chapter regarding the identity of the Being manifested to Juan Diego.

[2] This chapter will not attempt a re-articulation of the history of the Black Madonna phenomena, nor of the three Marian shrines essential to its focus. Readers interested in general histories may refer to the studies of Ean Begg, Lucia Birnbaum, Lottie Motz and others. Of particular value is James Preston's *Mother Worship. Nigra Sum* and Virgil Elizondo's *Guadalupe* are essential studies of the Montserrat and Guadalupe-Tonantzín cults.

[3] "Differing from white Madonnas, who may be said to embody church doctrine of obedience and patience, and differing in shades of dark, what all black Madonnas have in common is location on or near archaeological evidence of the prechristian woman divinity, and the popular perception that they are black. Elusive, they are frequently removed from religious and political implication by art historians, who call them 'Byzantine,' and by the church hierarchy, which has 'retouched' several of them white" (Birnbaum 3).

[4] The Lady's words are taken from the *Nican Mopohua*, the earliest narrative of the Guadalupe-Tonantzín event. I am using Virgil Elizondo's translation of the text (5-22).

[5] For example, Johnson suggests that songs composed to Nuestra Señora de Guadalupe by Mexicans may be, in fact, ancient hymns to the Corn Goddess (198).

[6] See Moss and Cappannari, "In Search of the Black Virgin: She is Black because She is Black."

[7] Moss and Cappannari quote the Scots catechism of 1552 who assert that Black Madonnas are more powerful suppliants than others (65).

[8] Birnbaum asserts that the Song of Song's erotic quality and the mutuality between its male and female voices links the Black Madonna to physical love and the relationship between the sexes (124-5).

[9] *"La imagen es venerable por su antigüedad; el color moreno de rostro y manos téngalo por obra del que la encarnó; a lo menos es contatante e indubitable que ni el humo de las lámparas que están apartadas más de 30 palmos, ni el incienso la pudieron ennegrecer, como dijo Pons."* Laplana is citing Jaime Villanueva, 1821 (Laplana 29).

[10] Johnson studies the *corridas*, ballads composed in honor of Guadalupe-Tonantzín and observes that "in general....there is total silence with regard to the Church and clergy, an indication of the lack of confidence in or fervor for the institution and its priests (201).

Works Cited

Birnbaum, Lucia Chiavola. *Black Madonnas: Feminism, Religion and Politics in Italy.* Boston: Northeastern U Press, 1993.

Begg, Ean. *The Cult of the Black Madonna.* Boston: Arkana, 1985.

Callejo, Carlos. *El monasterio de Guadalupe.* Madrid: Plus-Ultra, 1958.

Elizondo, Virgil. *Guadalupe, Mother of the New Creation.* NY: Orbis, 1997.

--- "Our Lady of Guadalupe as a Cultural Symbol: 'The Power of the Powerless.'" in Schmidt-Herman and David Power. *Liturgy and Cultural Religious Traditions.* New York: Seabury In other cases, Crusaders found such images buried in the East, and brought them home as Madonnas (Crossroad), 1977: 25-33.

Freeman, James M. Introduction. *Mother Worship.* Preston, xv-xxiv.

Johnson, Harvey L. "The Virgin of Guadalupe in Mexican Culture." *Religion in Latin American Life and Literature.* Lyle C. Brown and William F. Cooper. Waco: Markham Press Fund, Baylor UP, 1980: 190-203.

Johnston, Hank. *Tales of Nationalism: Catalonia, 1939-1979.* New Brunswick: Rutgers U Press, 1991.

Lafaye, Jacques. *Quetzalcoatl and Guadalupe: The Formation of National Consciousness, 1531-1813.* Translated by Benjamin Keen. Chicago: U Chicago, 1974.

Laplana, Josep de C. "La imatge de la Mare de Déu de Montserrat al llarg dels segles" in *Nigra sum: Iconografía de Santa María de Montserrat.* Montserrat: Publicacions de l'Abadia de Montserrat, 1995: 15-39.

Le∴n-Portilla, Miguel. *TonantzPn Guadalupe: Pensamiento n<huatl y mensaje cristiano en el "Nican mopohua."* M9xico: Fondo de Cultura Econ∴mica, 2000.

Moss, Leonard W and Stephen C. Cappannari. "In Quest of the Black Virgin: She is Black Because She is Black." In Preston. 53-72.

Motz, Lottie. *The Faces of the Goddess.* NY: Oxford, 1997.

Perry, Mary Elizabeth. "The Black Madonna of Montserrat." in *Views of Women's Lives in Western Tradition.* Ed. Frances Richardson Keller. Lewiston: Mellen, 1990. 110-28.

Poole, Stafford. *Our Lady of Guadalupe: the origins and sources of a Mexican national symbol, 1531-1797.* Tuscon: U Arizona Press, 1995.

Preston, James. J., ed. *Mother Worship.* Chapel Hill: UNC Press, 1982.

Sandstrom, Alan R. "The Tonantsi Cult of the Eastern Nahua." in Preston. 25-50.

Tormo y Monzó, Elias. *El monasterio de Guadalupe.* Barcelona: Hijos de J. Thomas. [19--].

Wolf, Eric R. "The Virgin of Guadalupe: A Mexican National Symbol." *Journal of American Folklore* 71(1958): 34-39.

Woodman, Marion. *Addiction to Perfection: The Still Unravished Bride.* Toronto: Inner City Books, 1982.

Zires, Margarita. "Los mitos de la Virgen de Guadalupe. Su proceso de construcción y reinterpretación en el México pasado y contemporáneo." *Mexican Studies/Estudios Mexicanos.* 10: (1994): 281-313.

Works Consulted

Behrens, Helen. *The Virgin and the Serpent God*. Mexico: Progreso, 1963

Campbell, Ena. "The Virgen de Guadalupe and the Female Self Image: A Mexican Case History." in Preston, *Mother Worship*. 5-24.

Guerrero, Andrés G. *A Chicano Theology*. NY: Orbis, 1987.

Kurtz, Donald V. "The Virgin of Guadalupe and the Politics of Becoming Human." *Journal of Anthropological Research*. 38:194-209.

Macià, Teresa. "La expansió del culte a la Mare de Déu de Montserrat als segles XVI i XVII." in *Nigra sum: Iconografía de Santa María de Montserrat*. Montserrat: Publicacions de l'Abadia de Montserrat, 1995: 41-48.

Rodríguez, Jeanette. *Our Lady of Guadalupe: Faith and Empowerment among Mexican-American Women*. Austin: U Texas, 1993.

Sicroff, Albert A. "The Jeronymite Monastery of Guadalupe in 14th and 15th Century Spain." in Hornek, M.P. *Collected Studies in Honor of Americo Castro's 80th Year*. Oxford: Lincombe Lodge Research Library, 1965: 397-422.

Siller Acuña, Clodomiro L. *Para comprender el mensaje de María de Guadalupe*. Buenos Aires: Editorial Guadalupe, 1989.

Taylor, William B. "The Virgin of Guadalupe in New Spain: an inquiry into the social history of Marian devotion." *American Ethnologist* 9-33.

Chapter 4

Paler by Comparison: Shadows of Cleopatra in Nineteenth-Century Representations of the New Woman Vampire

Barbara Lonnquist

Noting that of all Shakespeare's major tragedies *Antony and Cleopatra* remains the "least performed," Emry Jones quips, "Few actresses have made their name as Cleopatra." Mrs. Siddons, the "tragic muse" of eighteenth-century theater, immortalized in Sir Joshua Reynold's portrait of that name, "refrained on moral grounds" (Emry 7). And in the nineteenth century, despite England's obsession with the East, and with all things Egyptian, Shakespeare's *Antony and Cleopatra* was far more a reader's play than a play for audiences (Jones 7).[1] One critical explanation has been the play's lack of dramatic structure. Mrs. Siddon's objections not withstanding, the real reason may lie not so much on moral or structural grounds, but on the issue of gender, and specifically, on its fearless representation of a powerful and sexually independent female.

In Virginia Woolf's novel *Between the Acts*, set in 1939 just before England entered World War II, the elderly Lucy Swithin, who seems a throwback to the Victorian past, says to the director of a summer afternoon's country pageant, "But you've made me feel I could have

played...*Cleopatra.*" The director interprets her meaning, "You've stirred in me my *unacted* part" (153 emphasis mine). Wearing a silver cross, Lucy has been taken as the apotheosis of a dying faith in modern England. Her identification with the Egyptian past, and specifically with Cleopatra, who had used public pageantry to present herself as an incarnation of the goddess Isis, has been read as an instance of the archaeological span of history in the novel, in which the structures of the present day are presented as an overlay of an older pre-Christian, past. A more narrowly historicist view of the scene uncovers another layer of meaning in the juxtaposition of Lucy's "cross" with her allusion to Cleopatra. As an image of the almost "religious cult" of the angelic, sacrificial woman in Victorian society, Lucy's cross points to the feminist critique in Woolf's evocation of the powerful Cleopatra. At the same time that Woolf was drafting the novel, she was also in her private memoirs, according to biographer Hermione Lee, setting the Victorian past of her childhood against the present (739). That Woolf was thinking about Cleopatra in connection with women in the nineteenth century is suggested by another coincidence. In 1941, as she was revising the novel, she also wrote an essay about the celebrated Victorian actress, Dame Ellen Terry. The essay is written on the back of a manuscript page from the pageant in the novel (Lee 739). The potential significance of this is suggested by this fact: Cleopatra was one role Ellen Terry never played, or more properly, was denied (as will be discussed below)[2].

Swithin's wistful allusion to Cleopatra as the Victorian woman's "unacted part" is thus a poignant protest about the prohibition of roles to women in what the Victorians referred to as "the public sphere." Unlike the Elizabethans who understood with Shakespeare that "all the world's a stage"--a metaphor also exploited by Cleopatra, who was herself considered a "virtuoso of spectacle" (Pelling 292)--Victorian self-understanding rested on a strict division between the public (male) and the private or domestic (feminine) spheres.

The fate of Cleopatra, "Queen of the Nile" in the 'progress' of British literature from the Elizabethan to the Victorian Era, is also the story of England as it moved between two very different river queens. The public persona of Elizabeth I, presiding on her barge in the Thames, was in some ways evocative of Cleopatra; on the other hand, despite the imperial range of Victoria's reign, during which one of two obelisks, called "Cleopatra's Needles," was installed upon the Thames Embankment, the often reclusive queen, praised more for her "embodiment of feminine values" (Vallone 46), than for her

governance, was in many ways Cleopatra's antithesis.[3] If the maternal and wifely Victoria fulfilled the image of the "angel in the house," the poetic epithet for the sanctifying guardian of the domestic sphere and, by extension, all of England, this ideal was opposed by the dangerous "New Woman" emerging upon the public stage.

By the end of the century, the female vampire would evolve into the central trope for the deviant New Woman. The question that intrigues is why, unlike Shakespeare's fully realized figures of female strength and vitality, nineteenth-century figures of feminine power were gradually deprived a human form. This essay will examine Cleopatra as an historical prototype of the sexually and socially powerful "New Woman" and specifically how the figure of Cleopatra was effaced and literally disembodied in the mythologizing of the feminine as angel or demon in nineteenth-century literature. In Victorian England, Cleopatra became the spectacle that could not be staged, but only transfigured. The legacy of her myth survived, in dismembered or disembodied forms: the hybrid, serpent woman (lamia), the mermaid, and ultimately the pallid vampire are her shadows, and reminders of a more glorious, or at least more human, feminine past.

Beneath the surface of the Victorian myth of progress, with which the British Empire projected to the nation and to the world its sense of economic, military, and moral superiority, lay less acknowledged, nightmarish visions of nineteenth-century decline and decay.[4] In fact, to say that Britain's collective unconscious was host to a myriad of nightmares seems, in the light of recent historicist scholarship, to be an understatement. Not least among the century's frightening specters— French mobs revolting against aristocracy and English Luddites against progress, unsettling theories of biological evolution and racial fears of reverse colonization, to name a few--was the equally threatening figure of a progressive and, by the century's end, increasingly militant "New Woman." Exaggerated images of the "shrieking" New Woman projected the culture's own hysterical fears. Representations in magazines or poster prints of the era tended toward caricature. The advertisement for Sydney Grundy's satirical production, *The New Woman* at the Comedy Theater in London in 1894 --the year the term entered popular usage—quickly became the archetype of the new working woman in the cultural imagination: the respectably tailored, but notably plain and bespectacled "typewriter girl." Only obliquely, in such accessory details as a lighted cigarette in the foreground and the trademark latchkey hanging on the wall, suggesting an independence and freedom previously reserved for men, or in its bold predominance of red, black and yellow, does it hint at the dangers she posed. If

caricature was an attempt to minimize the fearsomeness of this new
social phenomenon, gothic literature's nightmare vision of a
metamorphic, often hybrid, feminine creature, presaging the vampire,
more clearly intimated the powerful threat the New Woman offered to
the Victorian social order, and to its "grandiose exaltations of domestic
womanhood" (*Woman and the Demon* 10), whose sanctifying social
role was equally installed in the cultural imagination by the title of
Coventry Patmore's poem "the Angel in the House." [5]

Although the vampire story in English makes its debut in the first
quarter of the century as a quasi legitimate offshoot of Romantic
poetry, concurrent with, but eclipsed by Mary Shelley's 1818
Frankenstein, female vampires do not openly commandeer the genre
until later in the century. John Polidori's 1819 "The Vampyre" (the
first to bear that title in English) was, with Byron's 1816 "Fragment of
a Novel," composed in response to the "ghost story" contest among
four British exiles in the summer of 1816, the most notable product of
which was Mary Shelley's *Frankenstein*. Both Bryon and Polidori
(who was Byron's physician and traveling companion) featured males
in the role of the life-sucking villain, whose real prey were also men.
Coleridge's shadowy personification of feminine danger in the poem
"Christabel" (1798,1816) is now generally recognized as an early
adumbration of the vampire.[6] Written in the wake of the cataclysmic
French Revolution and Napoleanic Wars, the gothic poem foregrounds
not so much a political but rather a gendered threat to the fortified
sanctuary of the *ancient regime*. The actual nature of Coleridge's
corrupting spirit, the lady Geraldine (her name is an anagram for "dire
angel") who invades the castle of Sir Leoline, remains ultimately a
mystery. The innocent Christabel, whom she mesmerizes, cannot recall
the facts of her nocturnal experience. Even when Geraldine disrobes in
the climactic moment of Part I, the horror we are invited to behold is
verbally effaced by a presumably male parental overseer acting as the
narrative voice:

> Behold! her bosom and half her side—
> A sight to dream of, not to tell
> O shield her! Shield sweet Christabel.

Earlier manuscripts had been more direct; one read "hideous, deformed
and pale of hue." The elimination of description in favor of visual
ellipsis suggests that perhaps it was not only her bosom that was
threatening; the reader soon infers that what is at stake here is a form of
knowledge prohibited to innocent English girls and readers alike.

Following Coleridge, John Keats further populated Romantic poetry with ambiguous, often hybrid, images of the feminine: the serpentine lamia, merciless enchantresses and metaphorical mermaids haunting Keats' poetry reveal an emerging perception of the hidden dangers of an increasingly powerful female in the first quarter of the nineteenth century. Although stage vampires (usually male) were popular from the 1820s, the clearly identified female vampire does not assume a position in fiction in English until 1872, with the publication of the Anglo-Irish Sheridan LeFanu's novella *Carmilla*. A clear descendant of Coleridge's Geraldine, Carmilla, like her predecessor, attacks a similarly motherless, and ostensibly innocent daughter of a powerful English father. What is articulated more explicitly in LeFanu's re-writing of Geraldine is the sexual nature of the power and knowledge with which she corrupts the future "angel in the house." Carmilla's ability in the narrative to confound not only the father, but the new symbol of authority in the nineteenth century, the male physician, amounts to a serious subversion of patriarchy -- and directly influences LeFanu's Anglo-Irish successor to the vampire story, Bram Stoker.

As Lefanu demonstrated, sexual knowledge is only one aspect of the New Woman's threat to British manhood; the other locus of her danger is in the intellect itself, a more potent threat unsettling the very foundation of patriarchal authority. Stoker's *fin de siècle* avatars of the New Woman in *Dracula* (1897), who upstage the eastern-European vampire once the narrative moves to English soil, were both educated for careers. Not surprisingly, thus, by novel's end, Lucy Westenra, the symbol of excessive and aggressive sexual desire (ostensibly the cause of her vampirization by Count Dracula) is firmly dead and Mina Harker, whose powerful, even "manly" intellect is not so easily killed off, appropriately submits to male authority. The conclusion shows Madame Mina Harker, who has just given birth to a son, as a stay at home mother who will employ her typing skills in the service of her husband, transcribing his account of the heroic, male struggle against an invading--and ultimately feminine--evil.

Stoker who was the personal manger for the renowned Sir Henry Irving, actor-manager at the Lyceum Theater in London, is said to have modeled the theatricality of his vampire, with the intention of having Irving play the Count in a stage adaptation of the novel. Stoker's insider's view of "the pomp and pageantry then puffing up" Irving's productions at the Lyceum (Fischler 354) and of the storminess of Irving's off-stage relations, no doubt, contribute to the melodrama of the novel. Critics have not been slow to see in Count Dracula a "sinister caricature" of the powerful and mesmerizing Irving (Belford 270).

Known especially for his protean stage nature, Irving captivated the audience as the consummate villain in such roles as Mephistopheles in Goethe's *Faust*, Iago in *Othello*, Iachimo in *Cymbeline*. Besides such popular stage vampires as the one in the Parisian production of *Le Vampyre*, the real source of Stoker's vampiric métier may have been Irving's Shakespearean performances, which made Shakespeare again the vogue in Victorian London. One thinks of the bloodthirst of a Macbeth or of Irving's striking, almost preternaturally vampiric, Hamlet. Barbara Belford speculates on the effect of Stoker's having witnessed nightly as Irving "intoned that most Draculaen of speeches from *Hamlet*: (258)

> Tis now the very witching time of night
> When churchyards yawn and hell itself breathes out
> Contagion to this world. Now could I drink hot blood.
> And do such bitter business as the day
> Would quake to look on. (III, ii, 388-390)

That Belford also links the "male anxiety over female sexuality" articulated by Shakespeare's and Stoker's heroes (258) underscores the degree to which Victorian fears of the New Woman were also underwriting the vampire theme. What deserves greater attention in the context of *Dracula* is the influence not only of Irving, but of his leading lady and collaborator, Dame Ellen Terry. Stoker's representation of the New Woman in league with the monstrous adheres to standard rhetorical oppositions between angel and demon in the Victorian myth of womanhood; the influence of Ellen Terry's stage life on the novel, moreover points to a simultaneous repression in drama and vampire literature of a fully embodied, truly powerful female.

As a case in point, Terry's 1888 legendary performance of Lady Macbeth--perhaps the most boldly ruthless of Shakespeare's tragic heroines, whose overreaching desire permanently stains her with blood--would seem to offer itself as a clear antecedent for Stoker's female vampire. Ironically, Terry's performance, considered magnificent in her time, expunged the raw power embodied in Shakespeare's "unsexed" queen. By contrast, the "unusual tenderness" with which she rendered the queen as "a devoted wife almost too closely bound up with her husband's ambition" (Ormond and Kilmurray 188) amounted to a recreation of the Victorian "angel in the house," more suggestive of the wifely Victoria than the independent agent of Shakespeare's play. Terry's Lady Macbeth, which conceals the raw power, the masculine energy of Shakespeare's predatory queen, offered the spectacle

Victorian tastes preferred. Despite the review in the *London Morning Post* describing Terry's performance as "so spiritual, so ineffable" that it questioned the presence of Lady Macbeth, feminist Victorian scholar and biographer Nina Auerbach reads in Terry's "tautly feminine" portrayal a "searing commentary on herself in the role of womanly actress" (*Ellen Terry* 259). Auerbach charges the *Post* with "turn[ing] her into a Pre-Raphaelite phantom" (261).

The metaphor of a "Pre-Raphaelite phantom" is instructive, for it points to the relation between the spiritual and the deadly in the Victorian myth of the feminine, a myth promoted in part by the "natural supernaturalism," to adopt Carlyle's phrase, of much Pre-Raphaelite art. Only when spiritualized into a phantom—or even a demon—could the powerful or sexual woman be tolerated, without totally threatening the Victorian social psyche. Such disembodiment, however, just barely masks the intolerable spectacle of the actual female body with its suggestion of unnamable desires. Although fear of female power informs both pictorial and literary representation of the feminine in the nineteenth century, it is in spoken or dramatic enactment that female agency becomes most threatening. (Recall that Coleridge's Geraldine becomes a "*sight* to *dream*" of --i.e. to visualize--*not* to *tell*." Christabel who is turned into a replica of Geraldine, significantly cannot "tell" of her experience. In *Patriarchal Territory, the Body Enclosed*, Peter Stallybrass observes that in traditions which hold "women's bodies as naturally grotesque ... silence, the closed mouth is made a symbol of chastity" (qtd. in Rackin 43). Pre-Raphaelite paintings, which commonly illustrated literary texts, often provide a visual explication of how those texts were understood in their day, revealing the hidden, often sexual significance suppressed by Victorian literary convention. John Everett Millais' painting of Tennyson's pining woman in "Marianna," for example, makes visually present the threat of wasted sexual energy repressed beneath the static verbal landscape of Tennyson's description of feminine passivity.

In its almost PreRaphelite splendor, John Singer Sargent's portrait of "Ellen Terry as Lady Macbeth" (1889), now in the Tate Gallery in London, not only suggests the repressed content in Terry's performance, but points to the suppressed roles in the oeuvre of Terry's career as a whole. Departing from an earlier sketch that placed Terry within the province of Shakespeare's play (the scene in Act II where Macbeth's wife goes out with her retainers to welcome the king to Inverness), Sargent's life-size portrait, of Terry holding the crown aloft, extracts her from the play, and as Richard Ormond and Elaine Kilmurry suggest, the drama of the painting characterizes "the actress rather than

her role"(177)—or to echo Woolf, in her "unacted part." Congratulating Sargent for revealing the "undisguised rage for power within the exemplary wife," Auerbach, reads the boldness of the gesture as a moment of "self-authorization" that stands in counterpoint to the anguish of a tragic muse:

> In Shakespeare's painting, Ellen Terry is neither Shakespeare's queen nor Irving's, for she rises into possession of the unsanctioned, forbidden, powerful self with a boldness she dreamed of but never realized. Sargent, discerning her lust for forbidden roles, painted her into the triumph she could not act, though it encompassed 'all that she mean to be'" (Ellen Terry 263).[7]

Auerbach's further comparison with Napoleon's self-authorizing gesture" suggests perhaps how dangerous Sargent's image was.

In its day, Sargent's painting was as legendary as Terry's performance; one might, in fact, say that it was a performance. This is suggested by Wilde's homage on seeing Terry enroute to his neighbor's studio in Chelsea: "The street that on a wet and dreary morning has vouchsafed the vision of Lady Macbeth, in full regalia, magnificently seated in a four wheeler, can never again be as other streets; it must always be full of wonderful possibilities" (qtd in Ormond and Kilmurray188; Woman and the Demon 209). The triumph of her costume, designed by Alicia Comyn Carr, was an exotic combination of Celtic and Oriental sensuousness: a heather-green wool dress overlaid with red beetles' wings, two gold-plated belts suggestive of armor, and a munificent cape with a Celtic border, (Ormund and Kilmurray 186). That the eastern motif was apparent to contemporary viewers is suggested by Wilde's other wittily appreciative remark that Terry's Lady Macbeth must do "her shopping in Byzantium" (qtd in Ellen Terry 171). The regal intensity of Sargent's portrait, which overrides the domesticated Lady Macbeth of Irving's production, echoes Shakespeare's own enlargement of her role beyond that in Holinshed's Chronicle, the historical source for Shakespeare's *Macbeth*. .

Besides restoring the dramatic energy of Shakespeare's heroine, Sargent's portrait performs a second recuperation. Its subtle tones of Orientalism gesture toward one of the "forbidden roles" to which Auerbach refers above: namely that of Cleopatra, who, like the transgressively "unsexed" Lady Macbeth (whom Terry also did not realize) embodied the forbidden desire to surpass the limitations of her gender.

Although Terry's Lady Macbeth informed Stoker's vision of Lucy Westenra as the nocturnal "Bloofer woman" (the text compares her to Ellen Terry, 258), the role of Cleopatra, denied to Terry, perhaps more clearly explains the threat of the undead in later nineteenth-century vampire stories. Cleopatra was the new woman before the phrase "New Woman" came into being. Unlike the 'murderess' of Macbeth, Cleoaptra has an excess of life. Furthermore, as an already actualized version of what is coming into the realm of possibility, at the turn of the century, she is what the "relentlessly modern" Victorians in Dracula () do not want their daughters to learn ever existed . Thus as march of the new woman comes closer in 1872 and 1897, LeFanu and Stoker dramatize female power as a more and more distant past that threatens to return.

Similarly, in Ellen Terry's career it was an ancient, historically documented, female agency that male directors and playwrights did not want to stage. Despite seemingly "progressive" attempts to raise the respectability of the actress in the public eye--like prostitutes, actresses were called "public women" (*Woman and the Demon* 205)-- Irving, the god-like actor manager did not move beyond convention in the roles he chose for Terry as his leading lady. Known as Irving's "stage bride," Ellen Terry could play the suicidal Ophelia to Irving's dominating Hamlet, the innocent and victimized Desdemona to his villainous Iago, or the supine Imogen to his treacherous Iachimo, but she did not play the powerful equal to Rome's Marc Antony. In the chronological move from an English history play in *Macbeth* to the wider political scope of *Antony and Cleopatra,* Shakespeare expanded his imaginative universe from kingdom to empire. This was an imaginative leap that the emperor of the Lyceum theater could not allow Terry to share. George Bernard Shaw's promise of the role to Ellen Terry (with whom he carried on an epistolary friendship) remained unfulfilled. Even had Shaw kept his promise, the "kittenish adolescence" of Shaw's heroine (Fischler 254) in *Caesar and Cleopatra* (begun at the end of the century and staged in 1906) was, despite the playwright's feminist politics, a far cry from the Amazonian power of Shakespeare's "Egypt." Although the Orient often served as the Victorian variation on the Gothic, it was still the case that the audience that could be fascinated by the vision of a murderous female power "behind the throne" in *Macbeth* had lost, it seems, the Elizabethan ability to conceive the combination of sexual and political power represented by Cleopatra, as "the president" of her "kingdom" (III,vii,18).

Playing with History: "Cliopatricks" and "Regina Meretrix"

Although not the focus of this essay, James Joyce's *Finnegans Wake* provided the genesis of my investigation of the female vampire as one of a host of representations of powerful and allegedly devouring women and, more specifically, of the hidden connection between the nineteenth-century vampire and her more fully realized literary forebear, Cleopatra. In a reference to his own country's devastated history at the hands of two powerful masters (Roman Catholicism and British imperialism) as "the bones of the story bouchal that was ate be *Cliopatrick*" (FW 91), the image of cannibalism insinuates Ireland's physical decimation during the famine (a political as well as natural tragedy) and the more remote ravaging of Celtic culture after the arrival of Patrick in the Fifth Century. The pun on "Cliopatrick" phonetically links Cleopatra, the last of Egypt's Ptolemaic pharaohs also defeated by Rome; Saint Patrick; a former Roman slave; and "Clio" the muse of history in classical Greece. Cleopatra as a devouring, sexual predator, infamous for her seduction of two Roman leaders, Julius Caesar and Marc Antony, is likened by Joyce to the mythical figure of the Celtic "sheela na gig," whose monstrous sexual appetite--like that of Cleopatra and the vampire-- was believed to devour young men ["bouchal" is Gaelic for young boy].

Joyce's explicit recognition of the sexual politics embedded in the Victorian myth of the vampire occurs in his parodic gender transformation of the American Civil War song "Tramp, tramp, tramp the boys are marching" into "*Vamp, vamp, vamp* the girls are merchand" (FW 246, emphasis mine). Here, the approach of the vampire invokes an army of radicalized New Women: the suffragette on the "march" for the vote; the working woman entering the "merchand" or market place; the female shopper exercising her new social and economic independence in urban department stores, as well as her less respectable counterpart in the business of buying and selling, namely the prostitute, the ubiquitous "public woman haunting an increasingly urbanized landscape ["merchand" phonetically invokes "mechant," French, "naughty"]

The history of Cleopatra, whom Shakespeare's Antony affectionately calls "my old serpent of the Nile," is as serpentine as the river she rules; it is her plural nature (as opposed to Antony's essential "oneness") that is her mythic identity. Her designation by the Roman poet Horace as the "fatale monstrum," for example, can mean two things. According to Christopher Pelling, "*monstrum*" as Horace used it, signifies "a 'miraculous portent' as much as a 'monster'; *fatale* is

'sent by destiny' as well as 'death-threatening'"(295). Like all famous rulers, whose stories are written and re-written, this last of Egypt's Ptolemaic pharaohs, has been the mobile subject of history, and perhaps, more than other rulers, as the "regina meretrix," or 'harlot queen,'" she has been the plaything of history. Fluctuating between wondrous and monstrous, as her persona was subjected to the vicissitudes¹ and politics of classical and later European history, Cleopatra embodies both the archetypal seductress of Roman propaganda ("Egypt's whore" and "enemy of Rome") and the powerfully gifted stateswoman and tragic lover venerated in art and drama.

In the rhetorical opposition between Egyptian excess and Roman duty from the earliest Roman propaganda to Shakespeare's play (a dualism re-inscribed in western Orientalist discourse[8] and vampire literature as well), Antony became the seduced victim of a languorous foreign mistress. Horace's early depiction of the Battle of Actium (31 BC) focused on Antony as enthralled by a woman:

> Future generations will not believe it –a Roman soldier
> Bought and sold, bears stakes and arms for a woman…
> (ninth *Epode*)

And although Cleopatra was not yet born in the time represented in Virgil's *Aeneid,* Rome's foundational epic, its composition during the decade following Cleopatra's death, explains the prophetic appearance of her flight from Actium on Aeneas' shield in Book 8. Here she is the "fatal mistress" in "gaudy robes," or the "ill fate" following Antonius who "hoists her silken sails" in flight. Virgil's description of Cleopatra facing defeat foreshadows the pallor of a victim in the grip of an enveloping vampire:

> pale at her coming death, bourne by the waves and wind;
> before her the Nile, all its great length mourning,
> throwing open its folds, calling the conquered host,
> with all its garb, to its dark bosom and hidden streams.
> (*Aeneid* 8:710-713)

As respect for the newly installed emperor, Augustus Caesar, required that he would have defeated "a genuinely more formidable enemy"(Pelling 294), there emerged in Horace's Odes a tragic, but more noble Cleopatra, whose death at her own hands, eclipses the cowardice of her flight from the Battle of Actium:

> She sought to die more nobly; she did not fear
> The sword, woman-like, nor sought to hurry
> her fleet to secret shores; she brought herself
> to view her fallen palace with a tranquil face... (*Odes* 1.37)

And because she is a queen deprived of triumph, Octavian can safely admit, "No humble woman, she."

Not surprisingly Roman propaganda demonized Cleopatra as the foreign mistress and monster of sexual excess (images given to the often eastern figure of the vampire); as the threat she posed decreased during the years of the Pax Romana under Augustus, she sometimes became, as Pelling notes, the object of wit (295)--or one of western patriarchy's greatest toys. Misogynistic jibes at Cleopatra, however, were offset by the Greek historian Plutarch's ethical and balanced portrait in his *Life of Marc Antony,* from which Shakespeare derived his material. As a biographer, interested in the details of human behavior, Plutarch offers a moral scrutiny of 'character' in which praise and blame mix. Cleopatra is at once truly charming and deliberately captivating: "It was when a man was with her that he felt her irresistible hold over him. Her looks combined with her powerful conversation and the charm which surrounded her whole manner. " The positive reference to her "powerful conversation" is in contrast to later gender codes enforcin silence upon the virtuous woman.

At other moments we see her tendency toward the theatrical: "She would make her face light up as he approached and made sure he would glimpse how it dropped and darkened when as he left; she took care that she was often seen weeping..." It is in mourning for Marc Antony, however, that Plutarch's Cleopatra attains nobility.. Although linguistically a bit overblown, her desire to be buried together, feels real:

> Nothing separated us when we were living, but it seems that in death, we may exchange places, you the Roman lying here, I wretched in Italy. That alone will be my share of your land. But if there is any force and power of the gods of hereafter, for those here have betrayed us, do not forsake your wife while she lives... but hide me and bury me here with you. I have ten thousand woes, but none so great and dreadful as these few days I have lived without you.

Here we see the adumbration of Shakespeare's motif of the immeasurable scope of love; for great love, and great lovers, time

contracts; worlds explode. Likewise, despite Roman voices of reason that protest her throughout the drama, Shakespeare's tragic heroine can be neither simply, nor rationally reduced.

Although Shakespeare also represents the standard opposition between things Roman (symbol of western rationality, morality and civic duty) and things Egyptian (symbol of eastern imagination, excess and sensuality), the Elizabethan audience would also have found in his complex moral and political portrayal of Cleopatra, a queen whose "self-sovereignty' in the final act mirrored that of their own monarch (Dash 246).

Shakespeare does, in fact, adapt Plutarch's narrative to Elizabethan experience. Cleopatra's feasts for Antony or her magnificent appearance on the Nile, borrowed almost directly from Plutarch, spoke to the English audience of their own queen as well[9]. Enobarbus's famous description of Cleopatra's barge on the Nile plays equal homage to Elizabeth in its evocation of Elizabeth's own revels on the Thames:

> The barge she [Cleopatra] sat in like a burnished throne,
> Burned on the water. The poop was beaten gold;
> Purple the sails, and so perfumed
> That the winds were lovesick with them. The oars were silver,
> Which to the tune of flutes kept stroke and made
> The water which they beat to follow faster,
> As amorous of their strokes. For her own person,
> It beggared all description ...
> The city cast
> Her people out upon her; and Antony
> Enthroned i'th' market- place did sit alone
> Whistling in the air, which, but for vacancy,
> Had gone to gaze on Cleopatra too,
> And made a gap in nature.
>
> *Antony and Cleopatra* II, 2, 196-203; 218-223

The grandeur and pageantry of Cleopatra's fluvial stage is echoed in the river entertainments held in the time of Elizabeth I, cited in Simon Schama 's *Landscape and Memory*:

> She was 'rowed up and down the river Thames, hundreds of boats and barges rowing around her and thousands of people thronging at the waterside to look at Her Majesty... for the trumpets blew, drums beat, flutes played, guns were discharged, squibs hurled up and down into the air as the Queen moved from place to place'. (Schama 329)

Like the Queen of the Nile, Elizabeth used the river as a political stage to "embrace all of her subjects in a brilliantly calculated triumph of public relations at a time when Elizabeth needed to establish her legitimacy." That it worked is suggested by an Elizabethan chronicler of the revels who concludes that "shewing herself so freely and condescending unto the people, she made herself dear and acceptable to them"(Schama 329).

The Egyptian note in Elizabeth's exploitation of the Thames as a stage is enhanced by the topological coincidence that a tributary of the Thames, joining it near Oxford, is the Isis River. Centuries before Cleopatra had delighted the royalists of upper Egypt by leading their river ceremonial procession, to Isis, where she sat in the sacred vessel itself (Samson 108).

Besides Elizabeth's use of the river for spectacle, her civic visits on land were no doubt present to Shakespeare when, borrowing from Plutarch's description of the Egyptian couple ambling up and down the streets at night in disguise, Shakespeare has Antony say to Cleopatra:

> ... and all alone
> Tonight we'll wander through the streets and note
> The qualities of people. Come, my queen;
> Last night you did desire it. (I, i , 52-55)

British historian, Mary Hill Cole in *The Portable Queen: Elizabeth I and the Politics of Ceremony* describes the "progresses" of Elizabeth as strategic "emblems of her rule," used to consolidate the nation and to further her own political and religious agenda (1-4). Moreover, as Cole demonstrates, the queen's maintenance of the "court on progress" for four decades, (1) allowed her to use "civic visits" to increase her access to the public in cultural forms (local dramas and speeches put on for the queen's visit) that were an elaborate form of "ceremonial dialogue"(9). Cleopatra had likewise used not only visual spectacle but conversation to garner popular support; she was the only one of the Ptolemies to master the language of the people she ruled (Samson 105) and according to Plutarch, she spoke several African and eastern languages beside her native Greek. Cleopatra's use of Egyptian ritual is echoed in Elizabeth's cultivation of a "conversation of ceremony," comprised of gesture, clothing, gifts and speeches, which gave the attending microcosm of society the opportunity, as Cole says, "to speak across the divide of status without challenging the hierarchy" (133).

It is interesting to note that as Elizabeth restricted her travels in the last years of her reign, the problem of creating a consensus among separate, confrontational groups within the nation increased. Although the progresses could not solve all of the problems faced by the last Tudor monarch, the value of this form of public exchange became more obvious in the face of the unrest and violence that accompanied the royal isolation of the Stuart kings who followed in her wake, as conversation turned inward to a chosen few (Cole 11, 134).

The ceremonial vitality shared by the last of the Ptolemies and the last of the Tudors perhaps accounts for the poetry and nostalgia that colors Shakespeare's representation of the pageantry in *Antony and Cleopatra*, written just three or fours years after the death of Elizabeth in 1603. Criticism within the play of the eastern excess of Cleopatra's court usually comes from a representative of Roman duty. The spirit of the play bids us to constantly weigh in a balance the different calls of public and private, of "kingdom" and "mirth." Caesars' warning regarding Antony's absence from Rome, "yet must Antony/ No way excuse his foils, when we do bear/ So great *weight* in his *lightness* (I, 4, 33-35, emphasis mine) mirrors the division within Elizabeth's kingdom regarding her own "absence" from London. Where her hosts supported her travels; her financial ministers often did not (Cole 4). Nevertheless it is not hard to see how the theatrical vitality, that Elizabeth both fostered and personified, would have informed the lost exuberance haunting the play from the start as Shakespeare mingles romance and ethics in his realization of Plutarch's Cleopatra.

Cole, as well as other historians of Elizabethan political ritual, have noted the bold inflection of gender in Elizabeth's efforts to fashion a public image that authorized her as "both king and queen; man and woman"(Cole 10). And despite the cult of Elizabeth as the Virgin Queen and Glorianna of the poets that flourished after the defeat of the Spanish Armada in 1588, the citizens as a whole were not always as comfortable with their monarch's unmarried status as the honorific "Virgin Queen" implied. In fact, some of the local performances put on for her visits turned into barely disguised allegories urging her to marry. Cole describes one pageant in particular as amounting to an extended and impassioned proposal of marriage in which the people's choice for her consort, Robert Dudley, was allegorized as "Deep Desire"(133). Maternal imagery and a quasi-liturgical marriage blessing enhanced one town's appeal for economic aid:

> like as you are a mother to your kingdom, and to the subjects of the same, by justice and motherly care and clemency , so may you, by

God's goodness and justice, be a natural mother, and having blest issue
of your princely body, may live to see your children's children, unto the
third and fourth generation … " (qtd. in Cole 132).

Obviously, the spectacle of the unmarried queen is a source of
anxiety, consonant with the general threat posed by the unmarried
women throughout history and literature.[10] In her study of virginity as
an anomalous position in society, Theodora Jankowski uses Elizabeth I
as an example of the subversive figure of the "resistant virgin." If as
noted above, it is only in mourning that Cleopatra is ennobled, it is also
in mourning that she assumes, in both Plutarch and Shakespeare, the
status of a wife. Greeting her own death in Shakespeare she calls,
"Husband, I come" (V,2,286). Cleopatra's redemption among the
Italians of the Renaissance, however, was not so easily obtained; her
reputation in continental Europe remained firmly that of the Egyptian
harlot. The Roman Catholic Church not only reinforced Octavian's
portrayal of Cleopatra as the enemy of Rome, but, according to art
historian Mary Hamer, "manipulated" this image to serve its own
position on women and sexuality. In the sixteenth century, Pope Julius
II, who liked to represent himself as a second Julius Caesar, erected
what he believed to be a statue of Cleopatra in the Vatican Gardens.
Only later was it correctly identified by the German archaeologist, J.J.
Winckelmann as part of the tradition of the Sleeping Ariadne. The
influence of the sculpture was immense in disseminating an image of
the languorous Cleopatra , echoing the myth of her sleepy gentle death
by an asp (Pelling), and also in conjoining notions of female beauty
and pleasure with death (Hamer 304). As in earlier oral culture the
Church had used art as a form of preaching, the Vatican's generation
of a host of indolent, supine Cleopatras insured that by the time the
statue was correctly identified in 1756, the spectacle of Cleopatra's
erotic languor as a type of the fallen woman, not unlike the figure of
Mary Magdalene in Christian iconography, was fixed in European
culture's visual imagination.[11] It was at this moment in western culture,
when the grandeur of the stateswoman, the Ptolemaic Pharaoh,
respected in her time as a Queen among Kings, "could be described
only as a whore" that, as Mary Hamer claims, "the language of myth as
it spoke of connection and of symmetry between women and men went
underground" (303).

Not only does the integrity of myth as a worthy form of cultural
transmission fall into decline, but also diminished was the spectacle of
an active feminine principle as positive energy, heralding the beginning
of what Bram Dykstra has called the Victorian "cult of the collapsing

woman" (70-79). Given the enervated and, in the case of the "Vatican Cleopatra," the falsified image that replaces the vibrant, complex figure of Shakespeare's Cleopatra, the logical question becomes, what intervened between the Elizabethan Cleopatra and the dangerous apparitions of foreign and sleepily seductive women that replace her in late eighteenth century British writing. One perhaps overly simple, but nevertheless logical answer to the question of her mutation is: Milton's Eve. Although it is not in the spectrum of this paper to investigate the nature or the cultural effects of Milton's primal figure of Eastern seduction)whose inordinate appetite, like that of Cleopatra, brought a male leader to ruin), it can be generally understood that the prone "serpent woman" who replaces the vitality of Cleopatra in the nineteenth-century cultural imagination, owes her reputation for ill in large part to Milton's epic creation.

Another potential cause for this muting and mutation of feminine power within the Romantic circle initiated by Wordsworth's and Coleridge's 1798 "revolution in poetry" was the 1789 political revolution that transpired across the English Channel. The horrors of the French Revolution gave birth to nightmares in the literature and art that followed, and particularly in the genre most poised to pick up the theme of continental horrors—namely, British gothic. The excesses of Roman Catholicism, also allegorized as the Harlot of Rome, was to England since the Reformation what Egypt had been to Rome centuries before. After Edmund Burke's demonization of the French mobs as "monsters" in *Reflections on the French Revolution* (1790)-- the bold response to which was *Vindication of the Rights of Man*" (1791), written by Mary Wollstonecraft (mother of the author of *Frankenstein*), followed by *Vindication of the Rights of Woman* (1792)-- the threat of class uprising was seconded only by the spectre of women rebelling against the patriarchal social order. As Claudia Johnson says of the seemingly apolitical surfaces of Jane Austen's narratives at this time, "no allusions [to *The Rights of Woman*] were necessary to remind audiences that female characterization ... was already a politicized issues in itself " (xxiii). The widespread feeling among conservative thinkers of the 1790s was that domestic security in the home was an important protection against anarchy in the nation (Johnson); political defense against a potential spread of the French Revolution to England necessitated the "angel in the house" more than half a century before Coventry Patmore's poem of that title.

In the fiction of the period, which required women to be "amiably weak" as Johnson expresses it, the woman who championed the rights of women was caricatured as a laughable creature (19) It was gothic

literature, and, a "freakish feminist" especially gothic poetry (poetry was still largely the province of male practitioners) that confronted her threat in the also distorted, but less risible figure of the demon—the dire angel (witch or vampire), the lamia who is both woman and serpent, or the equally hybrid mermaid. And despite convincing feminist readings that have recuperated the power instantiated in these literary projections of male fear, who often manage, nevertheless, to subvert authorial control within the text,[12] it is still the case that the vitality once found in the historical and positive mythological representations of an Elizabeth or Cleopatra has been undone, transformed into a bewitching illusion of feminine beauty or a virtual corpse—the neurasthenic "collapsed woman" or the parasitic undead (vampire). In each of these the "spectacle" of the living woman is evoked, (and even dilated) only to be reduced or effaced into a static or incredible form that the audience can endure – that is, can possibly imagine, but not quite believe.

Shakespeare's heroine actually predicts the future diminishment and distortion of her image; in Act V, referring to the spectacle Rome will make of the conquered queen, she says, "Some squeaking Cleopatra will boy my greatness/I'th'posture of a whore" (V,2,220). The self-referential pun on gender, with a "boy" speaking those lines on stage in Shakespeare's day, would shift to a less amusing allusion with the accent on the end of in the nineteenth century with the audience awareness that the female actress speaking the part was by her very profession put "in the posture of a whore."

What gets buried in the pale, gothic shadows, who inherit Cleopatra's position, is the magnificence and autonomy, the playfulness and the "marble-constan[cy]"of the sovereign figure who emerges (despite defeat) at the end of the play. What survives is the imagery attributed to her by her male detractors in the play: the culinary objectifications of her as both "dish" and devourer forecast the sexually voracious Liliths of the Victorian imagination; her intimacy with the serpent (also the mark of Milton's Eve) and Nilotic slipperiness, a protean ability, according to Roman propaganda, to "change her style to suit her victim," (Pelling 298) later inhabit the shape-shifting lamia, the hybrid mermaids and vampires of nineteenth-century British literature and art.

The mysterious Geraldine, the "dire angel" of Coleridge's two-part narrative poem "Christabel," (begun in 1797 and completed in 1816) has been read variously from the start. Only comparatively recently has the disruptive and predatory figure who gains entrance to the

chamber of the innocent Christabel been identified as a forerunner of the vampire. (The ghost story contest that led to Byron's and Polidori's male vampires in the summer of 1816 was initiated after hearing the poem; in fact, legend claims that Shelly ran from the room in fright after hearing Byron read it aloud at the Villa Diodati.

The medieval castle at midnight, outside which the young Christabel, praying under an old oak tree for the safety of her "betrothed knight" who is "far away" (28-30) hears the moanings of a strange lady bears all the markings of the gothic. True to the code of hospitality, Christabel invites the damsel in distress to "share your couch with me" (122). Christabel's invitation and carrying of the fainting lady across the moat in the moonlight fulfils the requirements of vampire lore, as does the "mastiff bitch" who makes an "angry moan" as Geraldine enters. Once in the bedroom, Geraldine is revived by a cordial of "virtuous powers" (192) made from wild flowers by Christabel's mother who died "the hour [she] was born" (197). As Geraldine prepares for bed, her voice suddenly alters as she addresses an unseen presence" using the language of the witches in *Macbeth*: "Off, wandering Mother, *Peak and pine!*"... "Off, woman, off! this hour is mine" (205,211 emphasis added).

Geraldine, revived by Christabel's administration of comfort and another drink of the virtuous cordial

> Her fair large eyes 'gan glitter bright
> And from the floor whereon she sank,
> The lofty lady stood upright:
> She was most beautiful to see
> Like a lady of a far countree.(221-225)

The allusion to "a far countree" –the stock trade of fairy tale and gothic—takes on the ominous possibility of beyond the grave. The climax of the scene, earlier described in this essay, intensifies the ambiguous origins of the lady. At this point in the point in the poem, the reader strains forward with the curious Christabel, reclining on her elbow to watch as Geraldine unbinds her vestments:

> Her silken robe and inner vest
> Dropped to her feet, and full in view
> Behold her bosom and half her side—
> A sight to dream of, not to tell!
> O shield her, shield sweet Christabel! (250-255)

Hear Coleridge thwarts our desire to know, and the lady warns Christabel that "in the touch of this bosom" (the mark of my shame") there works a "spell" that will prevent her from describing anything but the bare facts of her having found the lady I the forest whom she brought home in charity to "to shield her and shelter her from the damp air" (268-278). The narrative voice concludes part I with the vision of a smiling Christabel slumbering in the lady's arms, "as mother with a child"

> No doubt, she hath a vision sweet
> What if her guardian spirit 'twere,
> What if she knew her mother near?
> But this she knows, in joys and woes,
> The saints will aid, if men will call:
> For the blue sky bends over all!

The equivocal ending of Part I, published in 1798 in Lyrical Ballads, Coleridge's early collaboration with Wordsworth, maintains a dreaminess that is refuted in Part II composed in 1801 and published in revised from in 1816. In the ending described above, the reader is not totally sure of Geraldine's evil. The repeated word "shield" is used in both directions; the poem closes (as it opened) with a series of questions leading one to wonder if Geraldine could in fact be the spirit of the absent mother.

Her more nefarious effect is revealed in Part II, which takes place the following morning. In this section, Geraldine is introduced to Christabel's father "Sir Leoline" who recognizes her as the child of his former friend Sir Roland De Vaux of Tryermaine. Blinded by Gerladine's physical beauty and resemblance to the friend of his youth from whom he parted in anger – a loss he has mourned with the death of his wife. Unable to articulate the source of her anxiety, Christabel's voice dissolves in a hissing sound under Geraldine's narrowed eyes, that only she, not her father sees:

> A snake's small eye blinks dull and shy
> And the lady's eyes they shrunk in her head
> Each shrunk up to a serpent's eye,
> And with somewhat of malice, and more of dread,
> At Christabel she looked askance (583-587).

One possible explanation for the more dire warning in Part II about domestic disruption and danger from foreign outsiders—a warning lost on Sir Leoline's "impercipient eye" (Auerbach, *Our Vampires* 50)—is

Coleridge's move from earlier revolutionary to more conservative politics in the aftermath of the French Revolution. Geraldine's French name "deVaux" is a potential allusion to the fears of French invasion that plagued England at the time. (It also evokes the rebellious "Geraldine League" in Ireland in the sixteenth century who revolted against King Henry VIII.)[13] . Discussing the political significance of the gothic degeneration in the poem's hints of aristocratic endogamy, Andrea Henderson notes the single read leaf at the top of the oak under which Christabel prays is a sign of familial decline (881)[14]. The parasitic mistletoe growing out of the tree (Perry 133), hints, moreover, that the decline will not be rectified by the appearance of Geraldine in answer to Christabel's prayers for her betrothed knight.

The theme of morally dangerous friends explored in Jane Austen's parody of gothic novels in *Northanger Abbey* (1797), is repeated here with the added undertone of erotic seduction. The shadowy threat posed by Geraldine adumbrates the sexually voracious nature of the female vampire found later in the century. Le Fanu's Carmilla, a direct descendant of the spirit troubling the hearth in Coleridge's poem, expresses her possession of the innocent Laura in overt sexual imagery. Unlike Sir Leoline in Coleridge's poem, LeFanu proves himself to have had a more "percipient eye" to use Auerbach's phrase, with regard to the unspecified nature of Geraldine's evil. Where Geraldine had said to the spirit of Christabel's mother or protective spirit: "Off, woman off! This hour is mine," Carmilla claims her victim "with the ardour of a lover... with gloating eyes she drew me to her, and hot lips traveled along my cheek in kisses; and she would whisper , almost in sobs, 'You are mine, you shall be mine, you and I are one forever'"(90). This exaggerated version of the language commonly used in nineteenth-century "romantic friendship" between women (in *Northanger* Abbey, for example, Austen parodies female "romantic friendship" in Catherine Moreland and Isabella Thorp's sentimental tropes) suggests the threat that "sexual knowledge" among women posed to patriarchal rule.[15]

In Lefanu's narrative the eastern identity of the vampiric Carmilla, whose origins are clearly heterosexual, is in direct contrast to the very Englishness of the father and daughter living in Eastern Europe, a contrast that will be further exploited in *Dracula*. LeFanu may have detected the oblique suggestions of the east in connection with Geraldine's origins.

The medieval setting of Christabel's midnight prayer for the "weal of her lover," the betrothed knight who is "far away," is a likely reference to the Crusades, and thus the poem could be seen to invoke

the east from the start. Geraldine's fright at the mention of the Virgin Mary (repeated several times by Christabel and by an anonymous narrative voice beseeching the Virgin to "shield" Christabel suggests Geraldine's pagan origins. Although she has a French surname as the daughter of Roland de Vaux of *Tryer*maine, the place name of the family title bears a phonetic resemblance to the ancient city of Tyre in the East, known for its Tyrian purple dye—a Cleopatran note, associated with falsehood. Shakespeare's drama seems aware that Cleopatra is the last pagan queen before the Ausgustan reign in which Christ was born.

The most Cleopatran note in Coleridge's poem occurs at the climactic moment in Part I, when we see--or more properly, don't see-- the ghastly details of Geraldine's side. Plutarch's account of Cleopatra's death, which does not support artistic visions of the asp nursing gently at her breast, describes her in images that bear comparison with Geraldine; Plutarch's dying Cleopatra is "marvellously disfigured ... her voice was very small and trembling, her eyes sunk into her head... and moreover they might see the most part of her stomach torn asunder" (qtd. in Jones 274). Coleridge's praise for the "feliciter audax," the bold style, of *Antony and Cleopatra* (Jones 46) could also apply to the daring portrait of his own poem, with an important distinction. In both Plutarch and Shakespeare, we are left with the impression that Cleopatra was very real; Coleridge's serpent woman, despite the author's well-known appeal for our "willing suspension of disbelief," leaves us still wondering if such creatures could actually exist. If Geraldine is an evocation of the serpent of the Nile, her amorphous nature pales in comparison with the realized threat and splendor of Shakespeare's Cleopatra.

Keats' lamia figures bear a similar air of unreality. In the poem of that title, the lamia who enchants her victim in "a purple lined palace" is the immortal serpent woman, posing as a mortal. Critic David Perkins early noted the "grotesquerie" of her description

Striped like a zebra, freckled like a pard
Eyed like a peacock, all crimson barred.

as well as the parodic combination of a "head like a serpent" and " a woman's mouth with all it pearls complete" (146). The suggestion of Africa in the leopard and pard (as well as the "purple palace" and "pearls" evoke Cleopatra. One image, in fact, seems a deliberate allusion. In Keats' poem, the lover, Lycius, is like Marc Antony, intoxicated by the vision of the Lamia

his eyes had drunk her beauty up
Leaving no drop I the bewilderin g cup,
And still the cup was full. (I, 251-253)

In Shakespeare's play, Enobarbus describes the intoxicating vision of
Cleopatra's barge in which she "a seeming mermaid steers" and the
ensuing feast she lays for Antony in which Antony "pays his heart/For
what his eyes eat only" (II,2, 232). The lasting power of this vision (as
opposed to the phantasmagoria of the lamia) is endorsed by Enobarbus
who describes Cleopatra's undying humanity:

Age cannot wither her, nor custom stale
Her infinite variety. Other women cloy
The appetites they feed, but she makes hungry
Where most she satisfies; for vilest things
Become themselves in her, that the holy priests
Bless her when she is riggish. (II,2,240-245)

Keats' Lamia, on the other hand, proves pure illusion; a masquerade
with no emergent nobility in the fifth act. In this poem Lamia's illusion
of humanity is revealed to the victim, Lycius, by the austere eye of his
tutor Apollonius. At the end of "La Belle Dame Sans Merci," the
reader also questions the actuality of the sorceress who abandons the
pale knight after introducing him to a foreign, potentially eastern, world
of untranslatable pleasures. She is the ageless "fairy child," whose
victim could well have spoken the ending lines of "Ode to a
Nightingale"—"Was it a vision or a waking dream?/Fled is that music:
Do I wake or sleep?'"

In "The Eve of St. Agnes" where Keats rewrites the fate of
Shakespeare's "star-crossed" young lovers from warring families in
Romeo and Juliet, reality passes for illusion at the end. The structure
and setting of the poem is reminiscent of "Christabel"; we are led in to
another young maiden's chamber and invited to watch with an internal
spectator, here, the lover Porphyro, as the young Madeline prepares for
sleep. In this poem it is the maiden who dreams of her lover (according
to the ritual for St. Agnes Eve). When Porphyro plays "an ancient
ditty" identified as a lost Provençal song, "La Belle Dame Sans Merci,"
Madeline awakens from "the blisses of her dream" to find her lover
standing there, but "How changed thou art, how pallid, chill, and
drear!" Despite the elaborate feast of notably eastern delights set for her
in her chamber by Porphyro ("cinnamon;/Manna and dates... from Fez;

and spiced dainties.../From skilken Samarcand to cedared Lebanon" , a possible echo of the famous feast set for Cleopatra by Marc Antony, which Cleopatra, in turn, outdoes), the lovers do not stop to eat. The sound of a storm "Like Love's alarum" necessitates their exit and "They glide, like phantoms, into the wide hall;/Like phantoms, to the iron porch they glide" beyond a drunken porter who seems a vision straight out of *Macbeth*, they flea into the storm. Although Madeline's acceptance of the diminished, but real Porphyro appears to be a triumph over illusion, the imagery of the lovers "gliding like phantoms" into the haze of a storm undercuts the victory.

So too, one wonders about the virginal innocence of the young maiden, who, despite her protector, St. Agnes, the virgin-martyr known, seems to have dreamed a dream of foreign excess able to outdo the feast of Eastern "dainties" set for her by Porphyro. In her discussion of the mermaid and Medusa imagery in the poem, Mary Arseneau notes the ambiguity of the "alternately saintly and enchanting, inspiring and tempting, passive and powerful" depiction of Madeline (227). Hints of Geraldine's vampirism obtain in Madeline: the taper goes out as she enters the room in moonlight, and, as Arsenau has demonstrated, a number of previously ignored details in the poem associate Madeline "with an array of female demon and enchantress figures such as the mermaid, Medusa, Melusine, Duessa and Keats' own lamia and La Belle Dame sans Merci" (230). Arseneau focuses on the mermaid image in the description of Madeline's disrobing (232). Note again the similarity with Geraldine:

> Of all its wreathed pearls her hair she frees;
> Unclasps her warmed jewels one by one;
> Loosens her fragrant bodice; by degrees
> Her rich attire creeps rustling to her knees
> Half-hidden like a mermaid in sea-weed
> Pensive awhile, she dreams awake... (227-232)

The sea-weed in which she stands, *mermaid-like* in thought suggests a dangerous hybridity, a taint of some lower form of existence; moreover its placement in her waking dream suggests this "half-hidden," already erotic, and predatory nature is the reality that precedes and perhaps produces the "the blisses" of her sleeping dream. The legendary mermaid, known to devour men, is certainly an echo of Cleopatra's mesmerizing power, as cited above; moreover, the name of Keats' maiden, cognate in French, with Magdalen, is another version of the powerful and fallen woman.

The similarity between Cleopatra and Magdalen in much European art further links Keats' Madeline with the pagan figure hidden in Christian representations of Mary Magdalen, a gesture in keeping with the general tendency in European Christendom to replace "pagan" icons with Christian identities. Both figures have suffered the manipulation of their images into mythic constructions that serve the political vision of a reigning Roman power. It is the "pentitent," not the "prophetic" Magdalen who survives as the symbol of the fallen woman[16]. Exploited by social reformers in nineteenth-century Britain, many of who were also literary figures (Charles Dickens and Christina Rossetti were known for their work among prostitutes in reformatory "Magdalen" houses), the image of penitent Magdalen, unlike the unrepenting Cleopatra, was safer for symbolic representation. The chain of association uniting Eve, Cleopatra, Magdalen, lamia and vampire are hidden in Keats' ambiguous mermaid —just as the title of his poem, "The Eve of St. Agnes" produces an oxymoronic identification between fallen Eve and virtuous Agnes.

Killing- off Cleopatra: Vampires and New Women Vixens

If in Coleridge and Keats, Cleopatra is a hidden suggestion, her undying power in the form of the vampiric undead is finally killed off in *the* vampire story that closes the century--and tolls the end of the Victorian Era. Carmilla might share Cleopatra's unquenchable life, but Stoker's New Women, despite the camp associated with his cinematic offspring, are a far cry from a rich Cleopatran past. Embodied female power appears only twice in the novel: in Jonathan Harker's brief glimpse of a past world, after leaving western Europe, in the castle of Count Dracula and in the grave where the undead Lucy Westenra is finally extinguished with a stake in her heart. The "thrilling and repulsive" vision of the three vixens Harker meets in the hidden regions of Dracula's castle seem more like Macbeth's weird sisters with a heavily theatrical overlay of bestial sexuality: "All three had brilliant white teeth, that shone like pearls against the ruby of their voluptuous lips"(51). As one among them advances, Jonathan notes,

> The fair girl went on her knees and bent over me, fairly gloating. There was a deliberate voluptuousness which was both thrilling and repulsive, and as she arched her neck she actually licked her lips like an animal, till I could see in the moonlight the moisture shining on her scarlet lips and on the red tongue as it lapped the white sharp teeth "(52).

Jonathan's anxiety, lest Mina should read this scene in his journal
stems partly from a fear that his own desire, "an agony of delightful
anticipation" (52) be revealed. It also squares with Victorian fears that
women would read about or otherwise discover their own sexual
potentiality.

When after this scene, the reader meets Lucy and Mina through
their own journals and epistolary communications, they strike the
reader as relative ingénues and readers of a new genre of women's
magazines. They seem to whisper such confidences as Lucy's letter to
Mina describing the difficulty of being proposed to by three men in one
day: "I know, Mina, you will think me a horrid flirt—though I couldn't
help feeling a sort of exultation..."(80) and "Why can't they let a girl
marry three men, or as many as want her, and save all this trouble? But
this is heresy, and I must not say it" (81). Mina too, describing in her
journal a "capital tea" with Lucy in Whitby (the site of Dracula's
arrival in England), evokes magazine fiction: " I think we should have
shocked the 'New Woman' with our appetites. Men are more tolerant,
bless them! Then we walked home with some, or rather many,
stoppages to rest and with our hearts full of a constant dread of wild
bulls" (121).

What was actually being reported in the newspapers in the 1890s,
however, were reports on prostitution and crime. Thus the undead Lucy
in her nocturnal attacks on children, is serialized in news reports of the
"bloofer lady," as described by the children who witness her. In the
text, the *Westminster Gazette* reports on:

> "tiny tots pretending to be the 'bloofer lady," moralizing that "Some of
> our caricaturists might ...take a lesson in the irony of grotesque...
> [from these] *al fresco* performances. Our correspondent naively says
> that even Ellen Terry could not be so winningly attractive as some of
> these grubby faced little children pretend. (242)

Here the text imitates its own Victorian melodrama as it simultaneously
exaggerates and airbrushes the reality of the threat it perceives. Only
behind curtains and in the airtight privacy of the grave does the
voluptuous potential of Lucy emerge. Given that Mina is redeemed
and the wound on her forehead—the mark of her intellectual link with
the New Woman and with Dracula—is erased, it is in Lucy's grave that
the novel performs the death of a dangerously Cleopatran
voluptuousness. Here we see "Lucy Westenra, but yet how
changed"(288) in a caricature of a pathologically hysterical, even
orgasmic sexuality:

The Thing in the coffin writhed; and a hideous blood curdling screech came from the opened red lips. The body shook and quivered and twisted in wild contortions; the sharp white teeth camped together until the lips were cut and the mouth was smeared with a crimson foam. But Arthur never faltered. He looked like a figure of Thor as his untrembling arm rose and fell, driving deeper and deeper, the mercy-bearing stake...(295).

Both LeFanu's and Stoker's narratives are contemporary with early "case studies" about hysterical and sexually deviant women. One might also remember that the Ellen Terry, who performed in the stage version of *Dracula* at the Lyceum when Irving refused to participate, was the very actress denied the role of Shakespeare's Cleopatra. As Emry Jones explains, most heroic actors did not want to die as Antony in Act IV only to be upstaged by the Cleopatra who emerges as the protagonist in Act V (31). Symbolically, the staking of Lucy could be said to represent the century long attempt to hide or kill the Cleopatra that Enobarbus prophesied "age cannot wither." Lucy, in her post-vampiric death of course, resumes her "unequalled sweetness and purity" (296). Stoker's novel crowns the age of Queen Victoria who spent many of her last years, unlike Elizabeth I, in retirement, as the very vision of the good wife mourning the death of her husband.

The fear of female power in the artistic productions of the nineteenth century can be seen in the repression of the self-crowned sovereign who reigns in death in the final scene of Shakespeare's play. The sense of agency and "marble constancy" of Shakespeare's heroine would be totally effaced in George Bernard Shaw's Cleopatra, (composed contemporaneously with *Dracula* but not produced until 1906). Shaw's return to the less dangerous, adolescent figure who enchanted Julius Caesar in, what Shakespeare's heroine called, her "salad days" crowns the century-long repression of the powerful female in the literary imagination.

Like the historical Cleopatra, whose myth and reality are currently under investigation in the fields of art history and cultural anthropology, the lost Cleopatra in the literary history of the nineteenth-century calls for further critical analysis to fill in some of the gaps in that historical chain and also to pose the underlying question of why "real" or "strong" women have been and, I would argue, continue to be a frightening spectacle for the descendants of Roman culture.

Notes

[1] This obsession with the East can be seen in the surge of travel, the race to discover the source of the Nile, and the inclusion of Oriental Studies in the university.

[2] Woolf's piece on Ellen Terry was published in *The New Statesman &Nation*, February 8, 1941.The following month in her review of a biography of Hester Thrale (a friend of Samuel Johnson) Woolf's praise of her "prodigious appetite for life" evokes a standard trope in descriptions of Cleopatra. This was Woolf's last published work (March 8, 1941) a fortnight before her death.

[3] For the difficult transport of the Alexandrian obelisk to England, see Simon Schama *Landscape and Memory* (376-378). The arrival of Cleopatra's Needle in 1878, closely followed the crowning of Victoria as Empress of India in 1876. Current revisionist history has reopened the debate regarding the myth of Victoria as the reclusive domestic figure, leaning on her husband or mourning over his death. See Lynne Vallone, "Victoria Queen of Britain"; for a comparison of Victoria and Elizabeth see Nicola Watson "Glorianna Victorianna."

[4] Glennis Byron ("Gothic in the 1890s") describes late Victorian England as "all too aware of the dark side of progress, all too aware as Nordeau declared, night was drawing on" (133).

[5] For discussions of the vampire as a trope for the New Woman, see Linda Dowling "The Decadent and the New Woman in the 1890s"; also Carl Beckson's *Cultural History of London in the 1890s*. In Chapter six, Beckson explains how vampiric imagery was attributed to the suffragist activities of the New Woman (129-159).

[6] See James Twitchell, *The Living Dead: A Study of the Vampire in Romantic Literature*.(Durham: Duke UP, 1981, pp40-50); Edward Strickland. "Metamorphoses of the Muse in Romantic Poesis: *Christabe.l*"*ELH* 44(1977):641-658.

[7] The last words here, in double quotations are from Terry herself .

[8] Edward Said's seminal work *Orientalism* (1978)introduced the idea of the East as a discourse in the mouth of the west. Said explores this rhetorical pattern in what he calls the "imaginative geography" written in the west.

[9] Keith Rinehart's "Shakespeare's Cleopatra and England's Elizabeth I" present a number of similarities between the two monarchs. Among them: their political use of the marriage game for foreign diplomacy, important sea battles during their rule, and their personal jealousy about female rivals. Rinehart compares the comic

scene where Shakespeare's Cleopatra questions the messenger about the "appearance" of Antony's new wife Octavia in Act III, 3, with Elizabeth's quizzing of the ambassador from Mary Queen of Scots in the same way.

[10] Theodora Jankowksi, in *Pure Resistance,* presents Elizabeth as the example par excellence of the "resistant virgin" whose unmarried status is clearly a subversive force in society.

[11] Copies of the Vatican Cleopatra reached even the new world; Thomas Jefferson installed a replica of the sculpture in his home at Monticello. See Hamer (308).

[12] Nina Auerbach in *Woman and the Demon* argues for the subversive power of such figures despite the authorial intentions to demonize women. She claims furthermore that this irony is central to the feminine figures in Sandra Gilbert and Susan Gubar's seminal feminist analysis of the figure of the "Madwoman in the Attic" in nineteenth-century British literature (12).

[13] The ineffectual rebellion led by Sir Thomas Fitzgerald ("Silken Thomas"), the Earl of Kildare, has been called a "quixotic revolt." See Don Gifford's *Ulysses Annotated: Notes for James Joyce's 'Ulysses.'* Berkley: U of California P, 1989, p59). This would echo Coleridge's later feeling about the more tragic French Revolution.

[14] Henderson suggests that Geraldine, in contrast to the "isolation and decay" of Sir Leoline's castle, symbolic of the "rapidly collapsing order" he represents, is "possessed of a kind of revolutionary energy" (882-883).

[15] In her study of "romantic friendship" between women, Lillian Faderman observes that the phenomenon was not perceived as a threat until it was associated with the political unionization of women—most notably in the suffragette movement (236).

[16] See Susan Haskins study *Mary Magdalen: Metaphor and Myth.* Haskins analysis of the manipulation of the image of the Magdalen mirrors Mary Hamer's analysis of Cleopatra's reputation. Haskins notes the Pre-Raphaelite paintings that evoke Mary Magdalen (325). Although I am not concentrating here on the PreRaphaelite movement within the Nineteenth century, such famous works as Dante Gabriel Rossetti's larger than life portrait of the lamia in "Lilith" (accompanied by his sonnet "Body's Beauty") epitomizes nineteenth-century ambivalence toward the sexual new woman. The "voluptuous self-applause" (Bullen) of the figure as she regards herself in the mirror gestures toward Cleopatra. Her flaming red hair recalls John Singer Sargent's response to Ellen Terry as Lady Macbeth. On seeing the

100 *Balancing the Scales*

play, Sargent was, like the male in Rossetti's poem, equally enthralled by her "magenta" hair.)See Ormond and Kilmurray 188). For a complete study of PreRaphaelite representation of the sexual threat embodied in the female body see J.B. Bullen's *The PreRaphaelite Body*.

Works Cited

Arseneau, Mary. "Madeline, Mermaids, and Medusas in 'The Eve of St. Agnes'." *Papers on Language and Literature* 33(1997):227-243.

Auerbach, Nina. *Ellen Terry: Player in Her Time*. New York: Norton, 1987.

---. *Our Vampires, Ourselves*. Chicago:Uof Chicago P, 1995. .

---. *Woman and the Demon: The Life of a Victorian Myth*. Cambridge, Mass: Harvard UP, 1982.

Belford, Barbara. *Bram Stoker and the Man Who Was Dracula: A Biography of the Author of Dracula*. Cambridge: DeCappo, 1996.

Beckson, Carl. *London in the 1890s: A Cultural History*. New York: Norton, 1992.

Bullen. J.B. *The PreRaphaelite Body*. Oxford: Clarendon (Oxford UP), 1998.

Byron, Glennis. "Gothic in the 1890s." *A Companion to the Gothic*. Ed. David Punter. London: Blackwell, 2001.

Cole, Mary Hill. *The Portable Queen: Elizabeth I and the Politics of Ceremony*. Amherst: U of Massachusetts P, 1999.

Coleridge, Samuel Taylor. *The Complete Poems*. Ed. William Keach. London: Penguin, 1997.

Dash, Irene, G. *Wooing, Wedding and power: Women in Shakespeare's Plays*. New York: Columbia UP, 1981.

Dijkstra, Bram. *Idols of Perversity: Fantasies of Femiine Evil in Fin-de-Siecle Culture*. New York: Oxford UP, 1986.

Dowling,Linda. "The Decadent and the New Woman in the 1890s." *Nineteenth-Century Fiction* 33 (1979): 435-453.

Faderman, Lillian. *Surpassing the Love of Men: Romantic Friendship and Love Between Women from the Renaissance to the Present*. New York: William Morrow, 1981.

Fischler, Alan. "Drama." *A Companion to Victorian Literature and Culture*. Ed. Herbert F. Tucker. London: Blackwell, 1999.

Hamer, Mary. "The Myth of Cleopatra Since the Renaissance." *Cleopatra of Egypt: from History to Myth*. Ed. Susan Walker and Peter Higgs. Princeton: Princeton UP, 2001.

Haskins, Susan. *Mary Magdalen: Mythand Metaphor*. New York: Riverhead, 1993.

Henderson, Andrea. "Revolution, Repsone, and Christabel." *ELH* 57(1990)881-900.

Jankowski, Theodora. *Pure Resistance: Queer Virginity in Early Modern English Drama*. Philadelphia: U of Pennsylvania P, 2000.

Johnson, Claudia. *Jane Austen: Women ,Politics, and the Novel*. Chicago and London: U of Chicago P, 1988.

Jones, Emrys. Introduction. *Antony and Cleopatra*. By William Shakespeare. London: Penguin, 1977.

Keats, John. *The Complete Poems*. Third Edition Ed. John Barnard. London: Penguin, 1988.

Lee, Hermione. *Virginia Woolf*. London: Chatto and Windus, 1996.

Balancing the Scales

LeFanu, Sheridan. "Carmilla." *The Penguin Book of Vampire Stories*. Ed. Alan Ryan. New York: Penguin, 1987.

Ormond, Richard and Elaine Kilmurray. *John Singer Sargent: The Early Portraits*. New Haven: Yale UP, 1998.

Pelling, Christopher. "Anything Truth Can Do We Can Do Better." *Cleopatra of Egypt: From History to Myth*. Ed. Susan Walker and Peter Higgs. Princeton: Princeton UP, 2001.

Perkins, David. "Lamia." *Keats: A Collection of Critical Essays*. Ed. Walter Jackson Bate. Englewood Cliffs, New Jersey: Prentice Hall, 1964.

Rackin, Phyllis. "Misogyny Is Everywhere." *A Feminist Companion to Shakespeare*. Ed. Dympna Callahan. London: Blackwell, 2000.

Rinehart, Keith. "Shakespeare's Cleopatra and England's Elizabeth." *Shakespeare Quarterly* 25(1972):81-86.

Samson, Julia. *Nefertiti and Cleopatra: Queen-Monarchs of Ancient Egypt*. London: Rubicon Press, 1990.

Schama, Simon. *Landscape and Memory*. New York: Knopf, 1995.

Shakespeare, William. *Antony and Cleopatra*. Ed. Emrys Jones. London: Penguin, 1977.

Stoker, Bram. *Dracula* (1897) London: Penguin, Puffin Classics, 1994.

Vallone, Lynne. "Victoria." *History Today* 52(2002): 46-53.

Watson. Nicola, J. "Glorianna, Victorianna: Victoria and the Cultural Memory of Elizabeth I." *Remaking Queen Victoria*. Ed Margaret Homans and Adrienne Munich, Cambridge: Cambridge UP, 1997.

Chapter 5

The Return of the Goddess

Nancy Porter

Mythological images appeared when humans first begin to flourish, long before written history. It has been argued very effectively, that myths are of tremendous fundamental importance in human history, emerging in all cultures as the precursors of the deep beliefs and structures of society. Joseph Campbell sees myth as "the invisible plane which supports the visible one." [1] He explains further:

> Throughout the inhabited world, in all times and under every circumstance, the myths of man have flourished; and they have been the living inspiration of whatever else may have appeared out of the activities of the human body and mind. It would not be too much to say that myth is the secret opening through which the inexhaustible energies of the cosmos pour into human cultural manifestation. Religions, philosophies, arts, the social forms of primitive and historic man, prime discoveries in science and technology, the very dreams that blister sleep, boil up from the basic, magic ring of myth. [2]

Myths serve several important purposes. The first function is a mystical function, reflecting on the wonder of the universe, on its creations and on the mystery that underlies all forms. Second is a

cosmological function, hinting at the shape of the universe, but from an "unscientific" perspective, allowing for the mystery to come through. Third is a sociological function, confirming the social order to which it pertains. Finally, myths serve to teach how one can live a sensible human life. [3]

Early mythic images of the female are powerful reflections of nature. Representations of the female emerge as goddesses of the earth, the creators and sustainers of life. Representations of the "Divine Mother" or the "Sacred Feminine" transcend separate religions and societies and emerge as distinctive images in cultures around the world. The female's ability to produce and nurture life mirrors the earth's ability to sustain and nourish human groups and this "magic" was venerated by early cultures and has continued through the various stages of human history; it persists today although in a transformed and often distorted or subordinated fashion.

A Brief History of the Goddess

Figures of the goddess date back to almost 25,000 years ago. The first figures such as the Goddess of Lespugue discovered in the Pyrenees, as well as other goddess figures of a similar era found in Italy, Austria, France, Central Russia and other areas have similar characteristics. These figures are fertility figures with large breasts, bellies, and hips, and in a number of these figures there is similar emphasis on the buttocks and genitals with clear sexual connotation, portraying the woman as both the initiator and the producer of ongoing life. [4] Early Celtic images of women goddesses with exaggerated genitalia and suggestive posturing were generally placed high on churches or the exterior walls of buildings perhaps to provide protection against evil or an enemy attack.

The sexual image positions the female in a metaphorical role as a vessel of wisdom to whom young men go to prostitute themselves in order to gain knowledge and power. In Celtic myth, this figure known as Sheela-na-gig is an initiatress who allows penetration into the cave of knowledge and who presides at the second birth or rebirth, by absorbing the "dead and gone" into her divine womb in order to transmit to them heat and eternal life. The Goddess gives life, and also death, as well as regeneration.[5] Many of the early goddess figures have no feet, suggesting that they were stuck in the earth, as if emerging from it. [6] This imagery is of the Earth Goddess, woman representing nature. This grounded, dark image of woman representing the natural world is a persistent one and is often in contrast to the mythical images

of the male who is symbolized by day, by light, by rationality and who represents the physical or observable world.

Many of these early goddess figures, although they have exaggerated physical features suggesting maternity and sexuality, have little or no definition given their faces. It is paradoxical to consider the goddess of the beginning who has genitals but no face. Celtic scholar, Jean Markale, suggests that perhaps these sculptures and engravings are "symbols of femininity, anonymous and universal, a symbolic form of the ineffable divine." [7]

Joseph Campbell holds that the Goddess is the dominant mythic form of the agricultural world of ancient Mesopotamia and the Egyptian Nile and in earlier planting cultures. According to Campbell, very few European Neolithic images of the male figure have been found, compared with hundreds of images of the Goddess. There were bulls and other animals that could have represented man, but the Goddess seems the only visualized divinity of that time. "And when you have a Goddess as the creator, it's her own body that is the universe. She is identical with the universe . . .she is the whole sphere of the life enclosing heavens." [8]

As deity, the goddess reigned supreme in most prehistoric cultures. Her sacred presence seemed to reflect the people's veneration for nature and the reproduction of life in all forms on the earth that early peoples sensed and expressed. Her cult involved a minimum of dogma and relied on oral myths and stories that were passed down in the various human groups. The goddess figure appears in cultures all over the civilized world, most of whom had no contact with each other. Images of the sacred feminine emerged for thousands of years across the world suggesting some sort of psychic sameness in the developing human race.

What could be the source of these early powerful images of woman as goddess, as the earth, as the universe? Freud, Jung, Campbell and others suggest that this and other powerful mythic images emanated from the unconscious mind. As the primary investigator and philosopher of levels of consciousness, Freud asserted that the unconscious had a vast influence on human beliefs and behaviors, as it was a shadowy storage place of repressed and forgotten experience. Jung expanded this notion of a personal unconscious to include in addition, a collective unconscious.

> While the personal unconscious is made up essentially of contents which have at one time been conscious but which have disappeared from consciousness through having been forgotten or repressed, the

contents of the collective unconscious have never been in consciousness, and therefore have never been individually acquired, but owe their existence exclusively to heredity. Whereas the personal unconscious consists for the most part of *complexes*, the content of the collective unconscious is made up essentially of *archetypes*. [9]

Archetypes, roots of human mythmaking, are defined in psychology as universal, symbolic images that appear in myths, art, dreams and other expressions of the collective unconscious. [10] Jung makes it clear that they cannot be defined concretely, by their content, but rather by their form and even then only to a limited degree. He gives, as example, the image of the axial system of a crystal as representing the archetype. The axial system:

"preforms the crystalline structure in the mother liquid, although it has no material existence of its own. This first appears according to the specific way in which the ions and molecules aggregate . . . the axial system determines only the stereometric structure but not the concrete form of the individual crystal. The only thing that remains constant is the axial system, or rather, the invariable geometric proportions underlying it. The same is true of the archetype. In principle, it can be named and has an invariable nucleus of meaning but always only in principle, never as regards its concrete manifestation." [11]

There are a number of archetypes that Jung contends are born with the psyche and reside in the collective unconscious through life. Being born male would bring with it certain a priori tendencies of "maleness" that are counterbalanced by the anima archetype in the unconscious. This counterbalance reflects historically, the "divine syzygies" or opposites that are seen in various traditions including Gnosticism and the Chinese philosophy where the concepts are designated Yang (masculine) and Yin (feminine). [12] These figures are archetypal, that is able to take on a variety of forms associated with masculinity or femininity. Yang is associated with "day, light, sunshine, fire, heat, the sun, intellect, activity, dynamism and the observable physical world". Yin is associated with "night, dark, rain, water, cold, the moon, intuition, passivity, static ness, and the psychological world." In Chinese philosophy, when Yin reaches its climax, it recedes in favor of Yang, and after Yang reaches its climax, it recedes in favor of Yin. [13] In the Yin/Yang symbolism, the forms are interlocking and the dots inside the white and black halves symbolize that within each is the seed of the other. They are interdependent and complementary and cannot

exist without the other. The ultimate symbolism of the pairs of opposites is a state of balance determined by their dynamic interaction. So it is with male and female elements within the psyche, according to Jung.

In a man, that which could be identified as "not-I" is considered the anima-image, for Jung the "*a priori* element in his moods, reactions, impulses and whatever else is spontaneous in psychic life" [14] Yang implies that intellectual clarity and rationalism are associated with the masculine and thus the feminine takes on the cloak of the mysterious: that which is from nature, which represents instinct and inspiration. "Everything she touches becomes numinous-unconditional, dangerous, taboo, magical. She is the serpent in the paradise of the harmless man with good resolutions and still better intentions." [15] That which is female, then, becomes subject to many mythological and religious forms. She may appear as goddess or witch as she embodies the not-male which is largely natural, emotional, and sometimes irrational.

The anima exists unconsciously in man, and seems "outside" his psychic power and so is seen by him in the form of projections. The son's first projection of the anima is the powerful image of the mother. As the boy grows up and his contact with females broadens, he should begin to see his mother more individually and less archetypally. If not, he is delayed in detaching from the primordial image of the mother and for Jung develops a "mother complex". The result of the mother complex is either an imbalanced connection with the feminine, resulting in homosexuality or impotence, or the reverse rejection of the feminine seen in "Don Juanism" and misogyny. Jung contends that both of these complexes can have positive outcomes for the young man, in providing him, in the first case with a gift for friendship and tenderness and abilities in teaching and religious areas of life. The positive outcome for "Don Juanism" can appear as a bold and resolute manliness, ambitiousness, and the ability to sacrifice, bordering on heroism.[16]

The difficulty that the young man faces that is not faced by the young girl confronting her animus is the complication of the powerful mother archetype. The mother archetype, which does not, in this theory, have a father archetype of the same sort or of the same magnitude of power, is distinguished from the animus which the young girl seeks to unravel in her interactions with her father and other significant males. For Jung, the successful resolution of developing a compensating animus allows her a less conflicted inner image of mother. For the boy, the personal mother, his first connection to life

and to the female, can become entwined in the mother archetype of the collective unconscious.

> This is the mother-love which is one of the most moving and unforgettable memories of our lives, the mysterious root of all growth and change; the love that means homecoming, shelter, and the long silence from which everything begins and in which everything ends. Intimately known and yet strange like Nature, lovingly tender and yet cruel like fate, joyous and untiring giver of life – *mater dolorosa* and mute implacable portal that closes upon the dead. Mother is mother-love, *my* experience and *my* secret. . . . The sensitive person cannot in all fairness load that enormous burden of meaning, responsibility duty, heaven and hell, on to the shoulders of one frail and fallible human being - so deserving of love, indulgence, understanding, and forgiveness – who was our mother. . . Nor should we hesitate for one moment to relieve the human mother of this appalling burden, for our own sakes as well as hers. It is just this massive weight of meaning that ties us to the mother and chains her to her child, to the physical and mental detriment of both. [17]

> In the human experience of mother love, there is an influence and grace associated with the mother and her care and nurturance that is almost inexpressively powerful. The personal mother assumes this great power not because of her personal gifts or actions, but because of the archetype projected on her which "gives her a mythological background and invests her with authority and numinosity." [18]

Her connection with the life source and the myriad of associated wondrous mysteries, her care and nurturance as personal mother, and her place as archetype, born into the psyche of all humans, provides the mother image a unique and colossal power felt personally and present in all religion and mythology from beginning human history. Since archetypes are of unconscious form and fill out content as they become conscious, she can appear in various ways. She takes the form of goddess, the mother of God, the virgin, and Sophia the wise. "Other symbols of the mother in a figurative sense appear in things which represent the goal of our longing for redemption, such as Paradise, the Kingdom of God . . . or things arousing devotion or feelings of awe, as for instance the Church, university, city or county, heaven, earth, the woods, the seas or any still waters, matter even, the underworld and the moon, can be mother symbols." [19]

Images of the Sacred Mother

From the earliest signs of human intelligence through the modern times, the image of the goddess has existed and been reiterated countless times. It is embraced in some form by all of the major religions and has a message and imagery that is consistent across cultures and traditions. Andrew Harvey traces this imagery through the lenses of Hinduism, Sufism, Buddhism, Taoism, and Christianity in his book, *The Return of the Mother*. Commonalities abound in these religious traditions concerning what the message of the sacred feminine is. The patriarchal nature of all of these organized religions, is simultaneously a shared factor which tends to work in the direction of distorting or limiting the sacred feminine, and toward a dangerous imbalance in the fundamental aspects of social organization which presently threatens nature and ultimately the survival of the earth.

What is the message, common in all these belief systems, of the sacred feminine? Andrew Harvey proposes three laws of the Sacred Feminine that manifest her special connection with the mysteries of life and creation. The first he called "a knowledge of the unity of all life" – that all life is inherently sacred and one, that there is "unity behind multiplicity." He refers to a story from Ramakrishna, the nineteenth century Indian mystic, who speaks of the "mother" preparing the "white fish of awareness" in different ways according to the tastes and appetites of her children. Although the flavor varies, everyone is eating the same fish. Veneration of this principle of unity would diminish arguments between religions that claim that theirs is the path to exclusive truth. "In the wisdom of the sacred feminine, life is one, all paths lead to the One. . ." Her second law is the "law of rhythm", asserting that the universe has its own laws and harmonies which are already whole and perfect and which we need to revere and intuit. The third law Harvey calls the "love of the dance", that in restoring the sacred feminine, we would return to an exuberant vision of life that does not separate mind and body or body and spirit and that accepts in wonder and joy the ordeal and conditions of this life. [20]

Harvey maintains that the Mother gives three linked messages of adoration to those who will hear. "First, she says, 'Adore me. See me in my grandeur, nobility, majesty, and wildness and adore me. Go mad with love for me.' . . .The second message is: 'Adore each creature, each being, as part of me. The third message is: 'Adore yourself humbly as my child. Through that humble adoration a recognition of your self and your consciousness as being my self and my divine consciousness will arise, and with it a recognition that everyone else exists also in that sacred truth." [21]

This view of the deity emphasizes the divine in each individual, living on earth in accord with nature, and views the world and its inhabitants as part of am immense oneness. Chief Seattle's famous 1855 response to the US government's desire to buy his people's land concluded by saying, "All things are connected like the blood which unites us all. Man did not weave the web of life, he is merely a strand in it. Whatever he does to the web, he does to himself." [22] Hauntingly similar words come from nineteenth century Indian mystic Ramakrishna: the mother is the "spider that spins the great cosmic web and lives in it. She weaves the web itself, and is also the darkly luminous womb and void from which both spider and web are constantly being born." [23]

The Mother image in Indian tradition is not only one who nurtures, but she embodies all of nature, the beautiful and the fierce, the dark and light. Aurobindo, twentieth century Indian mystic and scholar describes her as having four interwoven aspects:

"One [*Maheshwari*] is her personality of calm wideness and comprehending wisdom and tranquil benignity and inexhaustible compassion and sovereign and surpassing majesty and all-ruling greatness. Another [*Mahakali*], embodies her power of splendid strength and irresistible passion, her warrior mood, her overwhelming will, her impetuousness swiftness and world-shaking force. A third [*Mahalakshmi*] is vivid and sweet and wonderful with her deep secret of beauty and harmony and fine rhythm, her intricate and subtle opulence, her compelling attraction and captivating grace. The fourth, [*Mahasaraswati*] is equipped with her close and profound capacity of intimate knowledge and careful flawless work and quiet and exact perfection in all things. Wisdom, Strength, Harmony, Perfection are their several attributes. . [24]

The goddess religion/philosophy is wise, forward reaching, realistic, holistic, and compassionate. In contrast with Western religions that have a "good" God in heaven and the "bad" relegated to Satan and hell, the mother of which Aurobindo speaks is the mother of all faces and phases, the blue sky and the hurricane, the dark and the light. It suggests the polarities, mother as both nurturer and destroyer which, in contemporary culture, is turned away from as a threatening image. As Andrew Harvey says, "There are two sides of the sacred

feminine, one, the soaring sumptuous rootedness that actually gives health, peace, serenity, and warmth, the feminine that grounds all things. And then the other side of which we are so afraid of in a patriarchal culture: the wild anarchic, accusatory feminine, the Kali [*Mahakali*] feminine that runs at the heart of illusion with a knife. Both aspects are in union, not separate, and both are necessary to divine balance."[25]

The goddess religion is in accord with nature and in concert with many spiritual ideas that seek wholeness and honor interconnectedness. There are five categories of Buddhism and the philosophy they present is harmonious with the "mother wisdom" discussed earlier. The first category is a ruthless honesty, setting aside defenses, false consolations and beliefs. The Buddha presented the facts of life to those who would listen, the facts of imperfection, suffering and death. The second category of Buddhism has to do with interdependence, the knowing that reality is one dance, one movement or flow and that everything is linked. Nothing is stable or permanent; we are always in a state of dynamic change. The third category is compassion, concern for every sentient being arising from our relatedness to all that is. The fourth category consists of the meditative and spiritual practices of Buddhism which seek to aid in reaching enlightenment. The fifth category is the vision of emptiness, of *anatta,* of the "no-self" nature of things which suggests that all is transient and subjective, that nothing exists as we imagine and that we and all things arise from a state of "dependent co-origination". [26]

Although all the major world religions preach compassion, wholeness, and interconnectedness similar to that just stated, men and women paradoxically receive vastly different treatment both in the writings of religions and in their practice. Enlightenment cannot take place in a female body according to Buddhism and women are precluded from becoming monks. This is repeated in Hinduism, Islam, and many of the Christian sects. Female religious figures such as Lilith, Eve, and Mary Magdalene are either scapegoated or denigrated in terms of their roles in the Jewish and Christian traditions. This disturbing and perplexing fact is associated with cultures becoming more organized, relying on agriculture and the herding of animals instead of hunting and gathering. At this point, patriarchal rule becomes the norm across the inhabited world and religions, with their hierarchies, rules and regulations, are written down with strong inclination toward male belief and interest and away from the goddess religions, founded on a mythical veneration of nature.

The Patriarchal Reversal of the Sacred Feminine

Joseph Campbell's succinct remark, "Society is always patriarchal, Nature is always matrilineal"[27] speaks volumes to the inherent split that ultimately ended the goddess oriented religions as societies became more "advanced". As the female Yin and the male Yang become unentangled and unrelated and start to function in a parallel fashion, the intrinsic natures of the complementary but distinctive faces of male and female come to light as contrasting forces. At its sparsest possible description, male "intellect and rationalism" began to be in conflict and contrast to female "intuition and naturalism". As patriarchal thinking became powerful, so did the notion of opposites. "The common assumption that the spiritual and the physical worlds are different in kind, is an assumption that, unreflectively held, separates mind from matter, soul from body, thinking from feeling, intellect from intuition, and reason from instinct. When, in addition, the spiritual pole of these dualisms is valued as higher than the physical pole, then the two terms fall into an opposition that is almost impossible to reunite without dissolving both of the terms." [28]

Historically, this reversal began in the Bronze Age, around 3500 B.C.E. There were several momentous discoveries and sociological changes which gradually led away from the mother goddess religions. In addition to the discovery of producing bronze from copper and tin, with all of those implications for emerging technology, came the art of writing. The goddess does not immediately go away, but now she is seen venerated on stone columns and on the walls of temples with carved images and hieroglyphs with stories that had been handed down by word of mouth for thousands of years before. The stories vary, but there are consistent themes and patterns which emerge.

> The great myth of the Bronze Age is structured upon the distinction between the 'whole', personified as the Great Mother Goddess, and 'the part', personified as her son-lover or her daughter. She gives birth to her son as the new moon, marries him at the full moon, loses him to the darkness as the waning moon, goes in search of him as the dark moon, and rescues him as the returning crescent. In the Greek myth, in which the daughter plays the role of 'the part', the cycle is the same, but the marriage is between the daughter and a god who personifies the dark phase of the moon. The daughter, like the son, is rescued by the mother. In both variations of the myth, the Goddess may be understood as the eternal cycle of the whole: the unity of life and death as a single process. The young goddess or god is her mortal form in time, which, as manifested life – whether plant,

animal, or human being – is subject to a cyclical process of birth, flowering, decay, death and rebirth. [29]

The mystical quality of nature has endured as the revered sacred source through this time, with the goddess as a central figure of veneration. Nature is not deciphered and understood in a scientific way, but sensed as an overwhelming wonder beyond human understanding. "It is not that the divine is every*where:* it is that the divine is every*thing.*" [30]

With the Bronze Age, however, came monumental scientific discoveries and social change that permanently altered human life including notions of the divine. One of the factors that had sustained the goddess as a sacred image was her mysterious ability to produce life. It is thought by many that early humans were unaware of the exact role of the male in procreation, and thus there was a reverence for the female, who though seemingly physically weaker, had the ability, mysteriously, to produce life. This generated profound respect, and at the same time, a kind of terror in the face of this unfathomable mystery, which ultimately resulted in regarding the divine as feminine. When elementary agricultural techniques succeeded hunting and gathering and raising herds replaced hunting wild animals, observation of animal behavior and herd propagation seemed to promote the realization of the male contribution to reproduction. The male, once considered sterile and useful only for hunting and war, now achieved a previously unfelt importance he did not know before, and steadily claimed the power of the dominant societal role. [31] In early cultures, the female was symbolically considered "the first planter". Later, with the invention of the plow and the "discovery" of his procreative powers, the male took over the agricultural lead with the plow cultivating the earth, suggesting intercourse and the ultimately the control of nature. [32]

With agriculture and the herding of animals, there is a sociological transition in the Bronze Age from village to town, to city, to city-state and ultimately to empire. People lived in close contact to each other; there were food surpluses due to advances in agricultural techniques and a new hierarchy developing to manage and control the evolving cultures. Previous to these changes, there were villages focused on agriculture and pastoral activities which transformed to cities and city states ruled by kings who increasingly had to focus on the defense of their land. This is the birth of the warrior and also the birth of a hierarchy in the community that included priests who organized the life of the society and who were responsible for keeping accounts, for taxation, for apportioning land and for distributing food. [33] It is at this

time that the Mother Goddess recedes into the background and father gods move to center stage. "Without too much risk of error, we can thus conclude that it was the priests who imposed the concept of a father god, creator of all things, in an effort to eliminate the ancient concept of the mother goddess." [34]

Marginalizing the sacred feminine results in an immense loss to society of its sense of wonder and reverence for nature and of the awareness that we are interconnected facets of the natural world. As Campbell says:

> This is one of the glorious things about the mother-goddess religions, where the world is the body of the Goddess, divine in itself and divinity isn't something ruling over and above a fallen nature. . . However our story of the Fall in the Garden sees nature as corrupt; and that myth corrupts the whole world for us. Because nature is thought of as corrupt, every spontaneous act is sinful and must not be yielded to. You get a totally different civilization and a totally different way of living according to whether your myth presents nature as fallen or whether nature is in itself a manifestation of divinity and the spirit is the revelation of the divinity that is inherent in nature. [35]

The notion that early priests were responsible for the imposition of a father god is confirmed by the history of the writing of Genesis. According to Markale, the "first eleven chapters were written late, according to the patriarchal tradition of Moses, as a mix of primal myth and historical reminiscence reduced to the state of symbolic image".[36] The serpent, the creature of the ground, of nature, is the symbolic figure of the mother goddess in many myths. In breaking the patriarchal ban and listening to the serpent, Eve's act represents the original sin of the Bible which is perhaps "the first act in this long struggle of God the Father against the mother goddess." [37]

The curses and punishments in Genesis can be interpreted similarly. The curse against the serpent, the mother goddess herself, condemns her to crawl and simultaneously, woman, through Eve, is to struggle against the serpent, rather than have the opportunity to honor the goddess. "You will give birth in pain" makes a punishment of what had been, to that point, the glory of women, their ability to reproduce, which put them in an instinctive biological relationship with nature and the divine. Instead of arousing men's desires, as was amply

demonstrated in the sexual imagery of the early earth goddesses, it would be the woman who desired the men or who would be at the disposal of men as obedient mate. The woman's familiar element, "Mother Earth" is cursed. Genesis 3:17-18 states "Because you have listened to the voice of the woman, you must henceforth command her, and cursed will be the ground because of you." [38]

The Old Testament is for many our own particular mythological universe, the place from which many or most of our beliefs and assumptions originate. Given the pressure to "believe" these stories, either literally or figuratively, it may be that we never even consider the possibility of looking at the world differently, that perhaps divinity is not transcendent or *beyond* nature. Christianity especially, diverging from Judaism, teaches of a fallen world rather than a divine one. Genesis creates a God figure who creates and rules alone with no lineage, no family, no mother, wife, or child. His voice comes to those whom he made in his own image as a disembodied voice. Genesis presents a creation myth which unfolds in a linear and intelligible way. [39] According to Joseph Campbell: ". . . wherever the poetry of myth is interpreted as biography, history, or science, it is killed. The living images become only a remote fact of a distant time or sky; furthermore it is never difficult to demonstrate that as science and history mythology is absurd . . . When a civilization begins to reinterpret its mythology in this way, the life goes out of it. [40]

It is historical fact that several different human groups influenced the first three chapters of Genesis at different times. The mythology of Genesis 1 belongs to the "E" or Elohim texts which emanated originally from the mythology of the northern kingdom of Israel and date to the eighth century B.C.E. Genesis 2 and 3 belong to the Yahwist or "J" texts which belonged to the mythology of the southern kingdom of Judah and date to the ninth century B.C.E. Both of these texts were reworked after the Exile. [41] The point to be made is that in these creation myths, a solitary, all-knowing male god is presented and the roles of men, women, and nature unambiguously delineated. That they are incontrovertibly the word of God is doubtful, given the human interventions. There is a broad span of interpretation that has emerged from the Bible's creation story. It is clear, however, that with Genesis and the emergence of the Old Testament, the goddess figure of prehistory was exiled. Is it possible to repress the goddess archetype interminably? Perhaps not.

Mary

The interpretations of the role or status of Mary, the mother of Jesus, have been evolving for two millennia. There is not a great deal written about Mary in the New Testament. Matthew 1:18 reveals Mary's virginity when it relates that before Mary and Joseph 'came together, she was found with the child of the Holy Ghost.' Luke also affirms Mary's physical virginity with the main emphasis on the concept that her child must be the Son of God and not of man. Mary's life is not chronicled in much detail in the Bible, but in the dogma of the Catholic Church she is "Mother of God, Perpetually Virgin, Immaculately Conceived and Assumed into Heaven, Body and Soul, where she reigns as Queen."

There are three dates that mark Mary's emergence into this designation. In 431 C.E., the Council of Ephesus proclaimed that Mary is the *Theotokos*, the Mother of God. In 1854, Pius IX proclaimed the dogma of the Immaculate Conception, that is, the Virgin Mary was conceived without original sin. In 1950, Pope Pius XII declared the Assumption of the Virgin as official doctrine, stating that Mary was 'taken up body and soul into the glory of heaven'. This was greeted with enthusiastic support by most members of the church.[42]

Mary certainly represents an intersection between the ancient notions of the goddess and Biblical representations of woman. Mary cannot formally represent the ancient goddess, despite the worship she inspires, as she does not bring forth the world from an infinite source which is herself, which is one way that the term "virgin" can be interpreted. Rather she is a maiden uncontaminated from the "sin" of sexual relationship, who was chosen to bear the divine, but not to be divine herself. She is the Queen of Heaven but not of earth, as earth no longer represents transcendent nature, but rather fallen nature. [43] Christian interpretation of the biblical tradition of the Fall has led to the view that "life is corrupt . . . sex in itself is corrupt, and the female as the epitome of sex is a corrupter, and every natural impulse is sinful unless it has been circumcised or baptized." [44] Jesus' public life is connected with various women, and given the defamation of women generally in the Bible, it is very possibly the case that:

> in the first centuries of Christianity, the masters of spiritual power
> were forced to 'cleanse' the texts of all that was too 'feminist' or
> reminiscent of the ancient goddess religion that still survived. Thus,
> the figure of Mary, the mother of Jesus, was minimized, reduced to
> no more than 'servant of the Lord.' Likewise the role of Mary of
> Magdala was reduced to only a prostitute's. But nevertheless, wasn't

she the Initiatress? It is to her, not to his mother, not to the apostles, that Jesus first appears after his Resurrection. This could not be by chance. [45]

Eve, Mary Magdalene, and Mary, the mother of Jesus, have all been "constructed" to some degree by the authors who had a hand in the writing of the Bible. The practical position of Virgin Mary, then, is particularly complicated for the church to define in a precise way, as she is associated with the divine and yet is not divine, and needs to be pure. The Immaculate Conception as a concept puts her in a position where all these paradoxes can plausibly exist together but ultimately the conclusions reached by official religion are perplexing and perhaps illogical.

Christianity has taught that the 'miraculous' birth without the 'sin' of sexuality is believed to redeem the Eve of its own invention, but it perpetuates the Judaic tradition of belittling the human order to honor the divine. It exalts a woman to the level of a goddess, creating as a goddess creates – at once mother and virgin – yet denies her either the title of goddess or the complete humanity of a woman. As Warner writes, 'In the very celebration of the perfect human woman, both humanity and women were subtly denigrated.' [46]

Mary, with her ineffable appeal and allure through the ages, presents a singular and unique image in the iconography of myth and religion. She can resonate as the return of the goddesses of prehistory who combined spirit and matter, as they emanated from the earth and yet were immortal and timeless. The ancient goddess image represents the primordial reverence for the earth and nature and her essence gives no evidence of a separation of the material world from the divine. They are the same thing, the one, and were symbolically represented by the ancient mother goddess who presided over the endless cycles of life and death. One could argue that Mary has been and continues to be experienced as goddess by various peoples throughout the world. Religious dogma is confounding as it continues to avow the separation of earth and heaven, of matter and spirit through its written doctrines. Mary's assumption into heaven body and soul makes this tension of opposites particularly apparent. In speaking of this, Carl Jung argues that understood concretely, the Assumption is a "counterstroke that does nothing to diminish the tension between opposites, but drives it to extremes, while understood symbolically, however, the Assumption of

the body is a recognition and acknowledgement of matter."[47] The separation of spirit and matter evident in the Christian interpretation of the biblical stories of creation, was heavily influenced by Greek philosophy which dominated the thinking of the ancient world when Christianity was emerging out of Judaism. This interpretation effectively marked the end of the unity of the material and the divine in Western theology.

The virginity of Mary is a topic of central interest and some debate in Christian doctrine. Divinity of parentage and miraculous birth are common in most all mythic traditions as the vehicles through which the hero or saviour comes into the community. Mary's virginity is important to many Christians, chief among them Roman Catholics, for without it there could be no Son of God, as both that which was female and its accompanying sexuality had been tainted as evil and subject to the overriding notion of original sin. Christ, the Redeemer of sin, thus, could not have been born like other men, so it was critical to consistency and sensibility in Christian theology to assign Jesus Christ virgin birth, and to extend the line back to Mary and her mother Anne.

> Mary's virginity was defined in imagery that banished sexuality and birth from embodying an aspect of divinity. She becomes the mother of the Redeemer and the mother of all believers, but she is no longer the mother of all living, as Eve was. So the natural processes of birth by which all living creatures come into being are rejected as links in the corrupting chain of original sin. Mary's womb, unlike Eve's, is uncorrupted by human fecundation, or the human processes of birth. In the imagery of the Song of Songs, it is 'a garden enclosed . . . a spring shut up, a fountain sealed'. [48]

The dualism and devaluation of nature through this Christian doctrine is fairly apparent. By identifying "spirit" with the Virgin Mary and "matter" to sinful Eve, women were left with no sensible lofty image to emulate. "for their motherhood could never achieve Mary's perpetual virginity, nor their virginity her fortunate motherhood. They could, therefore, identify themselves only with Eve." [49] This is in some contrast to the numerous affirmative images women could emulate among the Greek goddesses (though this was also a patriarchal system). Mary Magdalene, who should logically have had a seat of honor among the first followers of Christ as the "Apostle to the Apostles", was instead called a "penitent whore". Lilith, the mythic predecessor to Eve, showed personal resolve, but was relegated to a role of evil-doer to children for her petulance. The image

of "good woman" as obedient helpmate has been made abundantly clear in both the Old and New Testament.

Despite the unfortunate doctrine that makes the earth (and nature) unconnected to the divine, and shows woman as the embodiment of this imperfection, and despite the fact that Mary represents perfect humanity with a connection to both worlds, the image of Mary has had a spiritual impact that transcends simple understanding and explanation. Though not celebrated by the church as deity, Mary's presence abounds as she is and has been venerated for 2000 years in art, architecture, myth, and religious practice. The power of the image of Mary transcends confusing theology, and perhaps emanates from a much deeper and more profound place than can be found in written church doctrine.

All rational belief systems carry with them the notion that balance is a critical feature of sane living. People who value the special features of that which we consider "the masculine" and "the feminine" are exceedingly aware that these aspects of life are out of balance in current times. Patriarchy is an overwhelming and unbalanced force in the social affairs of every nation in the world as we aggress against each other and nature itself. It is clear that the essence of the Divine Feminine is not an apparent influence today. As stated before, it is hard to imagine a single culture that is not based on male principles of competition, dominance, and "rationality." It is perhaps even harder to imagine a culture that is based on principles of the Sacred Feminine, namely reverence for nature, each other and our own selves, and a sense of being part of an immense system of natural life that must be venerated and sustained. Perhaps the persistent, relentless presence of Mary in myth, iconography, and religion is, to a significant degree, related to an unconscious psychological compensation in Western culture.

Carl Jung proposed that if the conscious psyche of an individual or group (of any size) has become distorted or out of balance, then the unconscious psyche will compensate by insisting (through a variety of ways) that a balancing view enter consciousness. This chapter has shown that there is an absence of positive female figures in the Bible and the business of running religion by the church is almost completely male-dominated. This sits on top of and is fortified by patriarchal control of societal function: political, business, and military. It might be that images of the Virgin Mary have filled this void for the past 2,000 years.

> For many Catholics, perhaps the majority, it simply does not matter
> whether Mary is called a goddess; she moves the heart by any name,
> whatever position she is given in working out a scheme of things.
> *Madonna,* a recent book of pictures and hymns throughout the ages,
> shows that Mary was variously prayed to as 'Mother of the Word',
> 'Star of the Sea, Glorious Mother of God', Wide Open Gate of
> Heaven', 'Our Ambassadress and our Hope', 'Queen of Angels',
> 'Queen of Apostles', and 'Harrier of Hell'. It is notable that, as many
> a Protestant theologian has roundly protested, in art, for the most part,
> Jesus is either a newly born infant or dead! [50]

As Mary, the mother of Jesus, fills the role of compensating
archetype, other female figures in the Bible suffer the effects of
subordination and their images have been projected onto women in the
Western world through time. One of the paradoxes for feminists is the
reality that the difference that the female represents in contrast to the
male has been turned into detriment and disadvantage by the effects of
an unbalanced, patriarchal culture. This process is a topic of interest in
social psychology.

When a group is determined to be "inferior" by an opposing
dominant group, it is labeled defective or substandard in various ways.
Once this has happened, the dominant group tends to define acceptable
roles for the subordinates, and these tend to be roles which the
dominant group has no interest in performing. Preferred roles are
carefully guarded and largely closed to subordinates. Justification for
this is that the subordinates are unable or unwilling to perform
preferred roles because of innate deficiencies in mind and/or body. As
this order is enforced, the dominants have a hard time imagining the
subordinates performing the desired functions, and significantly, the
subordinates start to feel similarly and often question their own
abilities.

Subordinate groups are encouraged to develop personal
characteristics such as docility, passivity, obedience, and dependency
that please the dominant group. If they develop these traits, they are
often considered "well adjusted" by the social order. That social order
is clearly determined very strongly by the dominant group, and the
unequal relationships thus created are legitimized and incorporated into
society's guiding concepts. Ultimately, the dominant group becomes
the model for "normal human relationships" and so other types of
relationships, that might maximize compassion or intuition or
nurturance as would be seen in women, could be marginalized or seen
as lacking an essential ingredient such as "rationality". Dominants seek

to avoid the sort of conflict that might upset the status quo and often can be convinced that the tone of life that they have set is best for everyone. Obviously, they hold almost all of the power and authority and determine how this power may be legally or ethnically employed.

Subordinate groups are harder to understand, since they cannot function as dominants do in the social and political environment that has been created. They often have to resort to disguised and indirect ways of acting and reacting. Expressions of dissatisfaction and activism by subordinates tend to come as a surprise to dominants and the outspoken minority is often marginalized as odd or atypical. Subordinates know much more about the dominants than the dominants know about them. This knowledge often has to do with survival, as they need to remain in favor with those on whom they depend. Feminine wiles and feminine intuition are perhaps an outgrowth of this reality. Sadly, often subordinates know more about the dominants than they know about themselves, as much of their fate involves pleasing and attending to the dominants. In addition, subordinates often absorb a large number of the untruths created by the dominants about them, as it seems apparent that there are few other avenues in which they can find self description that is both truthful and empowering. [51]

Conclusions

The struggle between an imbedded patriarchy and an unconscious mythology is played out dramatically if we return to the representations of Mary, the Mother of Jesus, over the past 2,000 years. One could argue that there were two eras from the beginning of human time that had to do with the construction of the mythological and religious beliefs of human civilization. The first stage could be considered a "matriarchal stage" in which humankind was one with nature, knew and loved and relied on the Mother Goddess and was open to the kind of mystical awareness and guidance that she provided. The second stage, the patriarchal stage, began in Greece with a shattering of the old goddess archetypes and the construction of a new hierarchy, which was controlled by male gods. [52] This was paralleled by the Hebrew culture that also disassembled the goddess culture. "The term for the Canaanite goddess that's used in the Old Testament is 'the abomination'. . . . Many of the Hebrew kings were condemned in the Old Testament for having worshipped on the mountaintops, symbols of the Goddess. . So it's an extreme case that we have in the Bible and our own western subjugation of the female is a function of biblical thinking." [53]

In the early matriarchal stage, the goddess was a representation of the female, but simultaneously of nature. Ancient peoples venerated the earth and recognized the critical importance of maintaining it. With the striking change of the patriarchal era, the written religions stressed transcendence, that the divine was somewhere else and the earth was cursed.

> That is the biblical condemnation of nature which they (Americans) inherited from their own religion and brought with them, mainly from England. God is separate from nature and nature is condemned of God. It's right there in Genesis: we are to be the masters of the world. But if you will think of ourselves as coming out of the earth rather than having been thrown in here from somewhere else, you see that we are the earth, we are the consciousness of the earth. These are the eyes of the earth. And this is the voice of the earth, the whole planet as an organism.[54]

The religious traditions of this era have failed to provide a complex unifying vision of this world, being attached to detachment and transcendence. "Because they [religions] were all created in the second patriarchal stage of human development, they all essentially stress the masculine tendency to fear the body and to fear and hate women." [55] It is not difficult to support the notion that this view of life, death, and the divine has placed us in a very tenuous position as we move toward the future. The world is a chaotic and self destructive place as it has proceeded in a philosophy that does not treasure and revere nature, each other, and representations of the divine, but rather uses the earth as a tool with the hope of transcendence to another sphere of life and consciousness.

> The real war in the modern world is not between democracy and communism, capitalism and totalitarianism, liberalism and fascism; it is the war for the mind and heart of humankind between two completely different versions of reality: the masculine, or patriarchal version, which material science, most contemporary philosophy, and most modern art represents, and which holds human beings to be driven dying animals in a random universe; and that vision of humankind's essential divine destiny that mystics of all spiritual traditions throughout history have discovered and struggled to keep alive. [56]

Some may believe that those who speak about the suicidal way we are running our world are doomsday prophets who inflate the danger of over-consumption, short-sightedness and violence. The thinking person, however, must reflect on the view that our androcentric world culture has subordinated and distanced the feminine and the principles of compassion, concern, and nurturance for all living things which she represents. Given this, we are out of balance with nature, and as a result with ourselves.

The Return of the Mother and the Sacred Marriage

The mother image has been subjugated for thousands of years in terms of having a direct, overt impact on the management of communities, nation states, and the planet. If a creed or ideology is subordinated to that which is its opposite, the dominant philosophy becomes "normal and natural", rationalizations about why the current regime of ideology must persist become abundant, and those representing the subordinated group are made to feel that their contributions are less central or relevant to the conduct of society than those of the dominant group. Over time, when this is the case the marginalized group withers, both in the feelings of strength and influence experienced by itself and in its actual strength and influence as experienced by the dominant faction. As the result of the second phase of religious development when religion was codified and the loins of patriarchy were girded, the mother and her message have been sent underground and have remained largely untapped for several thousand years. Can the mother goddess and her wisdom return?

The Story of Images of Virgin Mary as Allegory

The dilemma of where Mary belongs in organized religion has been problematic. She needed to be human in order to give birth to a divine son but also in some sense divine to assure that Christ's passage into life on earth was untainted by the sin that was inherent in being human. The decisions around the Immaculate Conception and the Assumption made this dilemma more manageable, but from the beginning, her status was debated:

"The body of Mary is holy," wrote Saint Epiphanius (315-403), "but Mary is not divine." That great rationalist Saint Ambrose (340-397), maintained that "Mary was the temple of God and not the God of the temple, "no doubt to emphasize that while she might be the absolute mother of God, she was no less the "lord's servant" and not his "master," and that, in any case she was, in the words of Saint John

Chrysostom (340-407), "vain as all women are." There could be no
better way to debase the woman, even if she was Theotokos.[57]

Veneration and love have poured out of the people for centuries
toward images of Mary, despite definitions they are given. Perhaps this
emanates from a very deep archetypal source in which Mary embodies
the goddess figures of old. Some of the most interesting
representations of Mary are seen through the longstanding presence of
Black Madonna figures, explored earlier in this book. With several
hundred images still existing, there are many associations made in an
effort to understand her meaning, identity, and origins. A precise
understanding is probably unavailable but some consider her "the other
Mary". For Jung she is Isis; others consider her to be the iconic
remains of prehistoric Earth Mother worship. She is linked with
Cybele, Diana, Isis and Venus; cross culturally, she is associated with
Kali, Inanna and Lilith. [58] Her mystery, timeless appeal, and
persistence must be linked to several interrelated aspects of Mary and
the archetype of mother of nature that connect her to profound depths
of human consciousness and unconsciousness.

Andrew Harvey considers that there are three facets of the Black
Madonna that characterize the intense link of Mary to her people:

> I am coming to see in the Black Madonna three main and only
> superficially contradictory aspects of Mary: first, Mary as the
> mystery of transcendent blackness, the blackness of divine mystery,
> that mystery celebrated by the great Aphophatic mystics such as
> Dionysisus Areopagit, who see the divine as forever unknowable,
> mysterious, beyond all our concepts, hidden from all our senses in a
> light so dazzling it registers on them as darkness; second, Mary as
> queen of the fertility of nature, queen of tantra and all natural fertile
> engendering processes in the external and internal world; third, Mary
> as Jacophone da Todi's *"donna brucciata,"* the burned, seared
> anguished, but infinitely strong and dignified human mother who has
> learned and embodies the ultimate secrets of mystical and personal
> suffering. In the Black Madonna, Mary appears as all three of her
> crucial aspects as Divine Mother. [59]

In this description of the elemental meaning of the Black Madonna
lay both mythical and religious connotations. Mythically, she is
symbol of the darkness of divine mystery and embodies the
unknowable marvel of the divine. She returns, again, as the mythic
symbol of nature and fertility, as the goddess of old, the ancient notion
of the divine feminine. Third, in a religious sense, as described in the

Bible, she is the mother whose suffering emerges as her son, Christ, is sacrificed. With such roots in the human psyche, her continued presence in human life is not surprising.

Although much of this book speaks to the imbalance in human life that reinforces patriarchy and marginalizes the sacred feminine, a laser-like focus on the power of Mary neglects the breadth of her field, which includes the divine in the form of Jesus. Seen in more figurative mythic terms instead of literal religious terms, there is an extraordinary depth and extensiveness of meaning in their lives and relationship. First, there is a commonality of message. Both lived lives of radical humility. Joseph Campbell spoke of one of the purposes of myth as being the provision of models for living, and Jesus and Mary's lives can be understood as offering models for emulation rather than distanced figures approachable only through formal worship.

> Christ reverses all the patriarchal values of power, exploitation, and domination; reverses all his– and our– culture's fascination with toughness, hardness, harshness, violence and authority. The Sermon on the Mount is entirely about the feminine virtues of humility, patience, tenderness, and kindness. Christ is speaking as a male divinized by the Father-Mother, initiated into the transcendent force, and into the Mother's – his Mother's – radical knowledge of the power of powerlessness, the infinite force of humility. The kingdom he is revealing is the Father's and the Mother's. [60]

One of Mary's mythological representations is of the return of the mother goddess, the representation of nature, the reinforcement of the notion that the divine surrounds us, divine here being synonymous with earth and nature as they appear in Jesus' words as contained in the Gospel of Thomas. The Gospel of Thomas, which was written in 140 CE, translated into Coptic in 500 CE, was composed of 114 sayings of Jesus which have strong similarities sayings in the four canonical Gospels. The critical difference between Thomas and the other gospels is the "consistent inwardness of the Gnostic text, in which the 'Kingdom' is not 'in heaven' or 'in the sea', but it is 'within you and it is without you'. (Logion3). Two passages from Thomas portray this well: "His disciples said to Him": 'When will the Kingdom come?' Jesus said: It will not come by expectation; they will not say, 'See here' or 'See there'. But the Kingdom of the Father is spread upon the earth and men do not see it." (Logion 113) Another passage: "Cleave a (piece of) wood, I am there;
Lift up the stone and you will find Me there." (Logion 77) [61]

This interpretation promotes, as Campbell says, " a theology of immanence", that the divine is in all of nature, instead of a theology of transcendence, where one must leave the earth and nature to experience the divine. In this, Mary and Jesus have a mythic balancing bond, their relationship representing the connection of the divine to the natural and the male to the female.

The Sacred Marriage

The great myth of the Bronze Age is represented in the drama of the Great Mother Goddess (the whole) giving birth to her son (the part) at the new moon, her marriage to him at the full moon, her loss of him at the waning moon at which time she goes in search for him, and her rescue of her son at the crescent moon. There are variations on this in Greek myths, but the symbolism of the myth represents the endless and cyclical process of birth, flowering, death, and rebirth. This imagery, which is not incestuous but symbolic and mythical, with Mary and Jesus in similar roles, starts to be seen in pre-Renaissance paintings and mosaics in Italy. The imagery varies. Several paintings called *The Coronation of the Virgin,* and one entitled *Jesus and Mary on the Throne* depict Jesus and his mother relating to each other in the nuptial symbolism of the bridal pair. *Jesus and the Dormant Mary,* from the 13th century shows Mary's body lying in front of Christ who holds the baby that is her soul, as though he were himself the mother out of whose heavenly body the baby had come. Traditionally, the mother figure of this myth is the image of *zoë,* known as "The soul of the world", and she gives birth to *bios,* the face of humanity. In this painting, the roles are reversed, with Christ, as the spiritual mother, bringing Mary's eternal soul into being as she leaves her earthly body. The timeless myth portrays the Soul of the World renewing herself in humanity, her son, in a new manifestation of her being. [62]

> It seems that whenever the depths of the soul are touched by the need to go beyond the literal interpretation of formal doctrine, the old lunar myth is evoked again and the archaic images re-emerge. At the deeper level of symbolic imagery Mary, as *zoë,* brings the unmanifest divine world into manifestation as *bios,* in the person of her son. He is offered, or offers himself, as sacrifice in order that this translation of life from one dimension to another may flow back and forth. Mary is then the new incarnation of the old poetic vision, which is timeless because it reflects *zoë;* Jesus is the *bios,* in historical time who teaches the poetic vision. As both divine and human, he belongs to both realms and so he is the intermediary between the source and the

manifestation. It is the poetic vision that gives birth to the new order, for this is the language of the soul. [63]

The Sacred Marriage, then, has to do with the joining of the male and the female principles, the divine and the human, into an intertwining, eternal, repeating tale. The images of Jesus and Mary, in this way of thinking are symbols that at once suggest gender, but transcend it, and strongly assert the importance of the complementarity of opposites, which ultimately reflects a movement toward oneness.

This book has focused on the manipulation and transformation of symbolic images of women, and reflects, with the imbalance induced by millennia of patriarchal domination, the effects of the loss of the Sacred Feminine, the image of Mother Nature and Mother Earth. In the rampage toward "progress" and ultimately self-destruction that we now are living world-wide, there is a need for a new myth of the planet that reaffirms the notions of interdependence, preservation of divine nature, and the balance of the opposites that are the Yin and the Yang, the female and the male. Although goddesses like Mary emerge in various forms, bursting out of the psyches of people in need of an unconscious sensibility that seeks balance, an awakening to the wisdom and the necessity of the female archetype in the living of life, needs to emerge through honoring her in spoken word, writing, art, and religious and mythical imagery.

Notes

[1] Joseph Campbell, with Bill Moyers, *The Power of Myth* (New York: Doubleday Publishers, 1988), p. 90.

[2] Joseph Campbell, *The Hero with a Thousand Faces*. (Princeton, New Jersey: Princeton University Press, 1968), p. 13.

[3] Campbell, *The Power of Myth*, p.38

[4] Jean Markale, *The Great Goddess* (Rochester, Vermont: Inner Traditions International, 1997), p.51.

[5] Markale, *The Great Goddess*, p.59

[6] Wolfgang Lederer, *The Fear of Women* (New York: Harcourt Brace Jovanovich, 1968) p. 32.

[7] Markale, *The Great Goddess*, p. 59.

[8] Campbell, *The Power of Myth*, p. 210

[9] Carl Jung, *The Portable Jung*.Joseph Campbell, ed. (New York, Penguin Books, 1971), pp. 59-60.

[10] Carole Wade and Carol Tavris, *Invitation to Psychology* (New York: Longman, 1999), p. 320.

[11] Carl Jung, *The Archetypes and the Collective Unconscious* (Princeton, New Jersey: Princeton University Press, 1959), pp. 79-80.

[12] Jung, *Archetypes*, p.59.

[13] *Yin/Yang.* Retrieved July 21, 2002 from the website, "thebigview.com/tao-te-ching/yin-yang.thml."

[14] Jung, *Archetypes*, p. 28.

[15] Jung, *Archetypes*, p. 28.

[16] Jung, *Archetypes*, pp. 86-7.

[17] Jung, *Archetypes*, p. 92.

[18] Jung, *Archetypes*, p. 82.

[19] Jung, *Archetypes*, p. 81.

[20] Andrew Harvey, *The Return of the Mother* (New York: Putnam, 1995) p.26.

[21] Harvey, *The Return of the Mother*, p. 68.

[22] Anne Baring and Jules Cashford, *The Myth of the Goddess: Evolution of an Image.* (London: Penguin Books, 1993), p. 3.

[23] Harvey, *The Return of the Mother*, p. 31.

[24] Sri Aurobindo, *The Mother* (Twin Lakes, Wisconsin: Lotus Light Publications, 1995), pp. 36-7.

[25] Harvey, *The Return of the Mother*, p 207.

[26] Harvey, *The Return of the Mother*, pp.222-3.

[27] Campbell, *The Power of Myth*, p.125

[28] Baring and Cashford, *Goddess*, p. xii.

[29] Baring and Cashford, *Goddess*, p. 147.

[30] Joseph Campbell, *The Masks of God: Oriental Mythology* (Harmondsworth: Penguin Books, 1970), p. 12.

[31] Markale, *The Great Goddess*, p.4.

[32] Campbell, *The Power of Myth*, p.125

[33] Baring and Cashford, *Goddess*, p.152

[34] Markale, *The Great Goddess*, p. 5.

[35] Campbell, *The Power of Myth*, p.121.

[36] Markale, *The Great Goddess*, p. 5.

[37] Markale, *The Great Goddess*, p. 6.

[38] Markale, *The Great Goddess*, p.7.

[39] Baring and Cashford, *Goddess*, p.488.

[40] Campbell, *The Hero with a Thousand Faces*, p. 249.

[41] Baring and Cashford, *Goddess*, p.417-8.

[42] Markale, *The Great Goddess*, p. 15.

[43] Baring and Cashford, *Goddess*, p.553.

[44] Campbell, *The Power of Myth*, p. 54

[45] Markale, *Goddess*, pp. 23-4.

[46] Baring and Cashford, *Goddess*, p. 564.

[47] Baring and Cashford, *Goddess*, p. 572.

[48] Baring and Cashford, *Goddess*, p. 538.

[49] Baring and Cashford, *Goddess*, p. 539.

[50] Baring and Cashford, *Goddess*, p. 554.
[51] Jean Baker Miller, *Toward a New Psychology of Women* (Boston: Beacon Press, 1987), P. 10.
[52] Baring and Cashford, *Goddess,* p. 155-6
[53] Campbell, *The Power of Myth,* p. 216.
[54] Campbell, *The Power of Myth*, p. 40.
[55] Harvey, *The Return of the Mother*, p. 27.
[56] Harvey, *The Return of the Mother*, pp.15-16.
[57] Markale, *The Great Goddess,* pp. 15-6.
[58] J. Channell, *Who is the Black Virgin?* Retrieved July 20, 2002 from the website "shell.amigo.net/ma3/."
[59] Harvey, *The Return of the Mother*, pp. 371-2.
[60] Harvey, *The Return of the Mother*, p. 394.
[61] Baring and Crawford, *Goddess*, pp. 602-3.
[62] Baring and Cashford, *Goddess,* p. 608.
[63] Baring and Cashford, *Goddess*, p. 608.

Works Cited

Aurobindo, Sri (1995). *The Mother.* Twin Lakes Wisconsin: Lotus Light Publications.

Baring, Anne & Cashford, Jules (1993). *The Myth of the Goddess; Evolution of an Image.* London: Penguin Books.

Campbell, Joseph (1968). *The Hero with a Thousand Faces.* Bollingen Series SVII (2nd ed.). Princeton, New Jersey: Princeton University Press.

Campbell, Joseph (1970). *The Masks of God: Oriental Mythology.* Harmondsworth: Penguin Books.

Campbell, Joseph, with Moyers, Bill (1988). *The Power of Myth.* New York:Doubleday.

Channell, J. (1997). *Who is the Black Virgin?* Retrieved July 20, 2002 from the website "shell.amigo.net/ma3/."

Harvey, Andrew (1995). *The Return of the Mother.* New York: Putnam.

Jung, Carl G. (1959). *The Archetypes and the Collective Unconscious.* Bollingen Series Princeton, New Jersey: Princeton University Press.

Jung, Carl G. (1971). *The Portable Jung* (Joseph Campbell, Ed.). New York: Penguin Books.

Lederer, Wolfgang (1968). *The Fear of Women.* New York: Harcourt Brace Jovanovich.

Markale, Jean (1997). *The Great Goddess.* Rochester, Vermont: Inner Traditions International.

Miller, Jean Baker (1987). *Toward a New Psychology of Women* (2nd. ed,) Boston: Beacon Press.

Stone, Merlin (1976). *When God Was a Woman.* New York: Harcourt Brace Janovich.

Wade, Carole & Tavris, Carol (1999) *Invitation to Psychology.* New York: Longman.

Yin/Yang. Retrieved July 21, 2002 from the website, "thebigview.com/tao-te-ching/yin-yang.html."

Index